2010

Schilt Publishing

Lars Boering

Managing Director, World Press Photo Foundation

We believe in the power of showing and the importance of seeing high-quality visual stories. That has been in our DNA from the beginning.

In 1955 a group of Dutch photographers organized an international contest ('World Press Photo') to expose their work to a global audience. Since then the contest has grown into the world's most prestigious photography competition and, through our successful worldwide exhibition program, presents the winning stories to millions of people.

In the six decades that the World Press Photo Foundation has been working from its home in Amsterdam as a creative, independent, non-profit organization, the world has changed continuously, and new developments in the media and technology have transformed journalism and storytelling. Our mission has expanded, and we draw on our experience to guide visual journalists, storytellers, and audiences around the world through this challenging and exciting landscape.

Amidst these transformations and the expansion of our mission, the photo contest and the digital storytelling contest prove each year how important trustworthy visual journalism and storytelling are. This year we introduced a new process for announcing the contest results: first revealing six nominees for the photo of the year and for each category, before naming the winners at the Awards Show. We implemented this ambitious new program to enhance the recognition that the dedicated professionals who are committed to capturing these important and moving stories receive. Photography should be, and most definitely is, one of the world's conversation starters.

This year's photo contest showed me several things. Firstly, storytelling that has been worked on for a long period rises to the top. This is particularly the case in the Long-Term Projects category, where we find amazing quality among the winners. What also caught my eye is how strong Spot News photos are. These images are often shot under extremely difficult circumstances, and those making them form a special breed of photographers, able to make the most potent and unique pictures.

Equally powerful are the surprise of Sports, the beauty of Nature, and the importance of the new Environment category, introduced this year. The Environment category showcases very important work that photographers have spent a lot of time developing and producing. Their research and preparation shines through in the inaugural winners.

Photography that is good and real is not *of* something; it is *about* something. It should matter to the people to whom it visually speaks. Today the World Press Photo Foundation plays the role it began with in 1955. The great work in this 2018 edition of our yearbook continues to fulfill our purpose: connecting the world to the stories that matter.

Magdalena Herrera
Chair of the 2018 Jury

At first, it is overwhelming: 73,000 photos; 17 jurors, supported by two secretaries, conducting two jury rounds over 20 days, all designed to choose the best photography of the past year.

We, the jury members, are news photographers, nature and conservation photographers, visual artists, and photo editors of daily newspapers, weekly news magazines, and monthly photo magazines—all representing the industry.

Maintaining the standards and practices of the press—upholding the journalism in photojournalism—is crucial in this era of fake news. The World Press Photo contest is today the most serious photo competition in this respect. The contest has a team of researchers who fact-check the information provided in story resumes and captions, and others who perform forensic examinations to detect any manipulation.

But the essential question remains: what makes a good photograph, what makes a good story?

It's a challenging question, one you have to look at from cultural and geographical perspectives outside your daily field of work and beyond your regional boundaries. You have to try to ignore your prejudices. That allowed the most interesting reactions: the right to doubt, the possibility of changing your mind, of being challenged by your fellow jurors. Our ongoing conversations about photography before and after our judging sessions were as important as the viewings. We knew we wanted to be surprised; we wanted to be impressed, we wanted to see new approaches. Singles had to grab you, hook you. They have to come forward with their charge of emotion, empathy, and power. The accuracy of the instant. The telling moment.

A year's photography—and some photographic work made over more than a year—is passing before your eyes: mostly scenes of violence, despair, and suffering, but also photos that witness the beauty and transformation of our world.

I began by asking the members of the jury what they were looking for. The primary expectations were professionalism and respect for the subject, a new and challenging approach, to be surprised, and, finally, not to be attached to the kind of work they already knew.

From the judges' point of view, it is an amazing experience, an immersion in photography, with a rare opportunity during the selection process to exchange points of view with professionals outside one's field. Each of us has a voice. My role as head of the jury was to bring those voices out—all of them; to let them be heard, to challenge the others, before the final vote.

The amazing photographs you can see in this book and the exhibition worldwide over the coming year are a selection made by a panel of jurors who are all passionate about photography.

The 2018 Nominees

Adam Ferguson

Australia,
for *The New York Times*
→ page 131

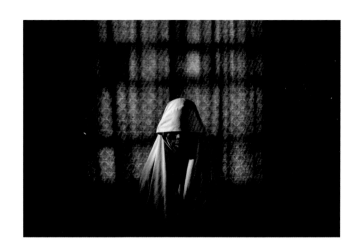

Toby Melville

UK, Reuters
→ page 80

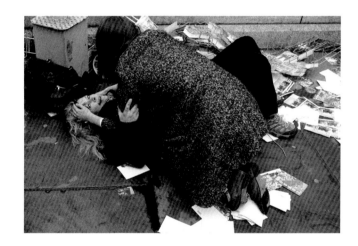

Ivor Prickett

Ireland,
for *The New York Times*
→ page 98

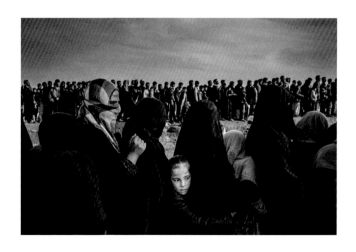

Ivor
Prickett
Ireland,
for *The New York Times*
→ page 96

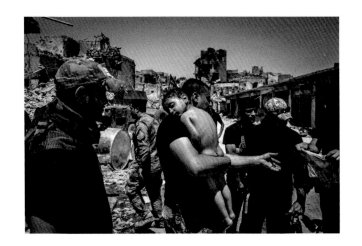

Ronaldo
Schemidt
Venezuela,
Agence France-Presse
→ page 18

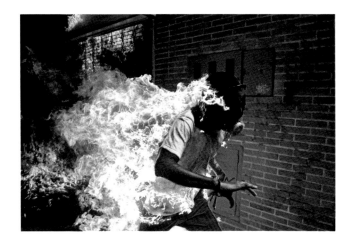

Patrick
Brown
Australia,
Panos Pictures, for UNICEF
→ page 24

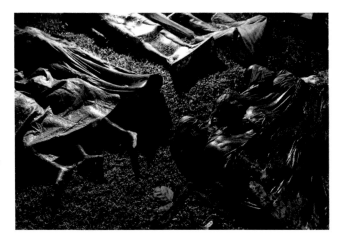

Contents

Environment

Sports

Nature

Long-Term Projects

The 2018 Singles

Magnus Wennman

Sweden, *Aftonbladet* / 1st Prize People

2 March 2017 › Djeneta (right) has been bed-ridden and unresponsive for two-and-a-half years, and her sister Ibadeta for more than six months, with *uppgivenhetssyndrom* (resignation syndrome), in Horndal, Sweden.

 Djeneta and Ibadeta are Roma refugees, from Kosovo. Resignation syndrome (RS) renders patients passive, immobile, mute, unable to eat and drink, incontinent and unre-sponsive to physical stimulus. It is a condition believed to exist only amongst refugees in Sweden. The causes are unclear, but most professionals agree that trauma is a primary contributor, alongside a reaction to stress and depression. It is also not clear why cases are found exclusively in Sweden. RS has so far affected only refugees aged seven to 19, and mainly those from ex-Soviet countries or the former Yugoslavia. For many, the syndrome is triggered by having a residence application rejected. Granting residence to families of sufferers is often cited as a cure.

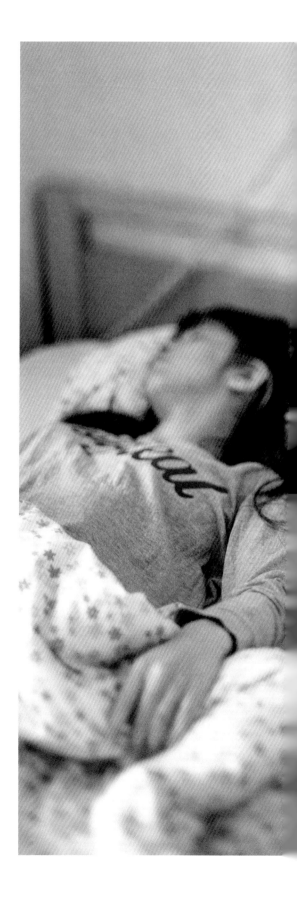

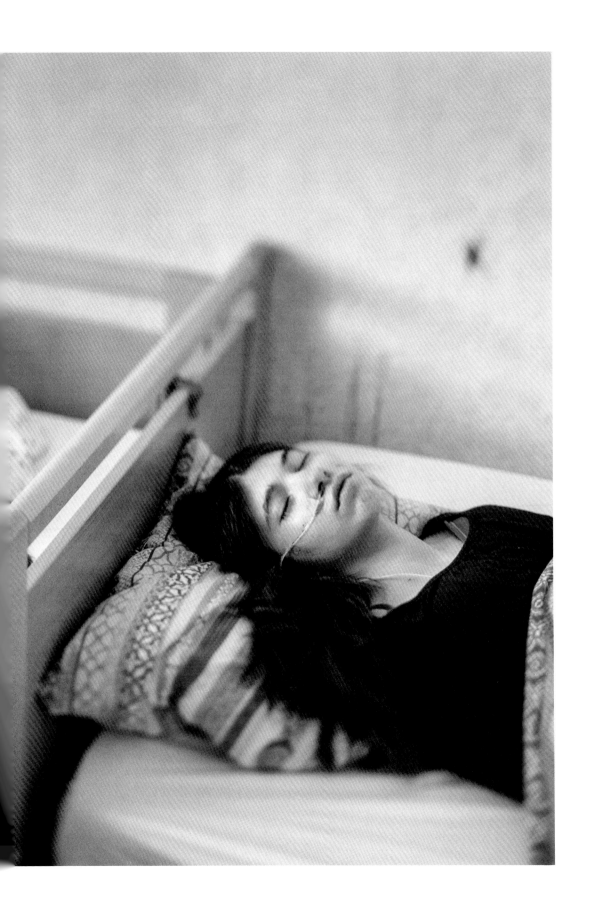

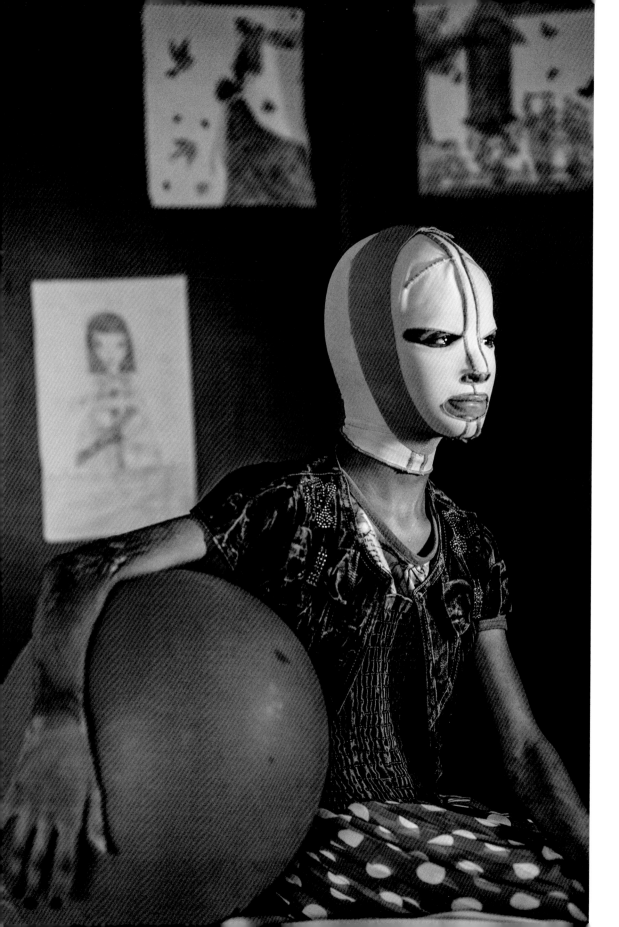

Alessio Mamo

Italy, Redux Pictures for Médecins Sans Frontières Jordan / 2nd Prize People

10 July 2017 › Manal (11), a victim of a missile explosion in Kirkuk, Iraq, wears a mask for several hours a day to protect her face, following extensive plastic surgery at the Médecins Sans Frontières Reconstructive Surgery Program, Al-Mowasah Hospital, Amman, Jordan.

Children and adults from Yemen, Iraq, Syria and Gaza who have been badly injured by bombs, car explosions or other accidents live in the hospital with a relative or friend. Manal, who was displaced along with her mother and two brothers, endured severe burns to her face and arms. She had no surgery before coming to Jordan and had difficulty in closing her right eye. After many plastic surgery operations, she now wears her mask for several hours a day, primarily to protect her skin from the light. Manal has many friends at the hospital, and loves drawing and telling stories, as well as the many organized activities for children.

Li Huaifeng
China / 3rd Prize People

11 November 2017 › Two brothers live in a traditional *yaodong* ('kiln cave'), carved into a hillside on the Loess Plateau in central China. The earth-lined walls have good insulating properties, enabling residents to survive cold winters.

The *yaodong* is one of the earliest housing types in China, dating back more than 2,000 years. The Loess Plateau, in the upper and middle reaches of the Yellow River, is approximately the size of France. The loess soil—fine, mineral-rich, wind-blown silt, accumulated over centuries—is hundreds of meters thick in some places, and the numbers of *yaodong* run into millions. The loess not only keeps the dwellings warm in winter, but also cool in summer. The brothers, who are both unmarried, have lived in this *yaodong* for most of their lives.

World Press Photo of the Year 2017

Ronaldo Schemidt
Venezuela, Agence France-Presse /
1st Prize Spot News

3 May 2017 › José Víctor Salazar Balza (28) catches fire amid violent clashes with riot police during a protest against President Nicolás Maduro, in Caracas, Venezuela.

President Maduro had announced plans to revise Venezuela's democratic system by forming a constituent assembly to replace the opposition-led National Assembly, in effect consolidating legislative powers for himself. Opposition leaders called for mass protests to demand early presidential elections. Clashes between protesters and the Venezuelan national guard broke out on 3 May, with protesters (many of whom wore hoods, masks or gas masks) lighting fires and hurling stones. Salazar was set alight when the gas tank of a motorbike exploded. He survived the incident with first and second-degree burns.

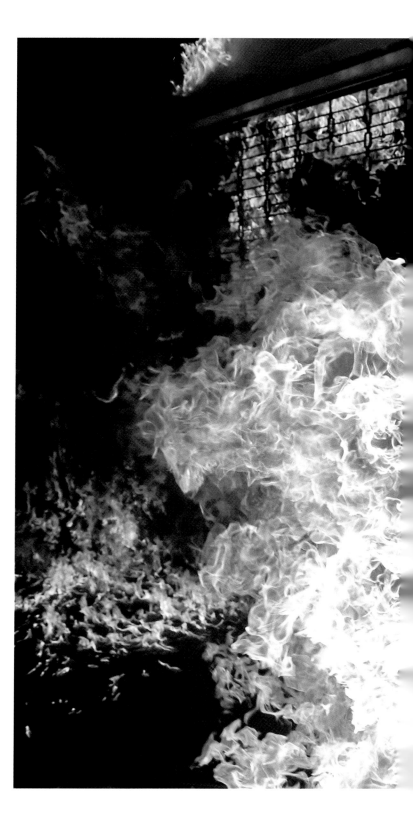

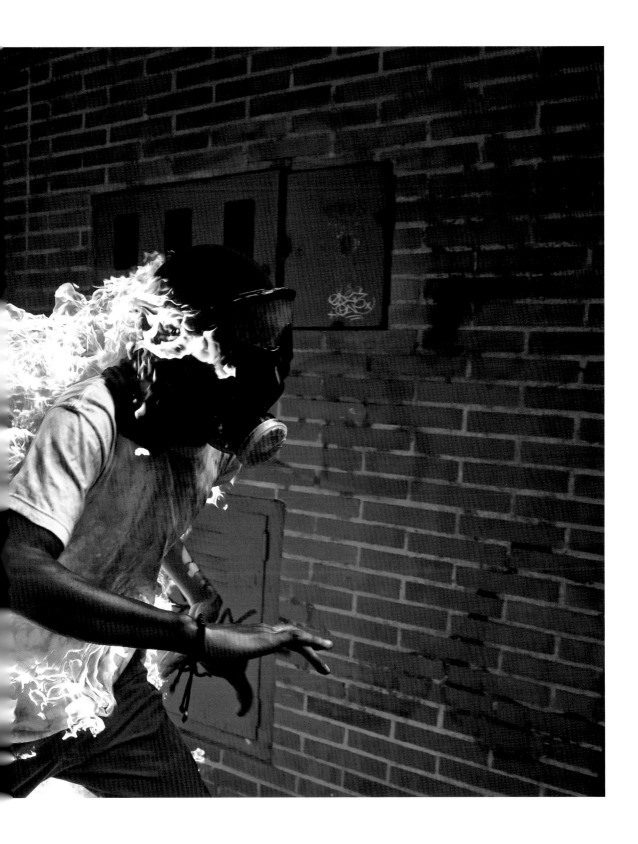

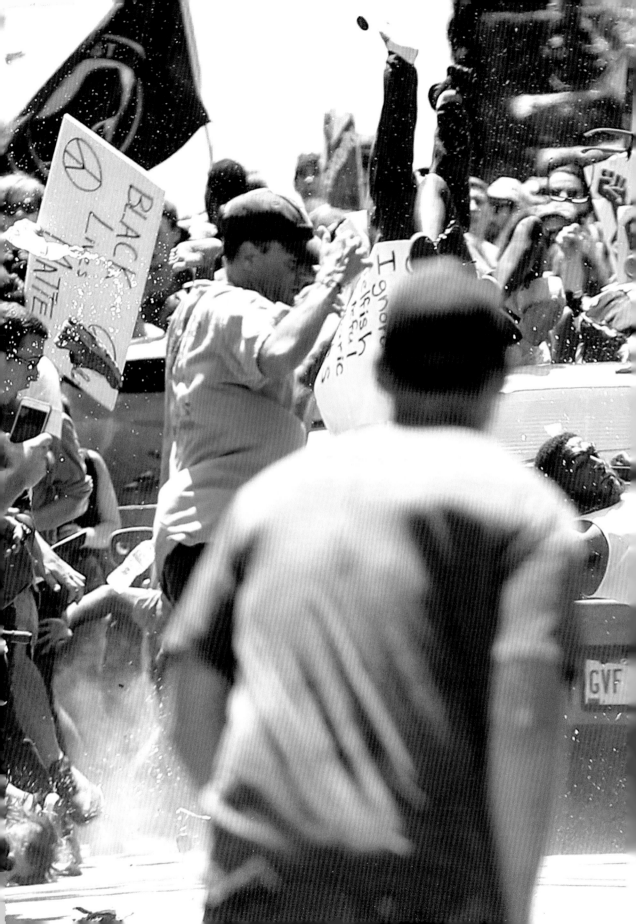

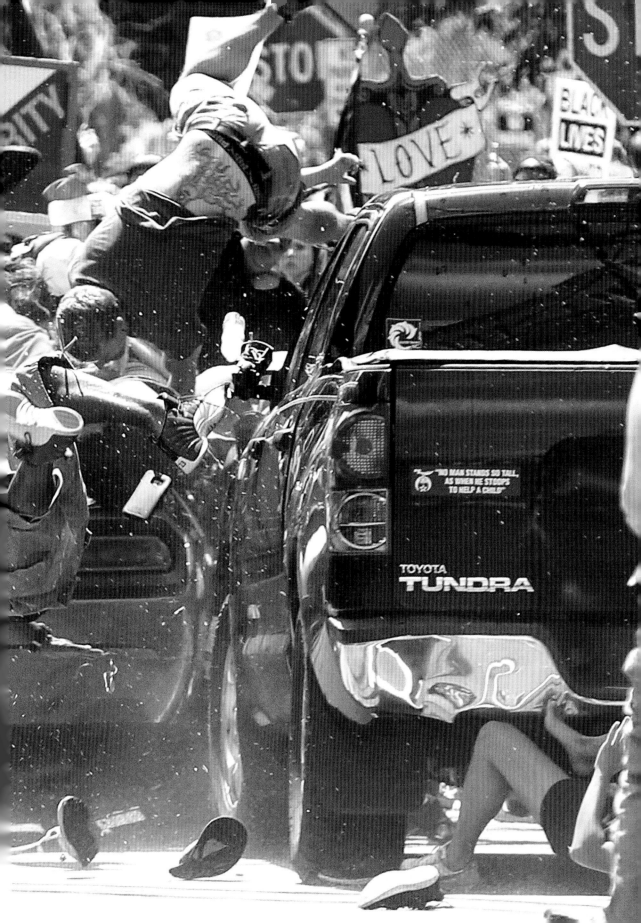

Ryan M. Kelly

USA, *The Daily Progress* / 2nd Prize Spot News

12 August 2017 › People are thrown into the air as a car plows into a group of protesters demonstrating against a Unite the Right rally in Charlottesville in Virginia, USA.

 The white nationalist rally, opposing city plans to remove a statue of Confederate icon General Robert E. Lee, attracted counter-protests. James Alex Fields Jr drove his car at high speed into a sedan, propelling it and a minivan into a group of anti-racist protesters, killing Heather Heyer (32) and injuring a further 19 people. Fields fled the scene in his own vehicle, but was stopped by Charlottesville police and later charged with murder.

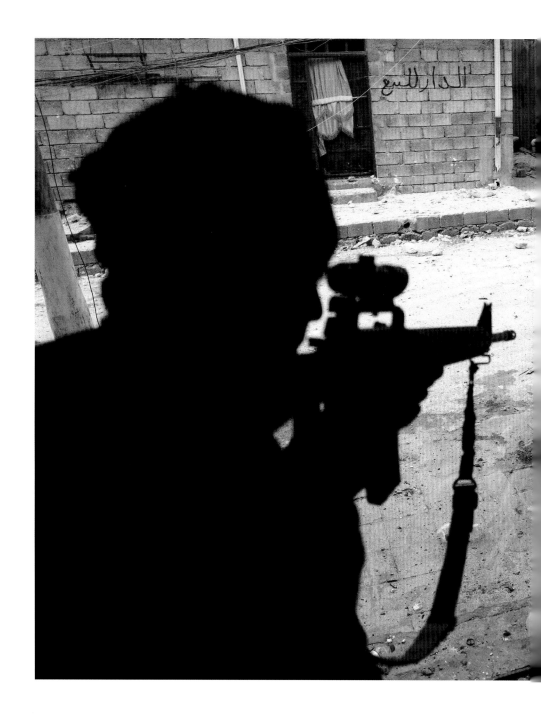

Goran Tomasevic

Serbia, Reuters / 3rd Prize Spot News

3 March 2017 › An Iraqi Special Forces soldier some moments after shooting dead a suspected suicide bomber, during the offensive to retake Mosul.

The battle to reclaim Mosul from ISIS had begun in October 2016 and lasted until July 2017, with fighting against pockets of ISIS militants continuing in some quarters of the city even beyond that date. The use of suicide bombers was a common tactic by the militants.

Patrick Brown

Australia, Panos Pictures,
for UNICEF / 1st Prize General News

28 September 2017 › The bodies of
Rohingya refugees are laid out after the
boat in which they were attempting to flee
Myanmar capsized about eight kilometers
off Inani Beach, near Cox's Bazar, Bangla-
desh. Around 100 people were on the boat
before it capsized. There were 17 survivors.
The Rohingya are a predominantly
Muslim minority group in Rakhine State,
western Myanmar. They number around
one million people, but laws passed in
the 1980s effectively deprived them of
Myanmar citizenship. Violence erupted in
Myanmar on 25 August after a faction of
Rohingya militants attacked police posts,
killing 12 members of the Myanmar security
forces. Myanmar authorities, in places
supported by groups of Buddhists, launched
a crackdown, attacking Rohingya villages
and burning houses. According to the
UNHCR, the number of Rohingya that
subsequently fled Myanmar for Bangla-
desh reached 500,000 on 28 September.

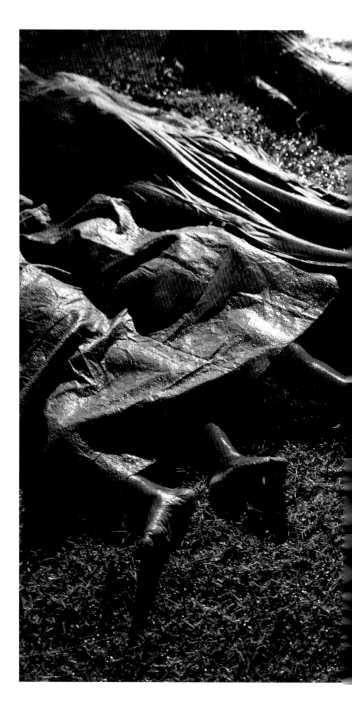

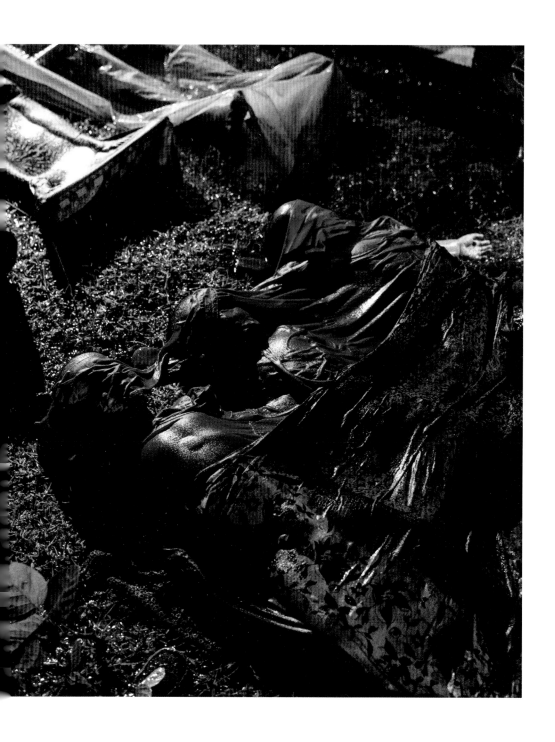

Richard
Tsong-Taatarii

USA, *Star Tribune* /
2nd Prize General News

18 June 2017 › John Thompson is embraced in St Anthony Village, Minnesota, USA, after speaking out at a memorial rally for his close friend Philando Castile, two days after police officer Jeronimo Yanez was acquitted of all charges in the shooting of Castile.

In July 2016, Officer Yanez had pulled over Castile's car in Falcon Heights Minnesota as it had a broken brake light. Castile, an African American man, handed over proof of insurance when asked, and informed the officer that he had a gun in the car. Police dashboard camera footage reveals that Yanez shouted, "Don't pull it out", and fired seven shots into the vehicle, fatally wounding Castile. Yanez was found not guilty of second degree manslaughter on 16 June 2017. Thompson was a high-profile presence at rallies following his friend's death.

Md Masfiqur Akhtar Sohan

Bangladesh, NurPhoto Agency /3rd Prize General News

9 September 2017 › A group of Rohingya at the Leda makeshift settlement in Cox's Bazar, Bangladesh, watch as houses burn just across the border in Myanmar.

After militants of the Arakan Rohingya Salvation Army (ARSA) launched an assault on a Myanmar government police post in August, Rohingya villages were targeted and houses burned, causing an exodus of refugees to Bangladesh. The Myanmar government blamed ARSA for the village attacks. According to the refugees themselves and Human Rights Watch, which analyzed satellite imagery, Myanmar security forces set the fires. By the end of November more than 350 villages had been partially or completely destroyed.

→

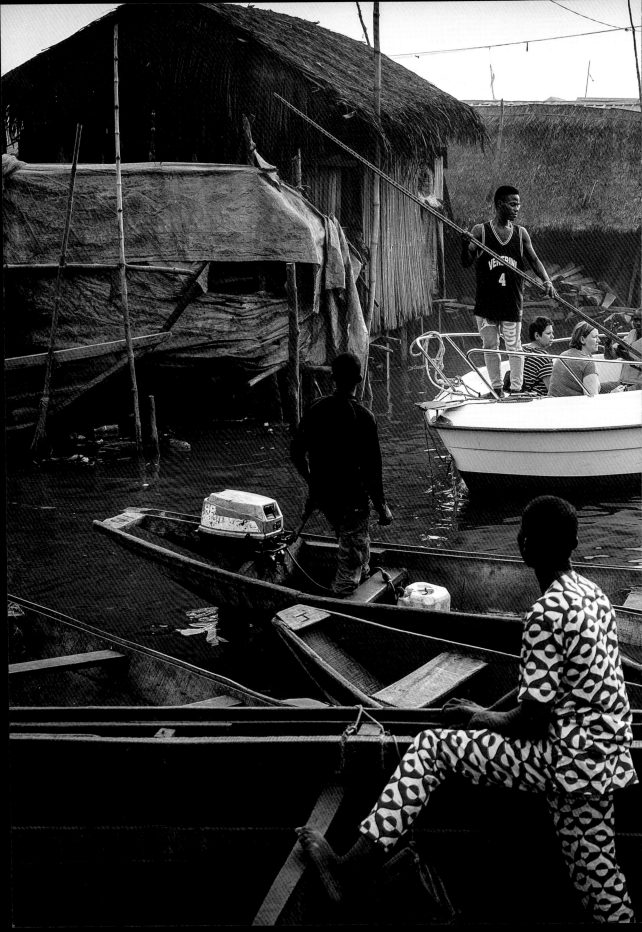

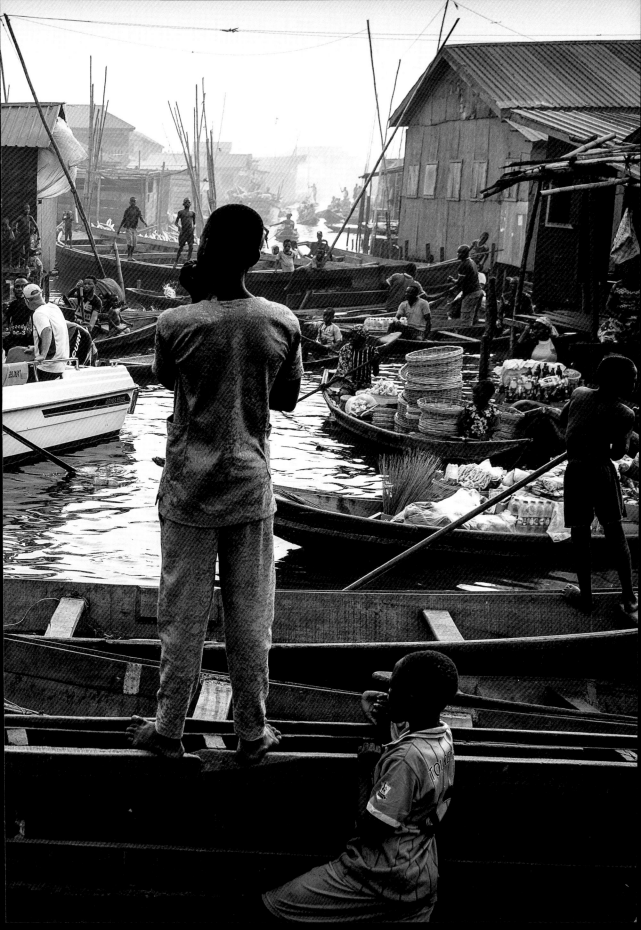

Jesco Denzel

Germany, laif /
1st Prize Contemporary Issues

24 February 2017 › A boat with tourists from Lagos Marina is steered through the canals of the Makoko community—an ancient fishing village that has grown into an enormous informal settlement—on the shores of Lagos Lagoon, Lagos, Nigeria.

Makoko has a population of around 150,000 people, many of whose families have been there for generations. But Lagos is growing rapidly, and ground to build on is in high demand. Prime real estate along the lagoon waterfront is scarce, and there are moves to demolish communities such as Makoko and build apartment blocks: accommodation for the wealthy. Because the government considers the communities to be informal settlements, people may be evicted without provision of more housing. Displacement from the waterfront also deprives them of their livelihoods. The government denies that the settlements have been inhabited for generations and has given various reasons for evictions, including saying that the communities are hideouts for criminals. Court rulings against the government in 2017 declared the evictions unconstitutional and that residents should be compensated and rehoused, but the issue remains unresolved.

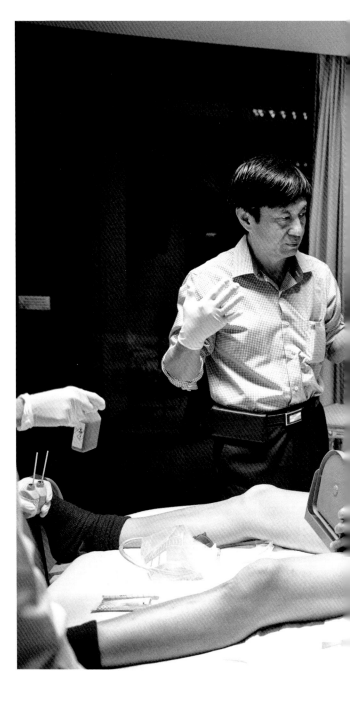

Giulio Di Sturco

Italy / 2nd Prize Contemporary Issues

3 February 2017 › Dr Suporn Watanyusakul shows patient Olivia Thomas her new vagina after gender reassignment surgery at a hospital in Chonburi, near Bangkok, Thailand.
 Thailand leads the world as a medical tourism destination, with gender-affirming surgery forming a strong niche. Treatment can be considerably cheaper than in other countries around the world, and the large numbers of patients mean that surgeons become highly experienced. The use of new technologies and procedures is also often given as a reason for Thailand's popularity among people seeking treatment for gender dysphoria.

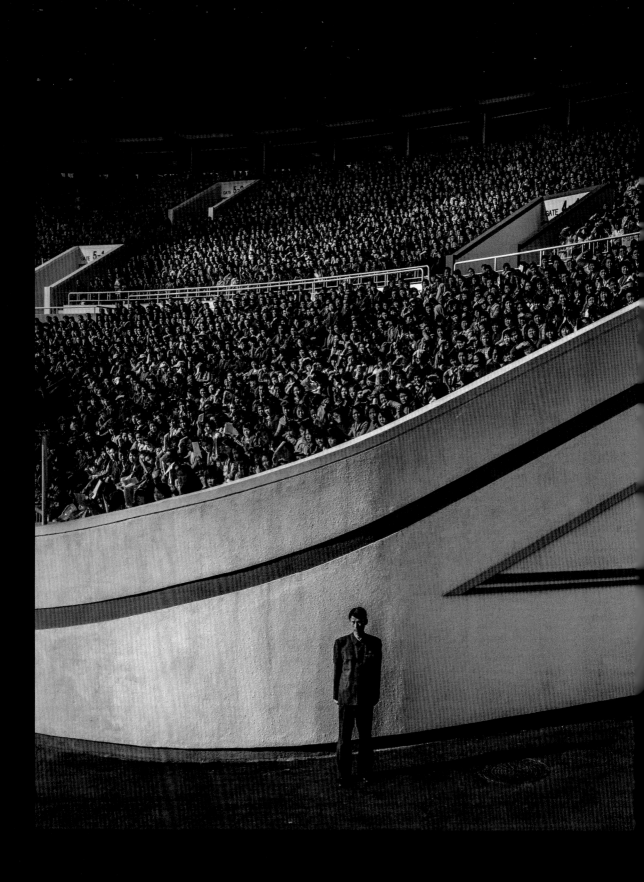

Roger Turesson

Sweden, *Dagens Nyheter* /
3rd Prize Contemporary Issues

9 April 2017 › A crowd awaits the start of the Pyongyang Marathon at the Kim Il-sung Stadium, while an official guards the exit, in Pyongyang, North Korea.

More than 50,000 spectators assembled to see the start of the marathon. Thousands more gathered on the streets of the North Korean capital along a route that took runners past such landmarks as the Arch of Triumph, Kim Il-sung Square and the Grand Theatre. North Korea is one of the most isolated and secretive nations on earth. A leadership cult has grown around the Kim dynasty, passing from Kim Il-sung (the Great Leader) to his son Kim Jong-il (the Dear Leader) and grandson, the current supreme leader Kim Jong-un. The country is run along rigidly state-controlled lines. Local media are strictly regulated, and the foreign press largely excluded or, if allowed access, closely accompanied by minders.

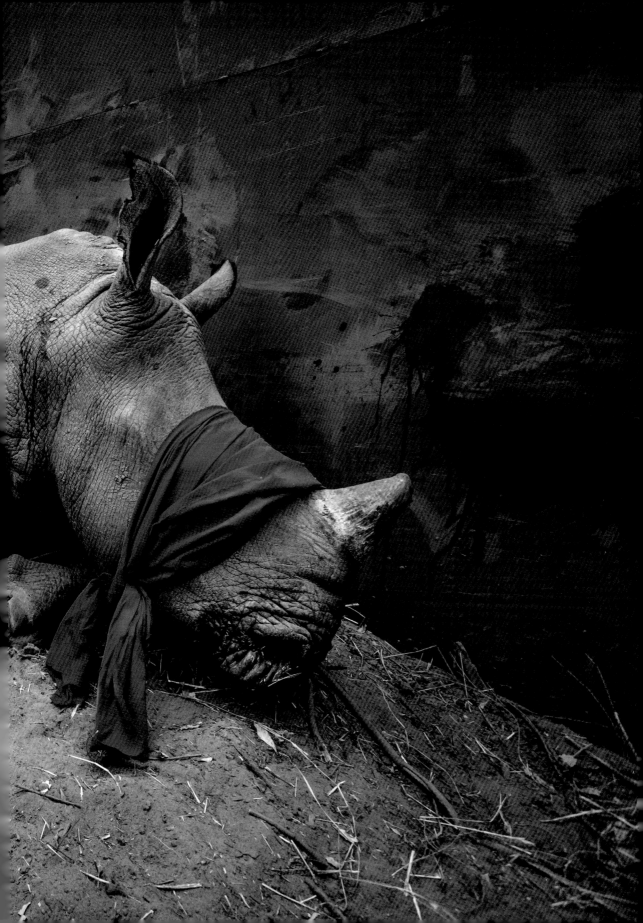

Neil Aldridge

South Africa / 1st Prize Environment

21 September 2017 › A young southern white rhinoceros, drugged and blindfolded, is about to be released into the wild in Okavango Delta, Botswana, after its relocation from South Africa for protection from poachers.

Southern white rhinos are classified as 'near threatened'. Rhinoceros horn is highly prized, especially in Vietnam and China, for its perceived medicinal properties, and in places as a recreational drug. Horns can fetch between €20,000 and €50,000 per kilogram. Poaching in South Africa rose from 13 rhinos a year in 2007 to a peak of 1,215 in 2014, and although these figures have declined slightly since then, losses are still unsustainable. Botswana is saving rhinos from poaching hotspots in South Africa and re-establishing populations in its own wildlife sanctuaries.

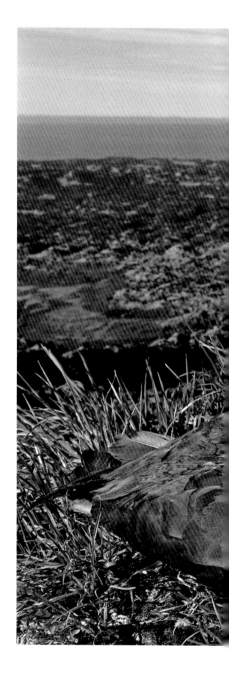

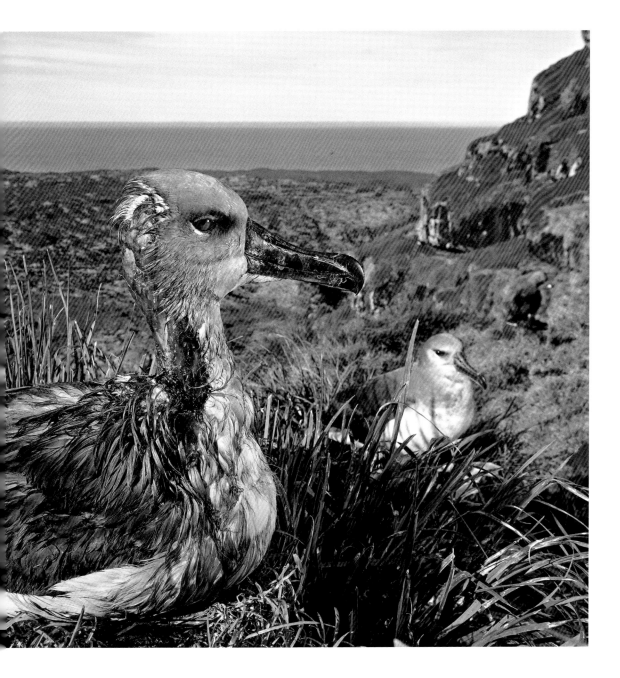

Thomas P. Peschak

Germany / 2nd Prize Environment

1 May 2017 › A juvenile gray-headed albatross on Marion Island, South African Antarctic Territory, is left injured after an attack by mice from an invasive species that has begun to feed on living albatross chicks and juveniles.

Mice were introduced to the island by sealers in the 1800s and co-existed with the birds for almost 200 years. In 1991, South Africa eradicated feral cats from Marion Island, but a subsequent plan to do the same to the mouse population failed to materialize. An expanding population and declining food sources led the abnormally large mice to attack albatrosses and burrowing petrels. An environmental officer has now been appointed to monitor the mouse population and conduct large-scale poison bait trials.

Thomas P. Peschak

Germany / 3rd Prize Environment

1 March 2017 › An historic photograph of an African penguin colony, taken in the late 1890s, is a stark contrast to the declining numbers seen in 2017 in the same location, on Halifax Island, Namibia. The colony once numbered more than 100,000 penguins.

The African penguin, once southern Africa's most abundant seabird, is now listed as endangered. Overall, the African penguin population is just 2.5 percent of its level 80 years ago; research conducted on Halifax Island by the University of Cape Town indicates the population has more than halved in the past 30 years. Historically, the demand for guano (bird excrement used for fertilizer) was a cause of the decline: the birds burrow into deposits of guano to nest. Human consumption of eggs and overfishing of surrounding waters are also seen as causes. In the seas around Halifax Island sardine and anchovy—the chief prey of the African penguin—are now almost absent.

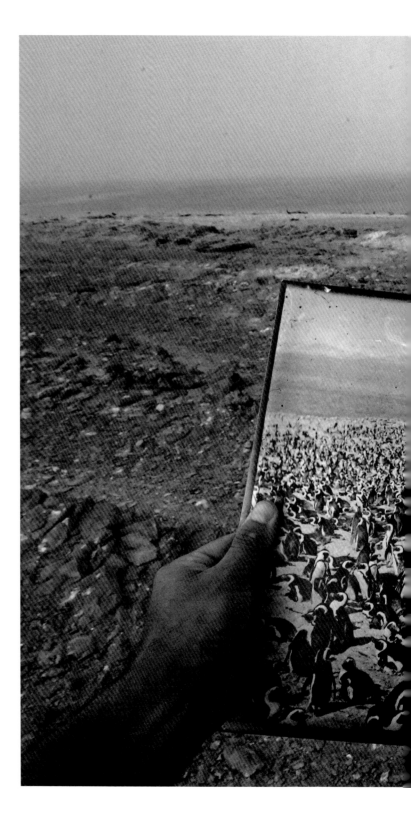

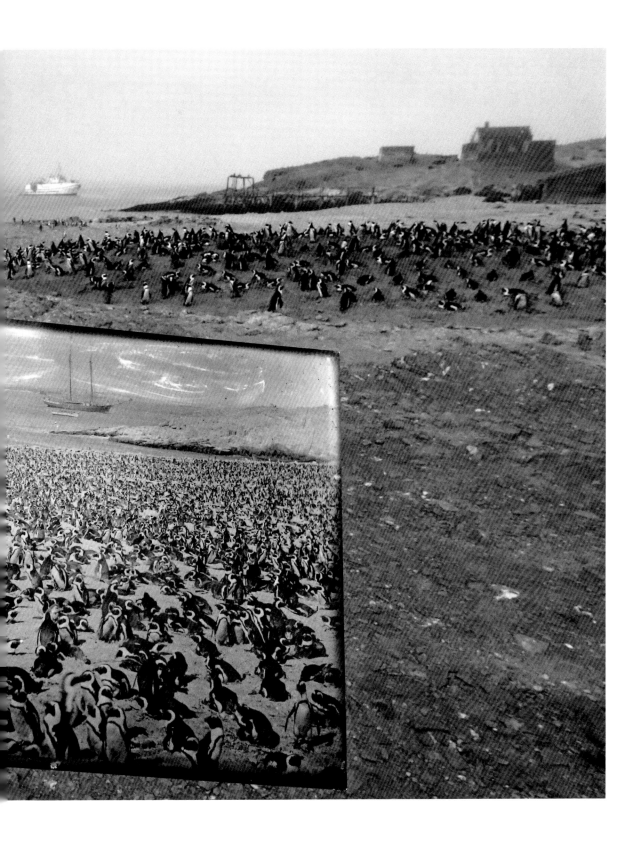

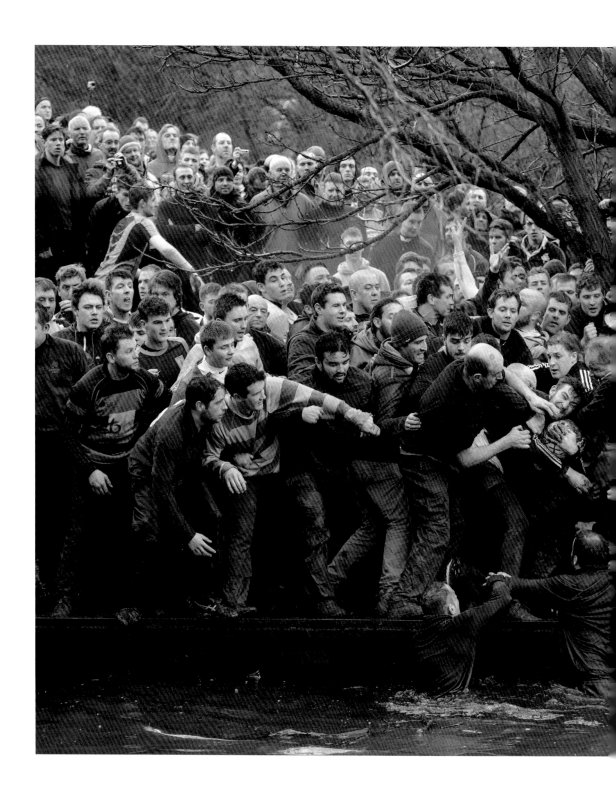

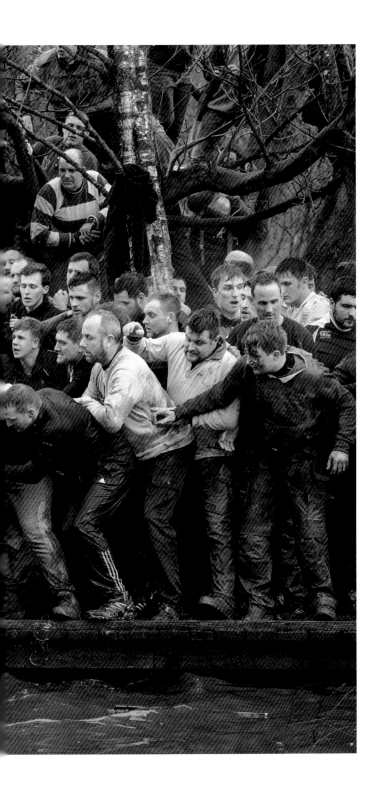

Oliver Scarff

UK, Agence France-Presse /
1st Prize Sports

28 February 2017 › Members of opposing teams, the Up'ards and Down'ards, grapple for the ball during the historic, annual Royal Shrovetide Football Match in Ashbourne, Derbyshire, UK.

The game is played between hundreds of participants in two eight-hour periods on Shrove Tuesday and Ash Wednesday (the day preceding and the day marking the start of Christian Lent). The two teams are determined by which side of the River Henmore players are born: Up'ards are from north of the river; Down'ards, south. Players score goals by tapping the ball three times on millstones set into pillars three miles apart. There are very few rules apart from an historic stipulation that players may not murder their opponents, and the more contemporary requirement that the ball must not be transported in bags, rucksacks, or motorized vehicles. Royal Shrovetide Football is believed to have been played in Ashbourne since the 17th century.

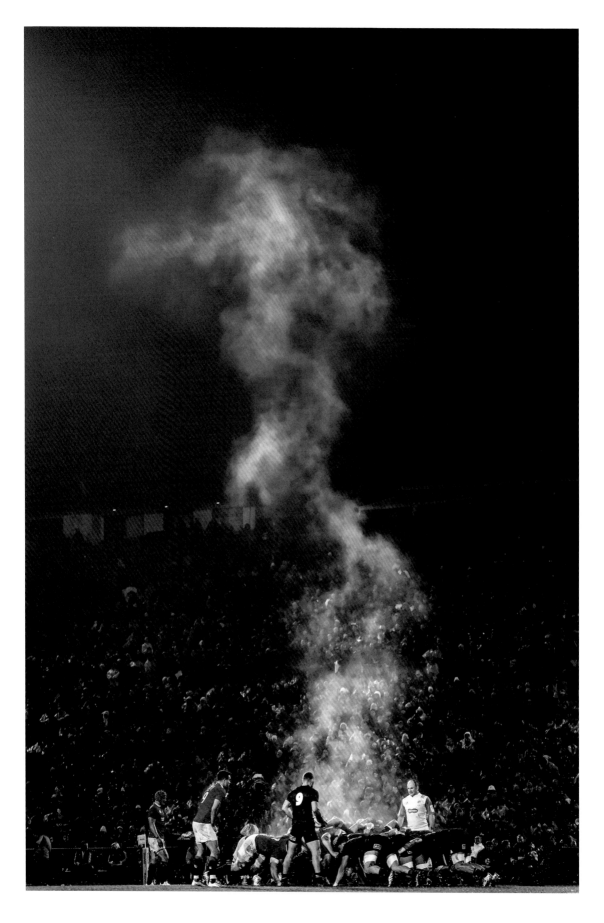

tephen McCarthy

land, Sportsfile / 2nd Prize Sports

June 2017 › The British & Irish Lions
d Maori All Blacks engage during
match at Rotorua International
dium in Rotorua, New Zealand.
All players in the Maori All Blacks
st have a confirmed Maori *whaka-
oa*, or genealogy. The British & Irish
ns is a composite squad formed
ry year by players from England,
otland, Wales and Ireland, selected
the coach who oversees the tour.
e squad tours annually through
e of the southern hemisphere's big
ee rugby union nations: Australia,
w Zealand and South Africa.
e Rotorua match was played in
t conditions and ended with a
-32 win for the Lions.

Erik Sampers

France / 3rd Prize Sports

14 April 2017 › Participants set off on a timed stage of the Marathon des Sables, in the
Sahara Desert in southern Morocco.
 The Marathon des Sables (Marathon of the Sands) is run over 250 kilometers in
temperatures of up to 50°C. Participating runners and walkers must carry their own
backpacks with food, sleeping gear, and other material. The marathon is conducted
in six stages, over seven days, with one long stage of more than 80 kilometers. The first
Marathon des Sables was held in 1986 with 186 competitors. The event now attracts
more than 1,000 participants from around 50 countries.

→

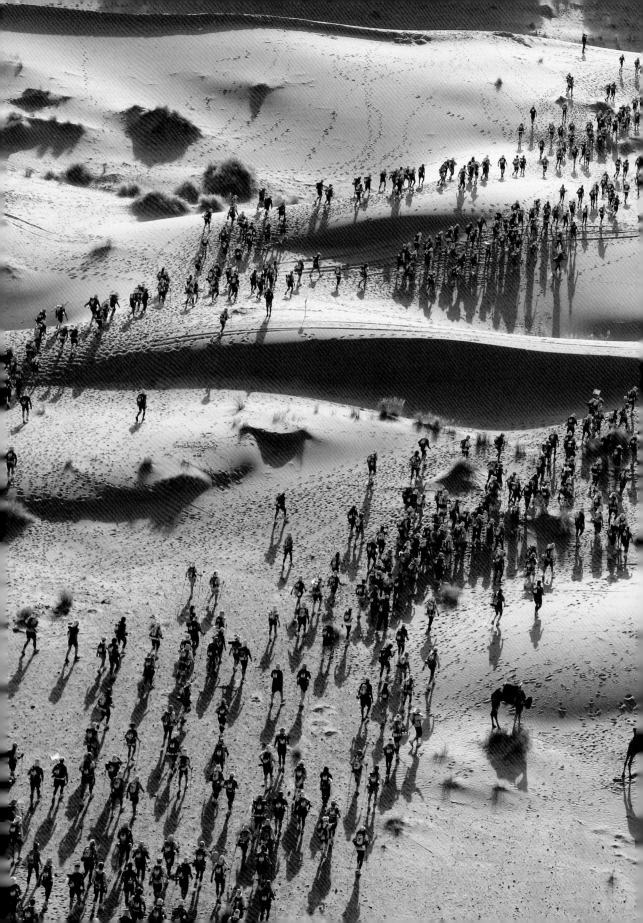

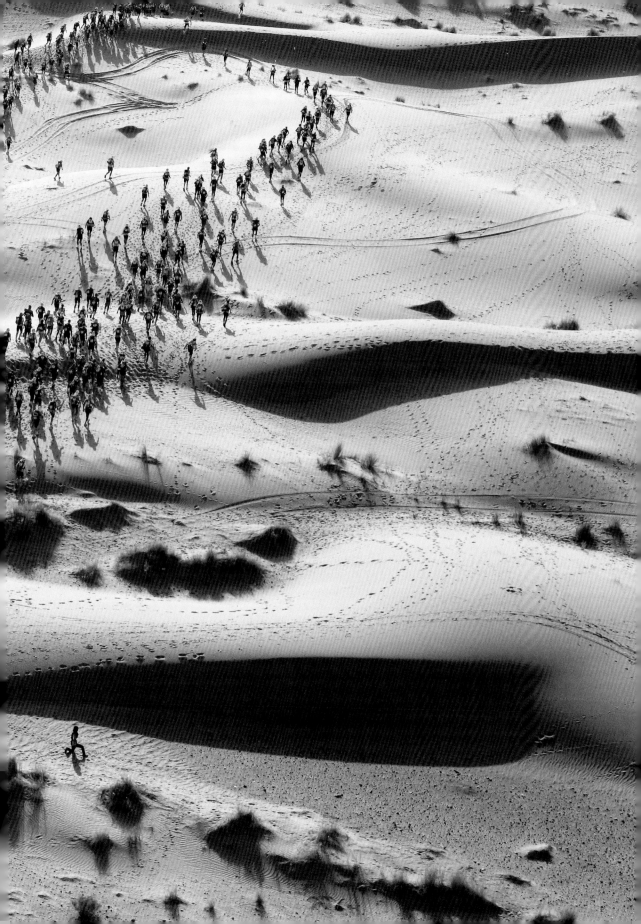

Corey Arnold
USA / 1st Prize Nature

14 February 2017 › A bald eagle feasts on meat
scraps in the garbage bins of a supermarket in
Dutch Harbor, Unalaska, Alaska, USA.
 Once close to extinction, the bald eagle has
made a massive comeback after concerted
conservation efforts. Unalaska has a population
of around 5,000 people, and 500 eagles. Some
350 million kilograms of fish are landed in Dutch
Harbor annually. The birds are attracted by the
trawlers, but also feed on garbage and snatch
grocery bags from the hands of unsuspecting
pedestrians. Locally, the American national bird
is known as the 'Dutch Harbor pigeon'.

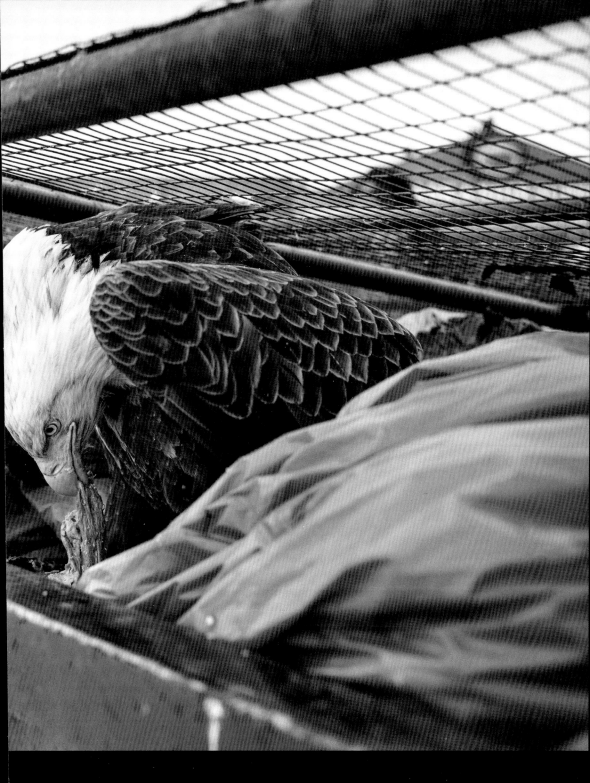

Thomas P. Peschak

Germany / 2nd Prize Nature

18 April 2017 › Rockhopper penguins live up to their name as they navigate the rugged coastline of Marion Island, a South African Antarctic Territory in the Indian Ocean.

 Among the most numerous of penguins, rockhoppers are nevertheless considered vulnerable, and their population is declining, probably as the result of a decreasing food supply. The birds spend five to six months at sea, coming to shore only to molt and breed. They are often found bounding, rather than waddling as other penguins do, and are capable of diving to depths of up to 100 meters in pursuit of fish, crustaceans, squid and krill.

Michael Patrick O'Neill

USA / 3rd Prize Nature

18 August 2017 › A flying fish swims below the surface in the Gulf Stream late at night, offshore from Palm Beach, Florida, USA.

 Moving its tail fin up to 70 times per second, a flying fish can reach an underwater speed of nearly 60 kilometers per hour. Angling itself upwards, it then breaks the surface while still propelling itself along by rapidly beating its tail underwater, before taking to the air and gliding—successfully escaping predators such as tuna, marlin and swordfish.

→

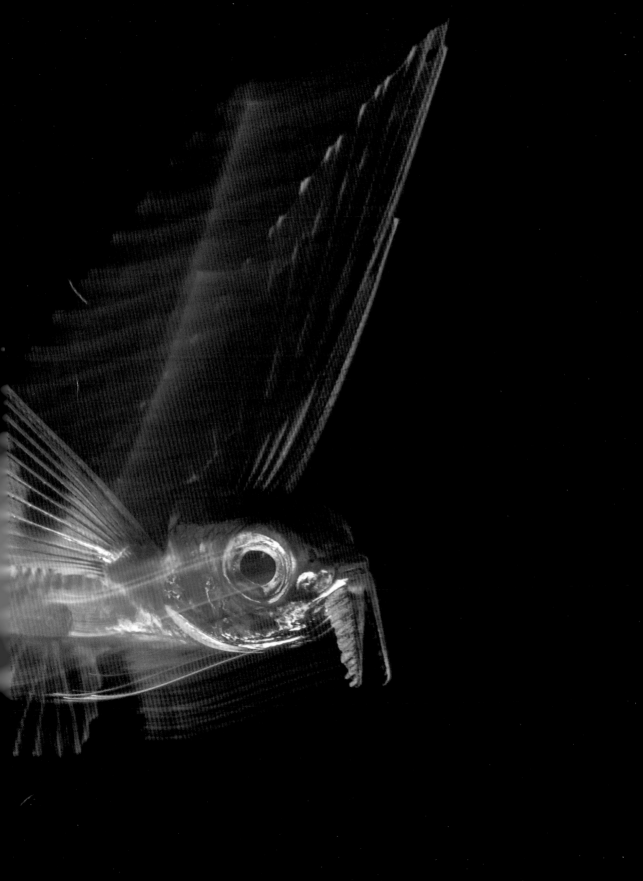

The 2018 Stories

Heba Khamis

Egypt /
1st Prize Contemporary Issues

6 November - 7 December 2016 › Breast ironing is a traditional
practice in Cameroon that involves massaging or pressing the
breasts of pubescent girls in order to suppress or reverse breast
development. The practice is carried out in the belief that it will
delay maturity and help prevent rapes or sexual advances.

 Above: A stone is heated to perform breast ironing.
Facing page: Kamini Tontines (12) hides her breasts after her
mother has ironed them. (*continues*)

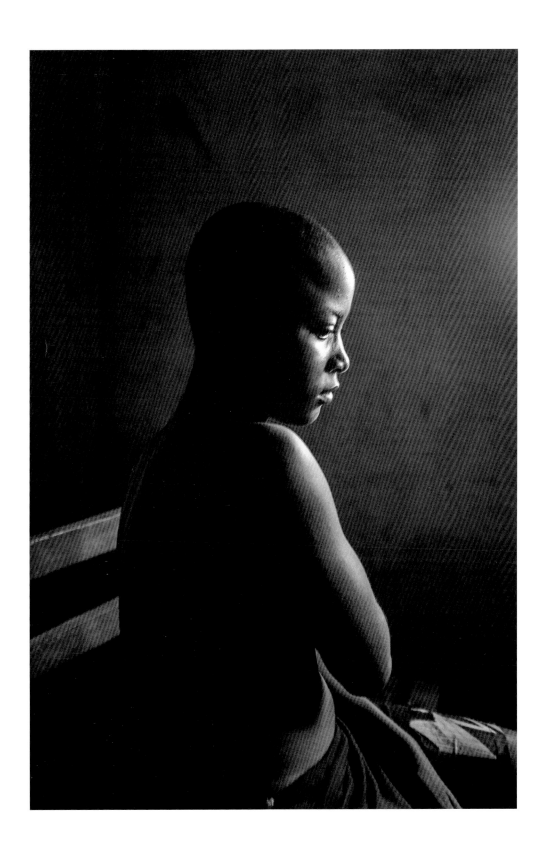

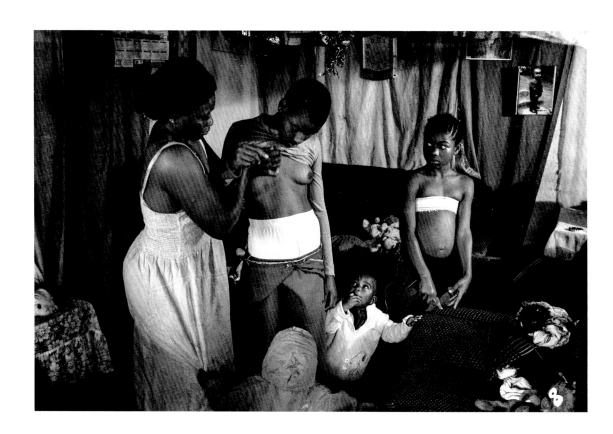

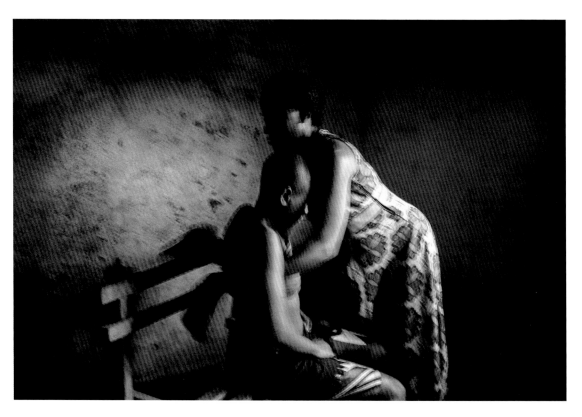

(*continued*) Breast ironing is usually done by the girl's mother or an older relative. Techniques differ from region to region. Some people bind the breasts with a belt, others heat a grinding stone, spatula or pestle and use it to press or massage the breasts.

Facing page, top: Veronica (28) massages the breasts of her daughter Michelle (10) while her other children watch. *Below*: Kenmeni bandages her daughter's breasts after ironing them. *Above*: In East Cameroon the prevalent method of breast flattening is pressing the breast with a stick and wooden bowl. (*continues*)

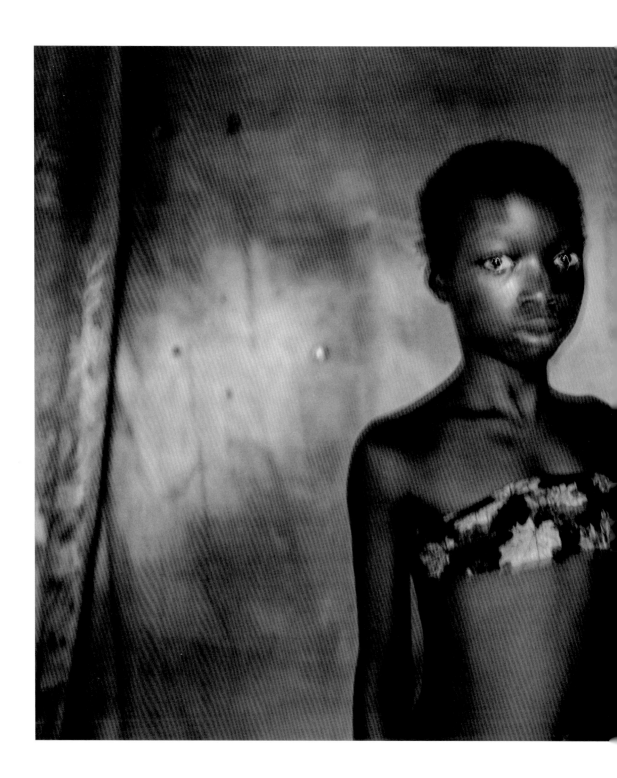

(*continued*) Although largely a Cameroonian practice, breast ironing does occur in some other countries across West and Central Africa. Local NGOs estimate that around 25 percent of women in the Cameroon have undergone some form of breast flattening; in some areas that rises to over 50 percent. Mothers explain that the painful procedure is an act of love, to make sure their daughters don't get pregnant and miss out on school or jobs. There is little medical research on the psychological and physical consequences of breast flattening, but according to the United Nations Population Fund, the practice exposes girls to numerous health problems deriving from tissue damage and infection.

Left: Suzanne (11) underwent breast ironing until her breasts were totally flattened.

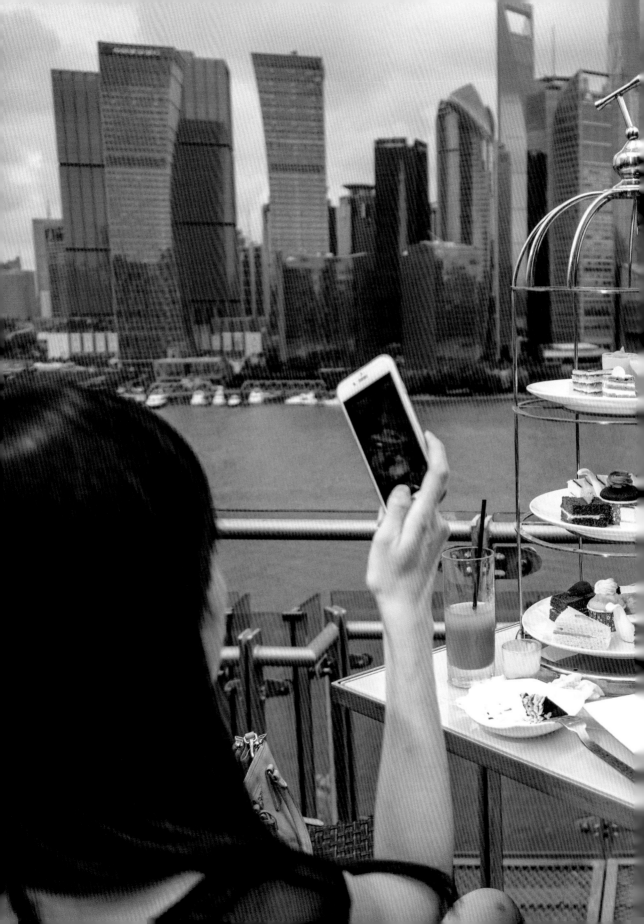

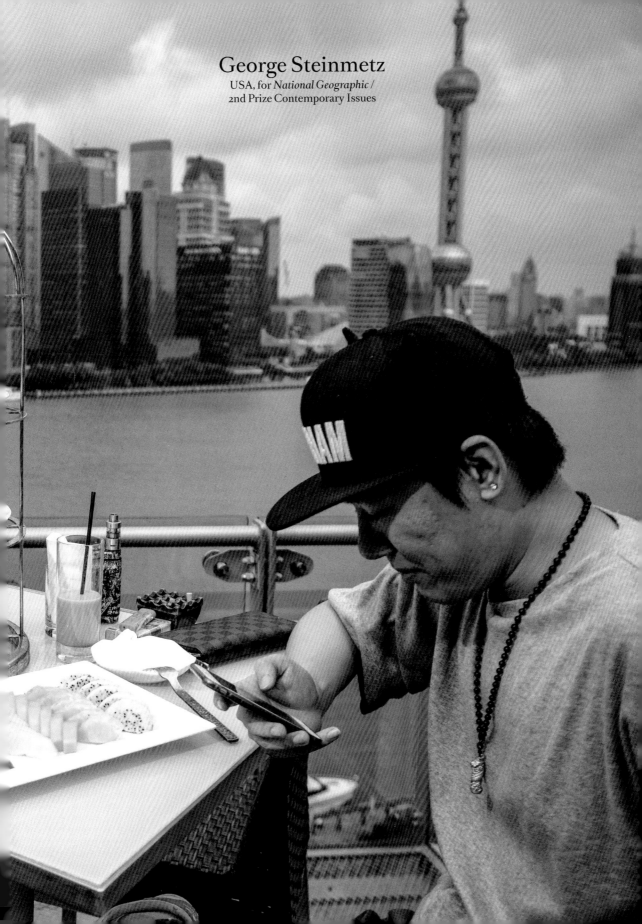

George Steinmetz
USA, for *National Geographic* /
2nd Prize Contemporary Issues

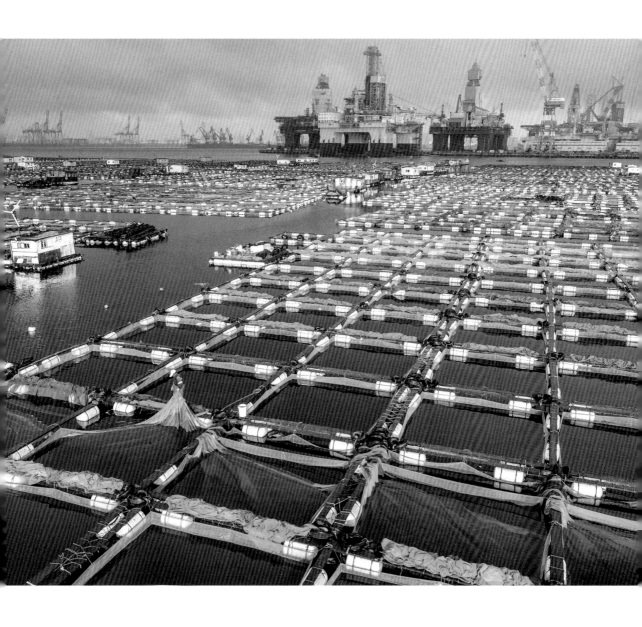

13 June 2016 - 9 July 2017 › Rapidly rising incomes in China have led to a changing diet and increasing demand for meat, dairy and processed foods. China needs to make use of some 12 percent of the world's arable land to feed nearly 19 percent of the global population. New technologies and agricultural reform offer a partial solution, but problems remain as farmers and the young flock to work in cities, leaving an aging rural population, and as land becomes contaminated by industry.

Previous spread: A wealthy Shanghai couple enjoy an afternoon tea of Western-style cakes, fruit and iced coffee. *Facing page*: Thousands of people converge on Xuyi County, in the eastern province of Jiangsu, for an annual crayfish festival. *Above*: A network of sea cucumber pens share Yantal Harbor with an industrial shipyard where oil-drilling platforms are being built. *Next spread*: A chicken facility belonging to the large state-owned food-processing conglomerate, COFCO. *Two spreads forward*: Seaweed hangs to dry on a novel system of rotary drying racks, in Shandong, eastern China.

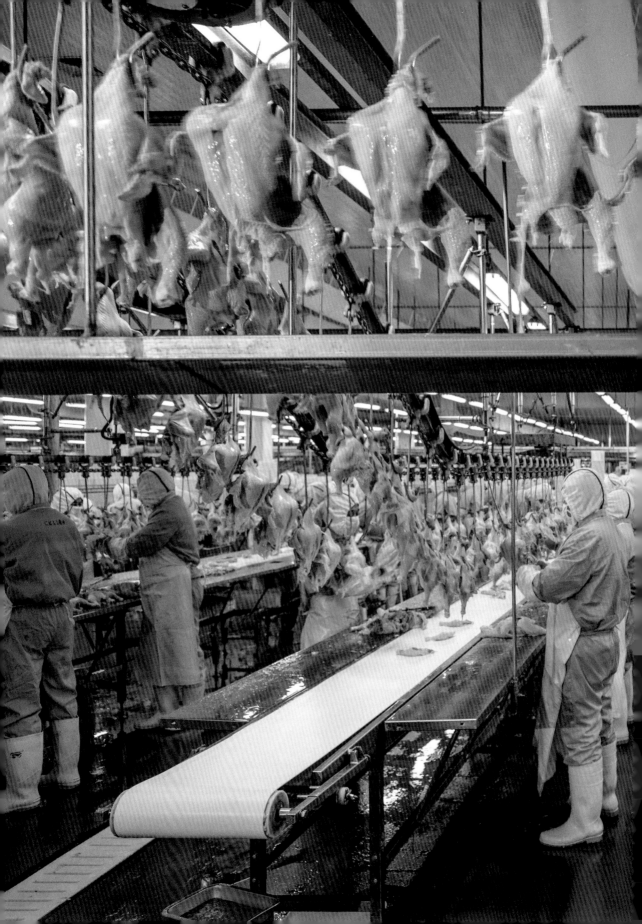

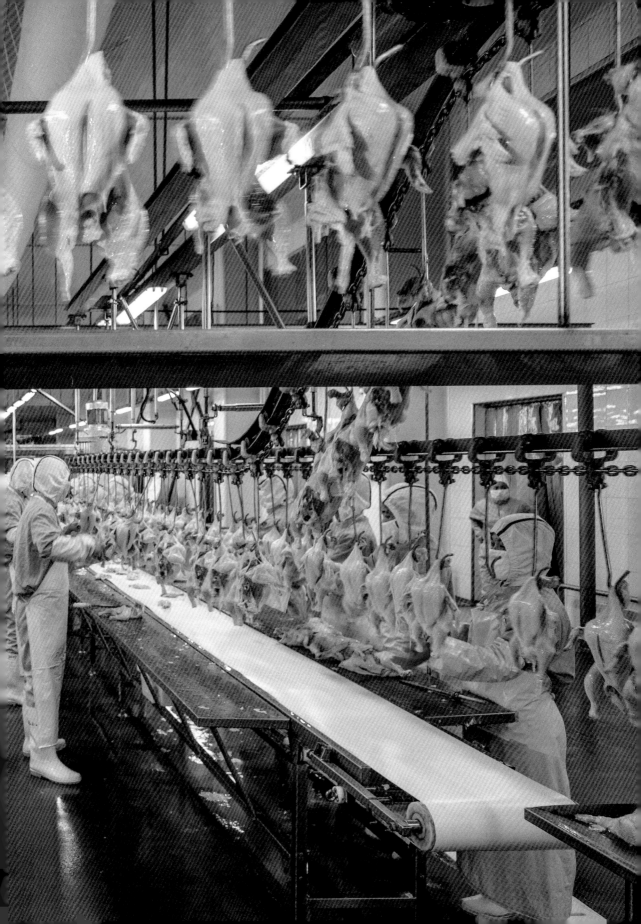

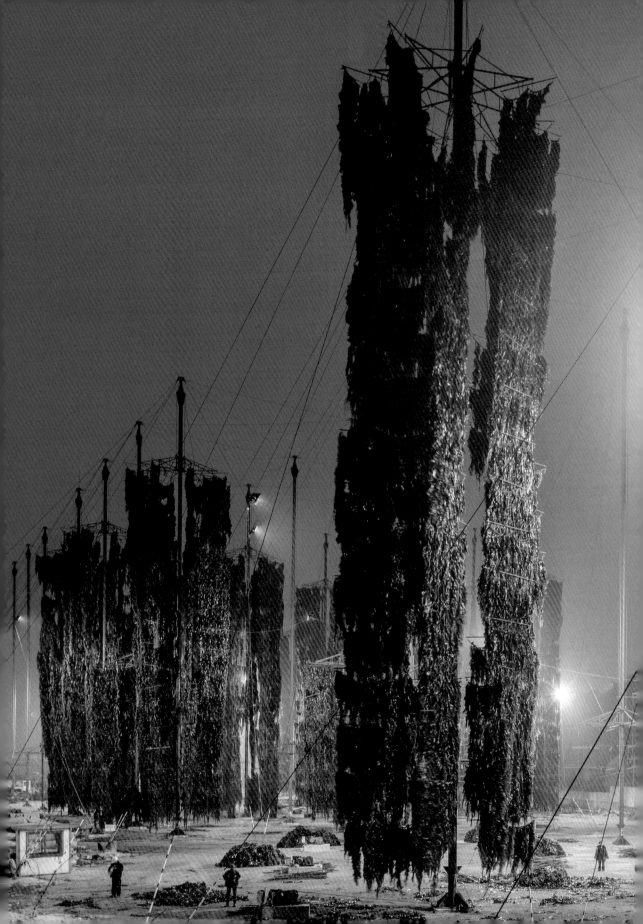

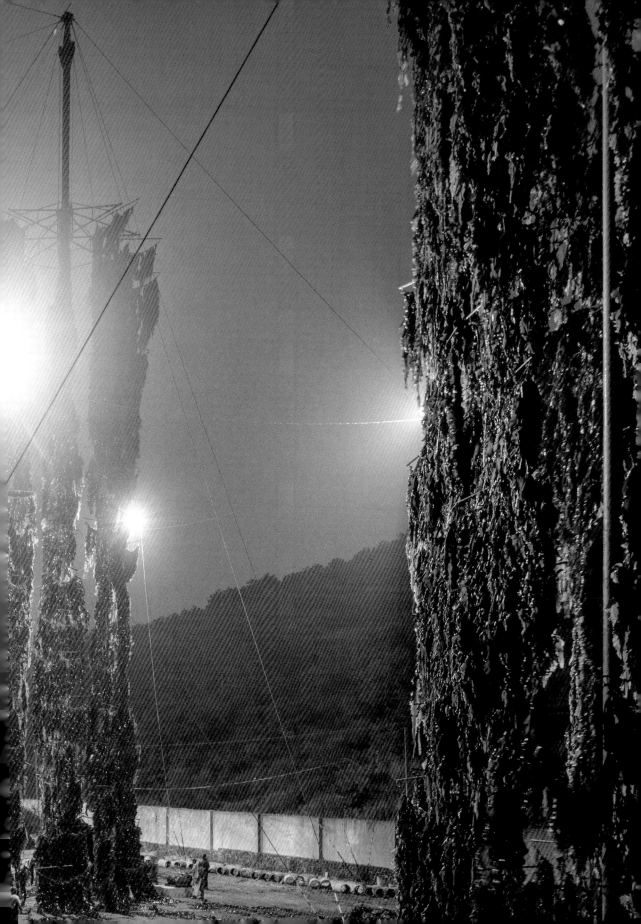

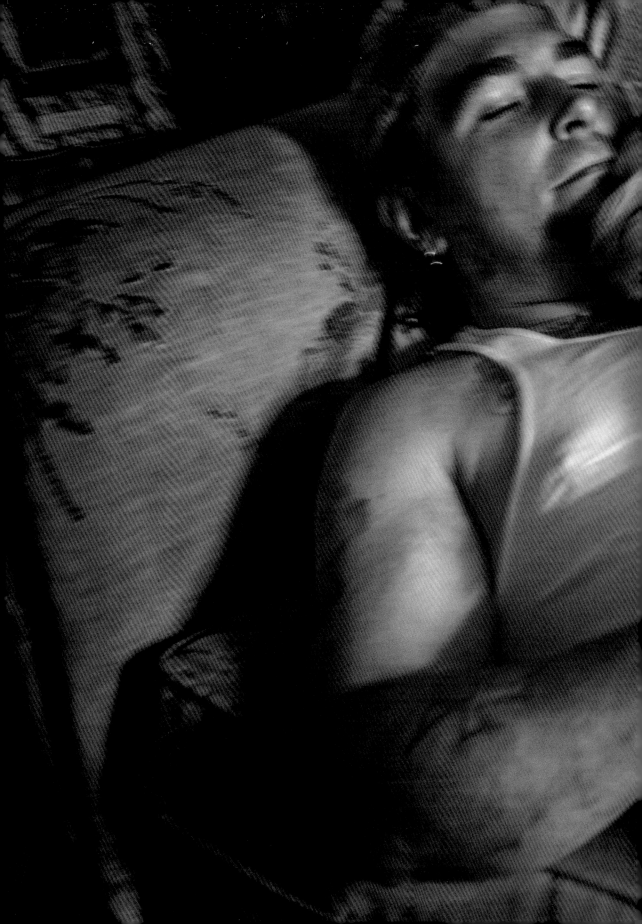

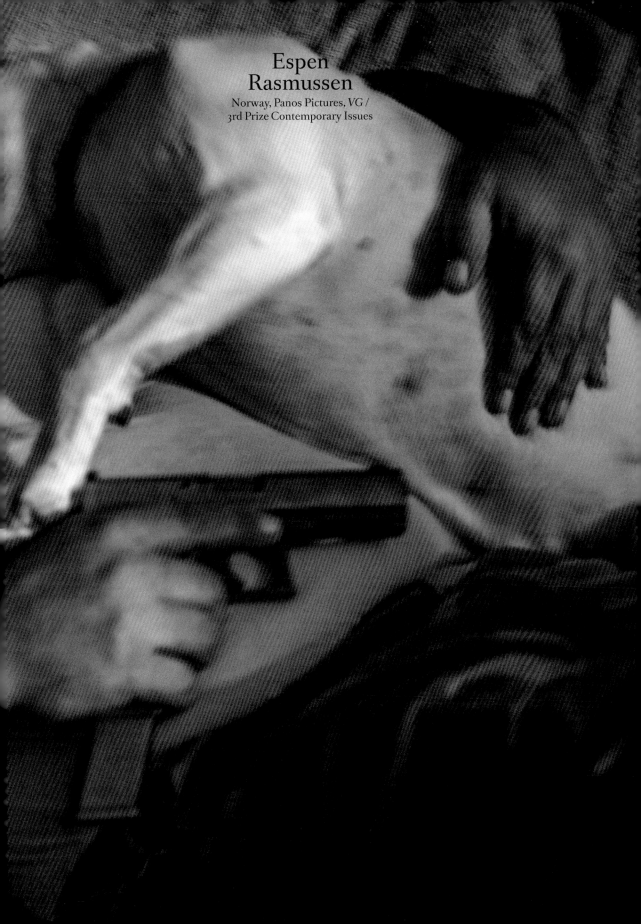

Espen
Rasmussen
Norway, Panos Pictures, VG /
3rd Prize Contemporary Issues

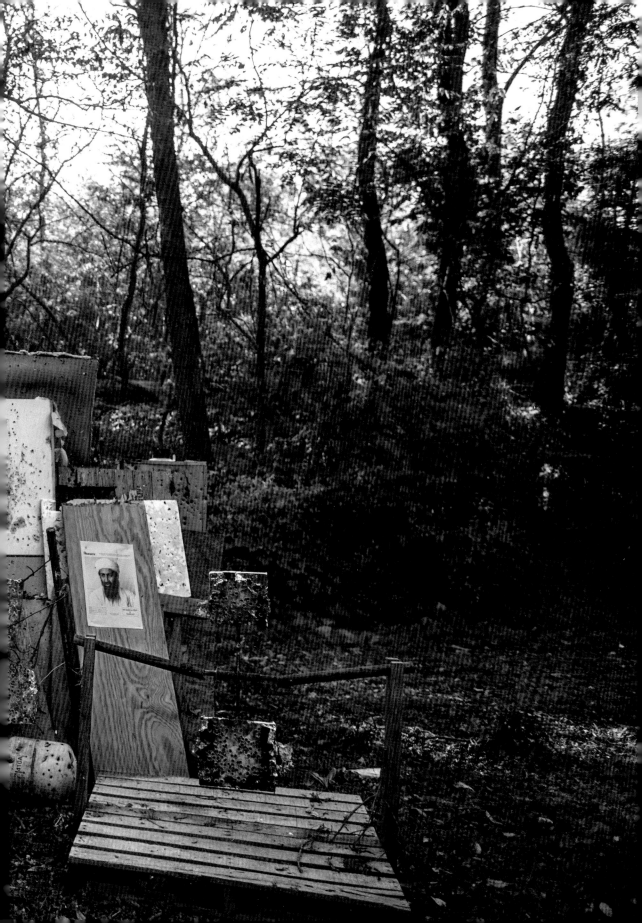

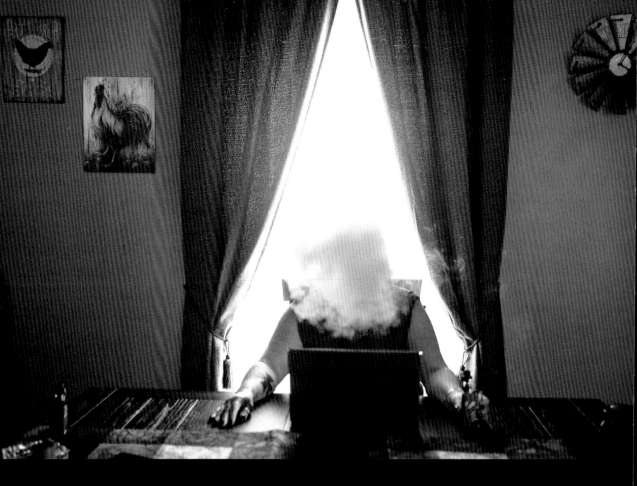

23 September – 1 October 2017 › Degrees of rage in three US states: a journey made in the weeks after the Unite the Right rally in Charlottesville, Virginia. The rally was the first gathering of far-right groups from all over the country in decades, held in part to demonstrate opposition to the removal of the statue of Confederate general Robert E. Lee. The photographer travelled through Virginia, West Virginia and Maryland meeting a range of people, from extreme right activists to patriots and those angry at the way the US is governed, in an attempt to understand why white anger has risen to the surface.

Two spreads back: Danny Bollinger (43), leader of the militia group My Brothers Threepers on his couch in Maryland. *Previous spread*: Targets with Osama bin Laden in Danny Bollinger's garden. *Above*: Lorri Cottrill (45), leader of the US neo-Nazi National Socialist Movement, smokes an e-cigarette in her home in Charleston, West Virginia. *Facing page, top*: Tommy Kinder, a patriot and proud of his country, poses with his rifle at home in Fort Creek, West Virginia. *Below*: The controversial statue of Robert E. Lee stands under a plastic shroud, in Emancipation Park, Charlottesville.

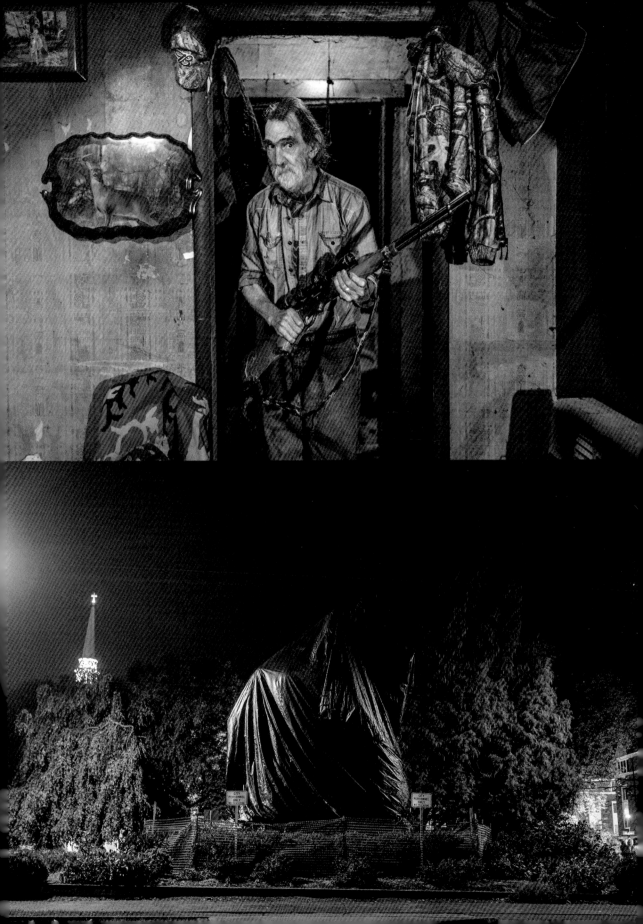

David Becker

USA, Getty Images /
1st Prize Spot News

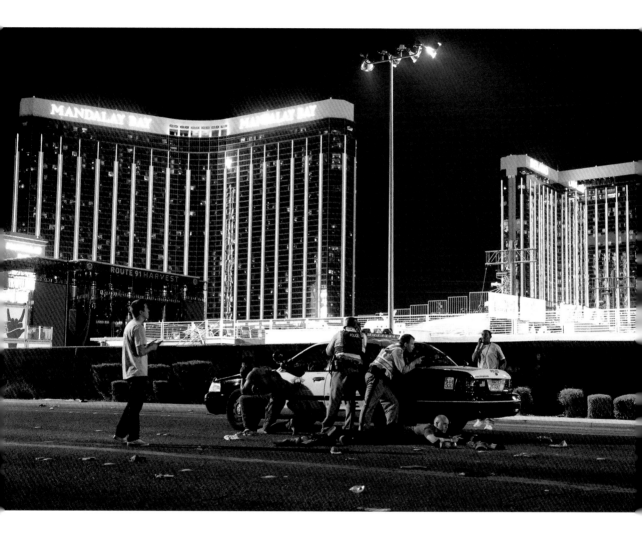

1 October 2017 › Fifty-eight people were killed and more than 500 wounded when gunman Stephen Paddock opened fire on a crowd of around 22,000 concertgoers at the Route 91 Harvest Country Music Festival at the Mandalay Bay Resort and Casino in Las Vegas, Nevada, USA. Paddock fired for ten minutes from a suite on the 32nd floor of the hotel.

 Above: Police outside the concert grounds. *Facing page*: A man lies protectively on top of a woman, as others flee the shooting. (*continues*)

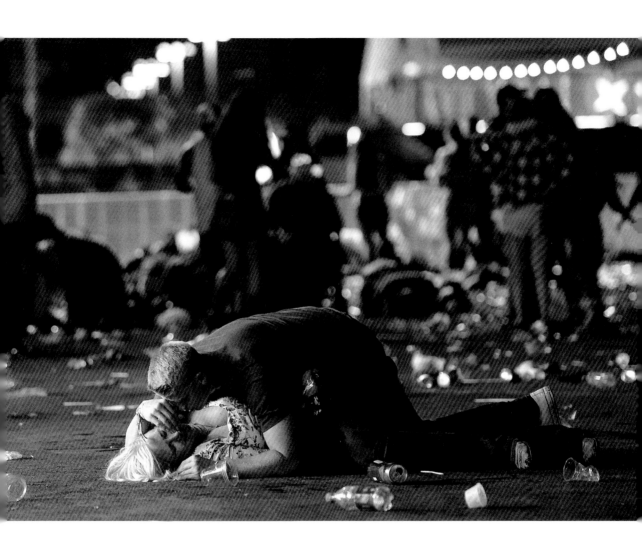

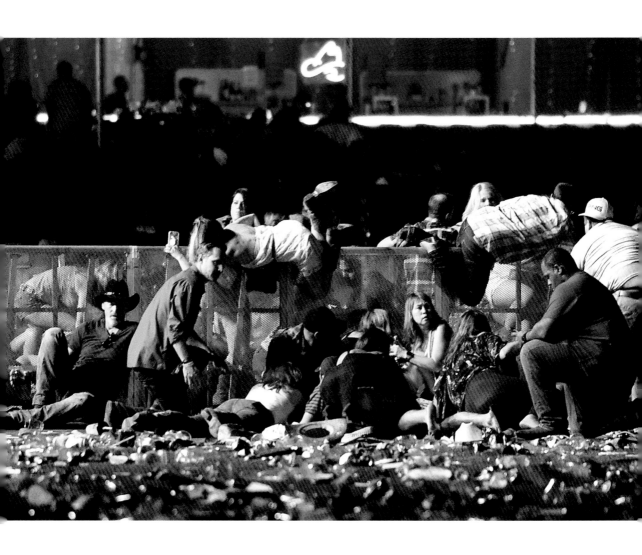

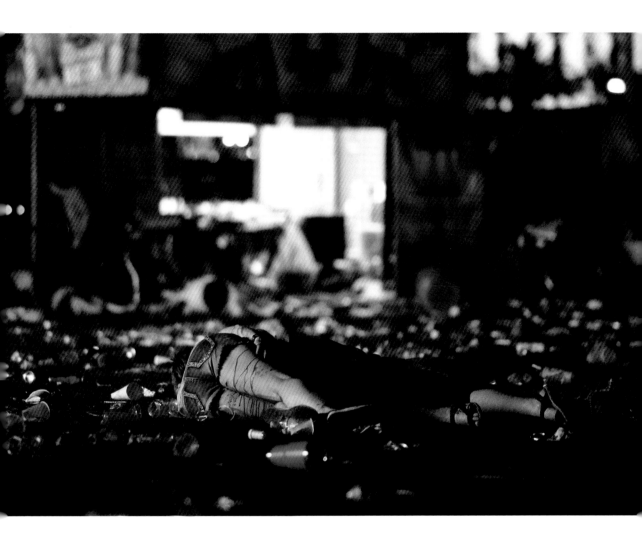

(*continued*) Paddock killed himself in his hotel room after the shooting. Twenty-three guns were found in his room, some of which had been specially adapted to mimic fully automatic weapons, firing 400 to 800 rounds per minute. Paddock had no criminal record, and no motive was established for the massacre.

Facing page: People scramble for shelter after gunshots ring out. *Above*: Injured people lie on the ground after the gunman had opened fire.

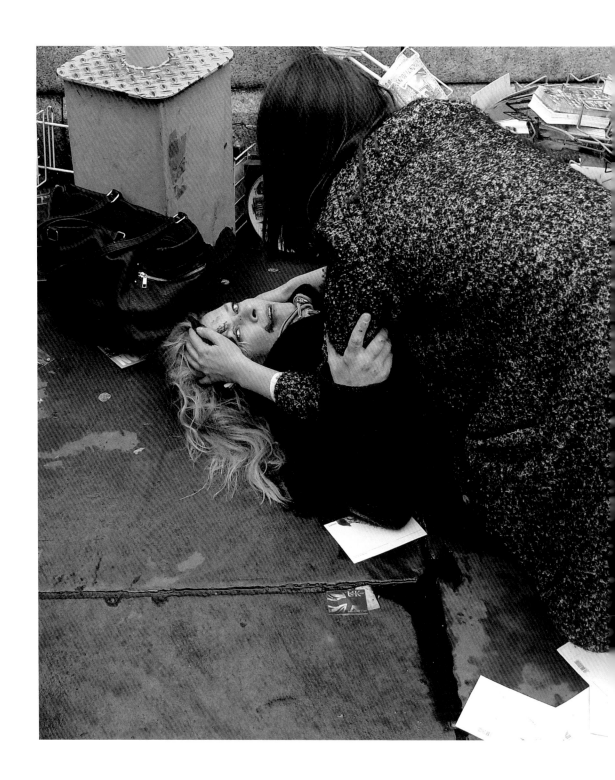

Toby Melville
U.K., Reuters /
2nd Prize Spot News

22 March 2017 › On 22 March, Khalid
Masood drove a rented SUV along
the sidewalk of Westminster Bridge,
near the British Houses of Parliament
in central London. Three people were
killed instantly, and two more died in
the days after the attack; at least 40
were injured. Armed with two knives,
Masood left the car and attempted
to enter the grounds of parliament,
where he fatally stabbed one of the
policemen who tried to stop him,
before being shot and killed.

Previous spread: A passerby
comforts US tourist Melissa Cohran.
Melissa survived, but lost her
husband, Kurt, in the attack. *Right*:
Passersby tend to a victim lying on
the paving after being thrown off
Westminster Bridge by Masood's
attack. (*continues*)

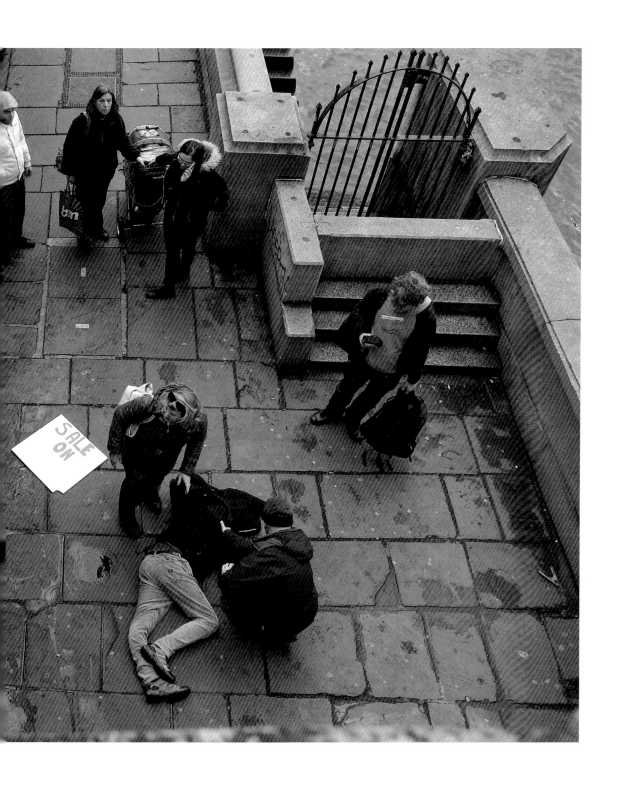

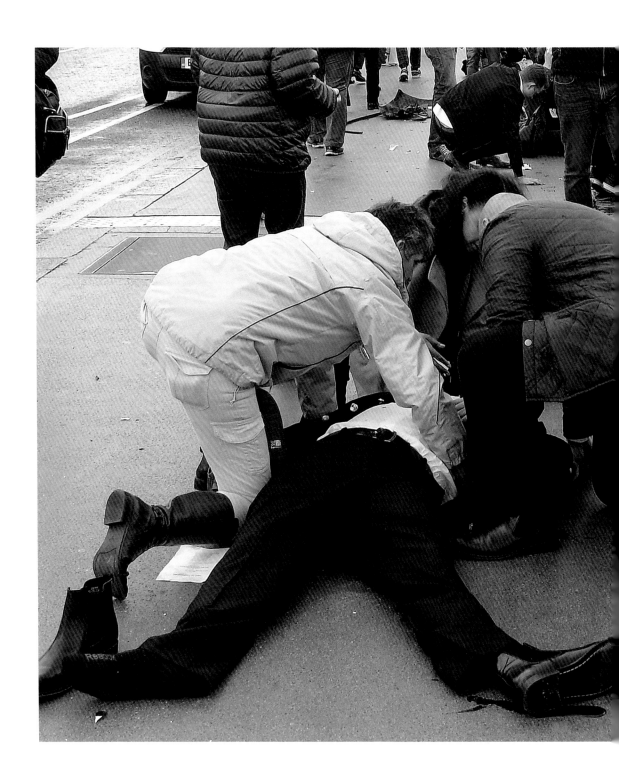

(*continued*) Born Adrian Russell Elms in Kent, UK, Masood changed his name when he converted to Islam. Although ISIS claimed responsibility for the attack the following day, police investigating found no evidence of any links between Masood and either ISIS or al-Qaeda.

Left: Passersby comfort an injured man lying on the sidewalk after Masood's attack.

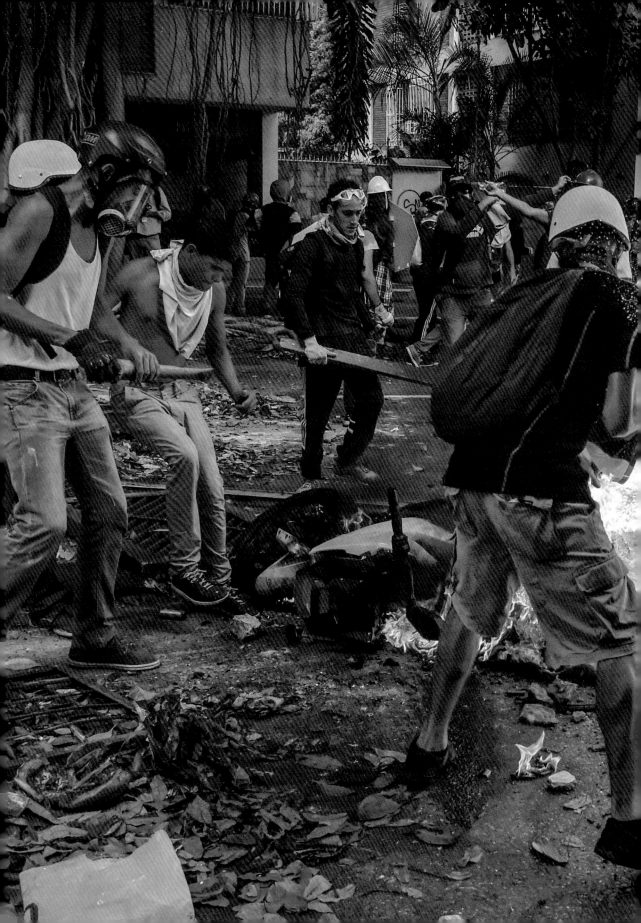

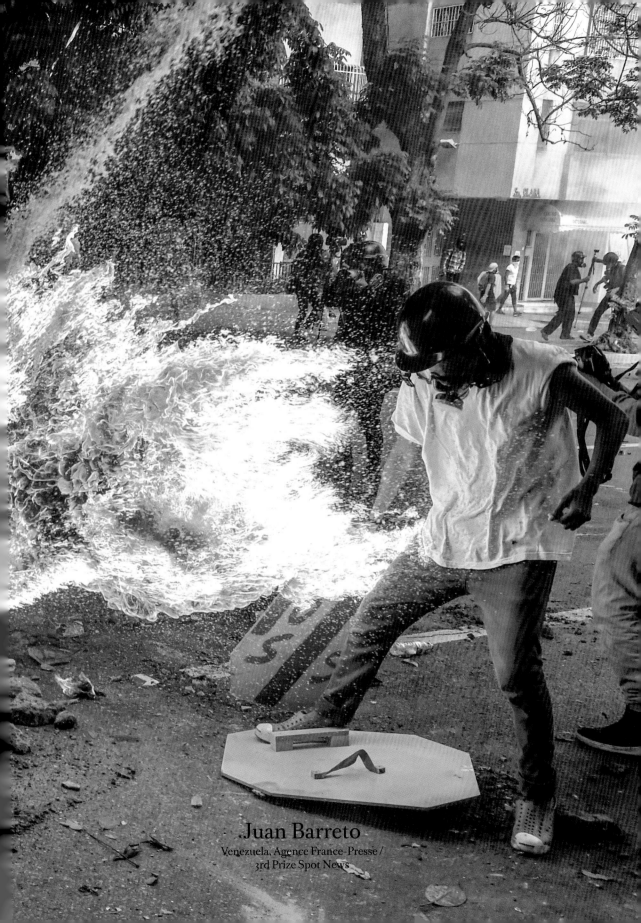

Juan Barreto
Venezuela, Agence France-Presse /
3rd Prize Spot News

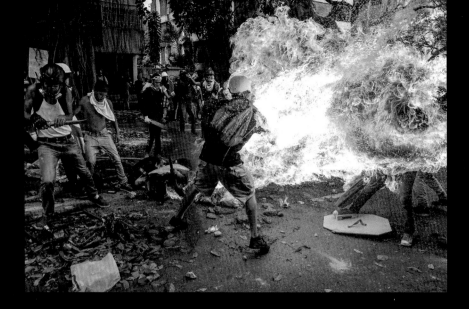

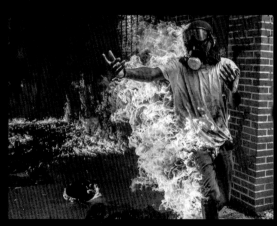

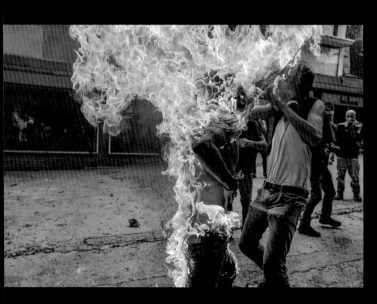

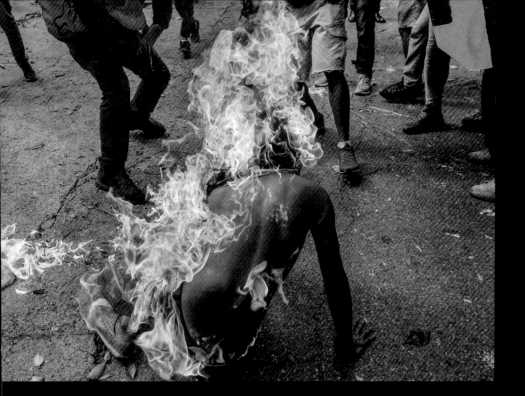

3 May 2017 › José Víctor Salazar Balza (28) catches fire after the gas tank on a motorcycle explodes, during a protest against the Venezuelan president, Nicolás Maduro, in Caracas. Violent clashes had broken out between demonstrators and the national guard. The motorcycle, belonging to a member of the national guard, was apparently being destroyed by protesters. Accounts of the incident differ, but some say that an object thrown by protesters caused the gas tank to explode. Further reports maintain that Salazar's clothing caught fire so readily because he was doused in petrol either by a bomb he was carrying, or that of a fellow protestor. Salazar suffered severe burns to more than 70 percent of his body, but survived the incident.

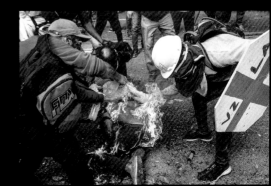

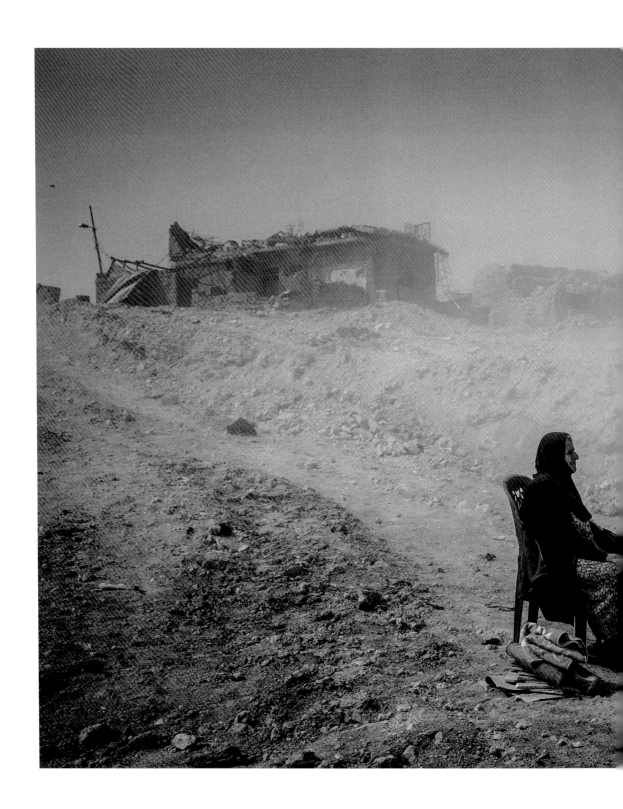

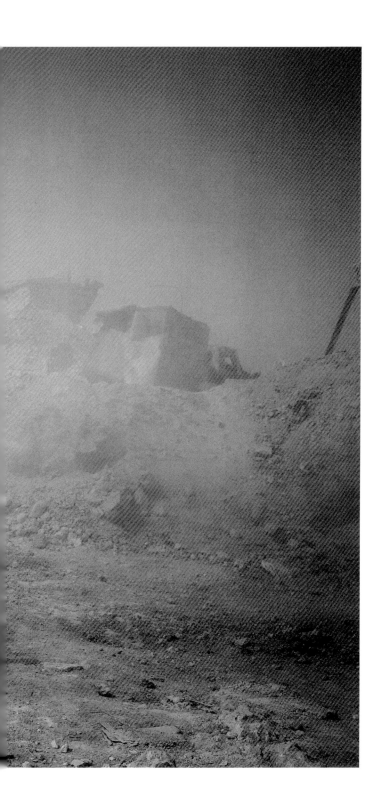

Ivor Prickett

Ireland, for *The New York Times* /
1st Prize General News

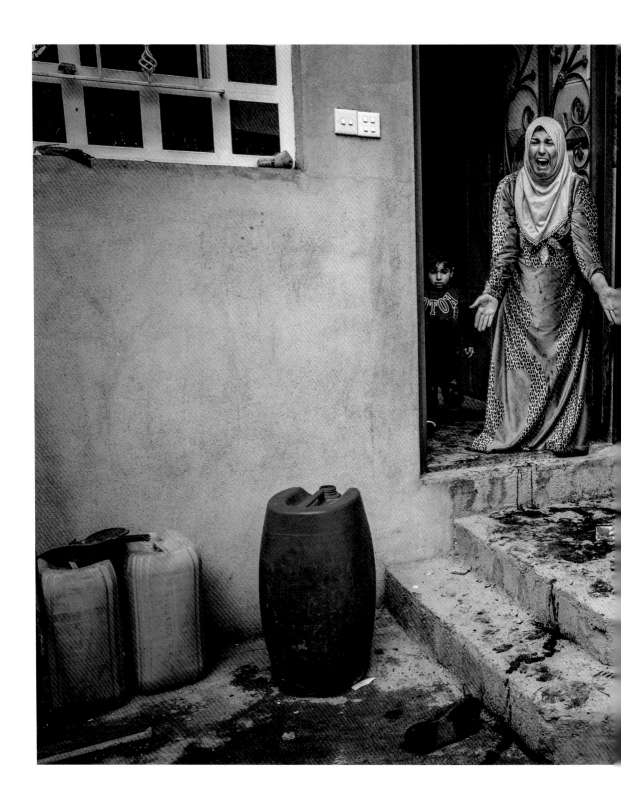

16 January - 16 September 2017 ›
On 10 July, after months of fighting,
the Iraqi government declared the
city of Mosul fully liberated from
ISIS, although fierce fighting con-
tinued in pockets of the city. Mosul
had fallen to ISIS three years earlier,
and the battle to retake it had begun
in October 2016.

Previous spread: Nadhira Aziz
looks on after west Mosul had been
retaken, as Iraqi Civil Defense workers
dig out the remains of her sister and
niece from her house in the Old City,
where they were killed by an airstrike
in June. *This spread*: A woman in the
Jidideh neighborhood of west Mosul
screams out shortly after a mortar
attack has killed her son. (*continues*)

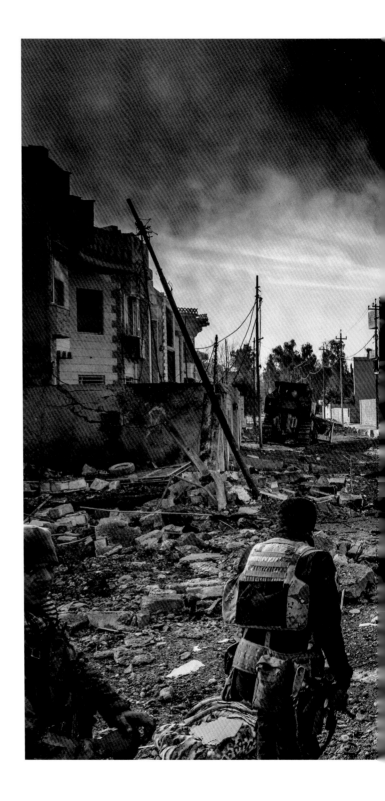

(*continued*) The retaking of Mosul in effect had two parts: the battle for the eastern half of the city, and that for the west, across the Tigris River. East Mosul was recaptured by the end of January 2017, but the offensive on west Mosul, particularly the densely built-up Old City, proved more difficult.

Right: Iraqi Special Forces soldiers survey the aftermath of an attack by an ISIS suicide car bomber, who managed to reach their lines in the Andalus neighborhood, one of the last areas to be liberated in eastern Mosul. (*continues*)

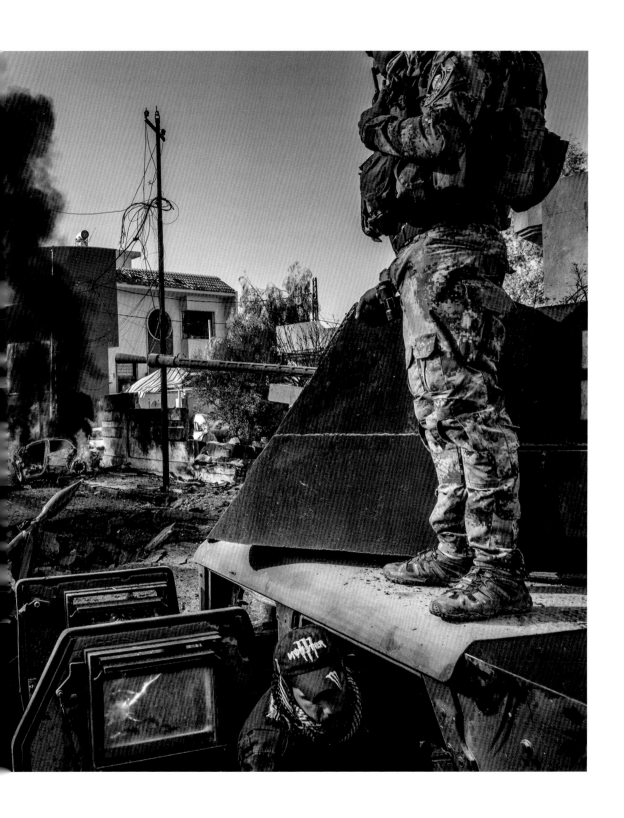

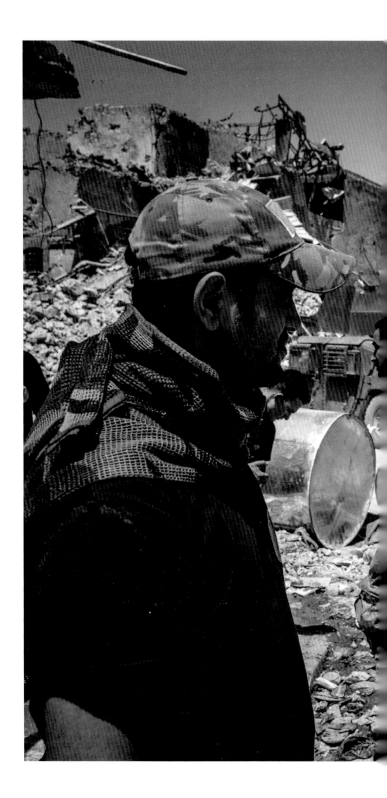

(*continued*) Large areas of Mosul were left in ruins. Huge numbers of civilians were caught in the crossfire as battle raged. A United Nations report gives an absolute minimum of 4,194 civilian casualties during the conflict, with other sources putting the figure much higher. The Office of the UN High Commissioner for Human Rights pointed to extensive use of civilians as human shields, with ISIS fighters attempting to use the presence of civilian hostages to make certain areas immune from military operations.

Right: An unidentified young boy, who was carried out of the last ISIS-controlled area of the Old City by a man suspected of being a militant, is washed and cared for by Iraqi Special Forces soldiers. The soldiers suspected that the man had used the boy as a human shield in order to try to escape, as he did not know the child's name. (*continues*)

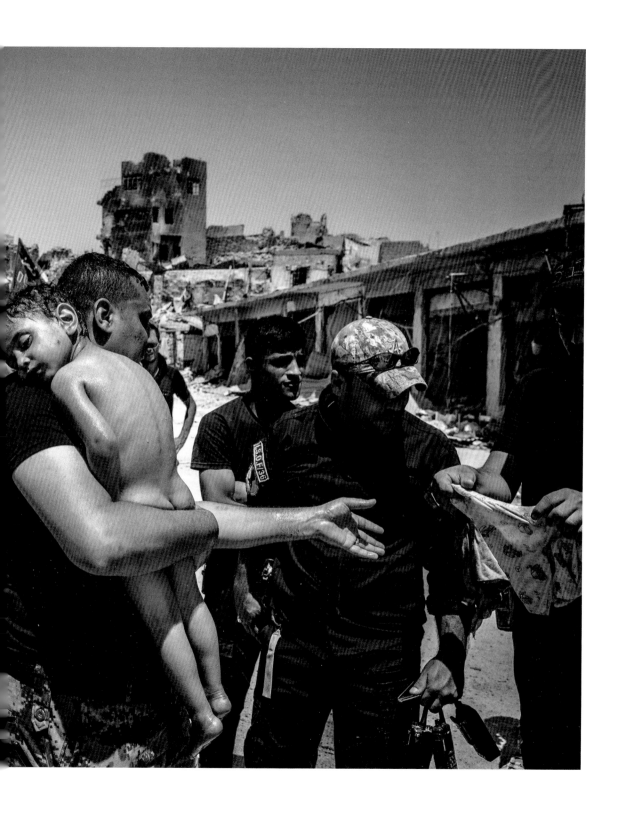

(*continued*) After months of being trapped in the last remaining ISIS-held areas of the city, the people in west Mosul were severely short of food and water. Those who chose to remain in the city rather than go to one of the many camps for displaced people, initially relied on aid in order to survive.

Right: Civilians line up for aid distribution in the Mamun neighborhood of west Mosul, on 15 March.

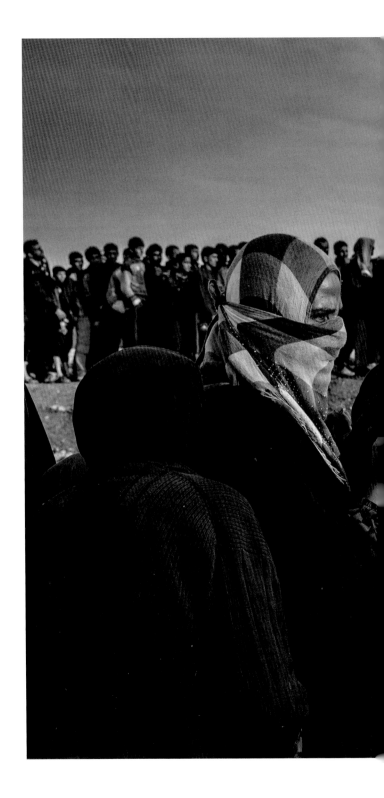

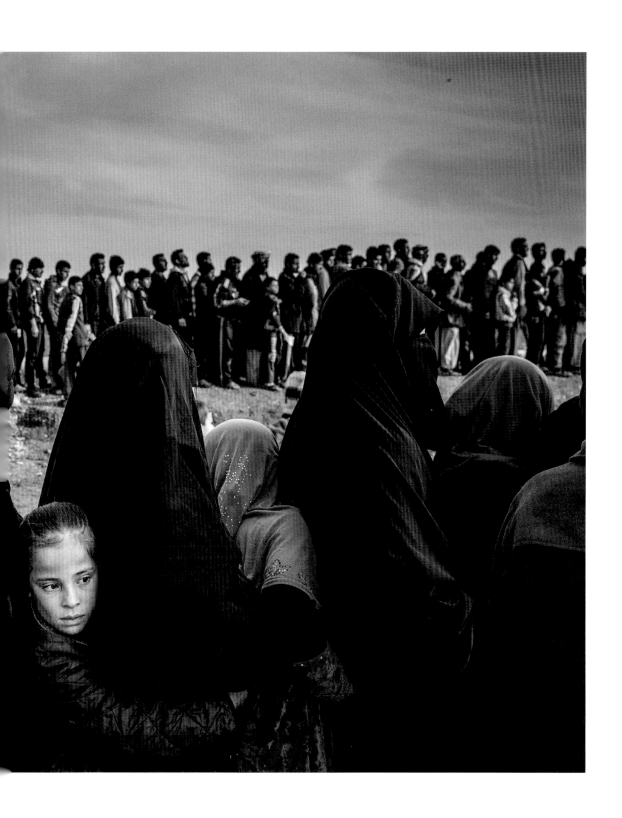

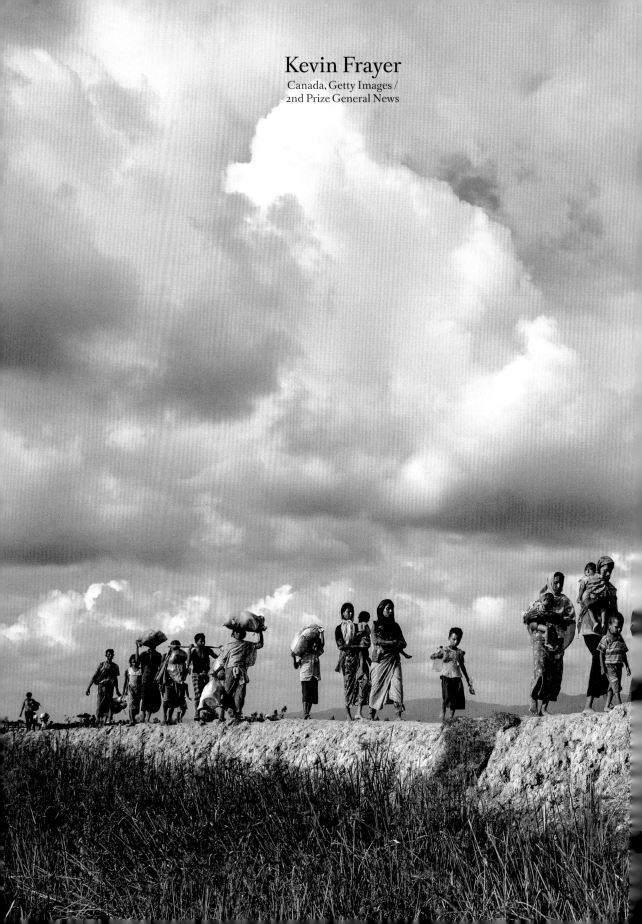

Kevin Frayer
Canada, Getty Images /
2nd Prize General News

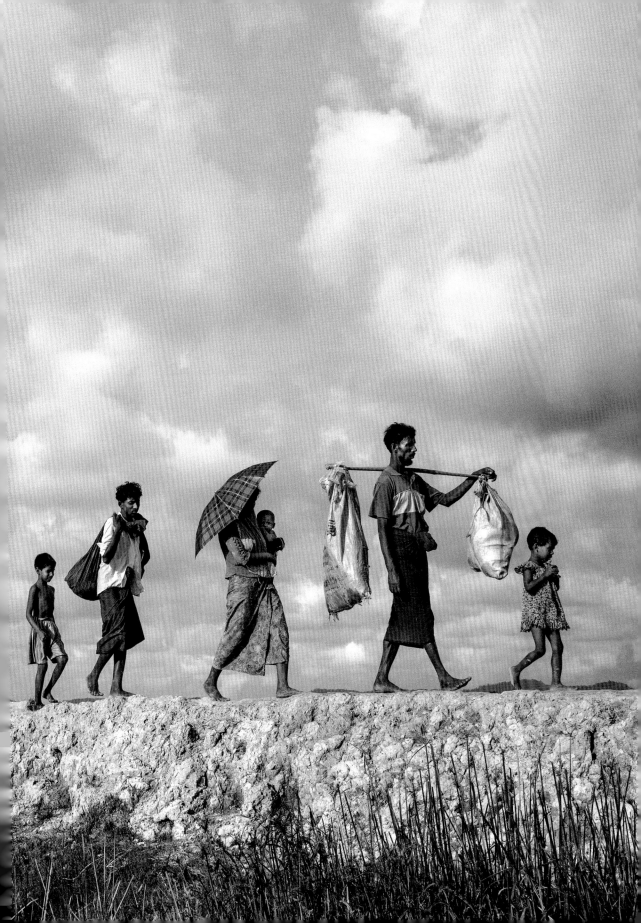

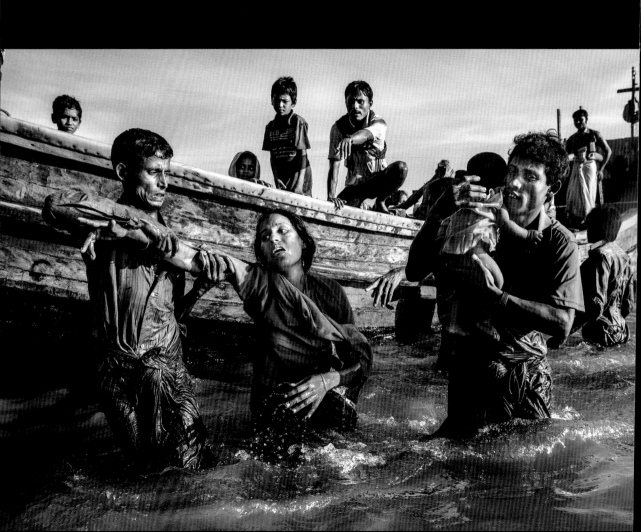

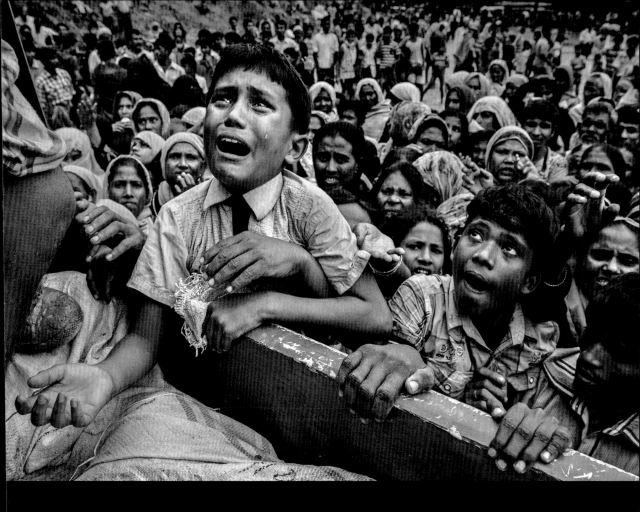

19 September - 2 November 2017 › Attacks on the villages of Rohingya Muslims in Myanmar, and the burning of their homes, led to hundreds of thousands of refugees fleeing into Bangladesh on foot or by boat. Many died in the attempt. According to UNICEF, more than half of those fleeing were children. In Bangladesh, refugees were housed in existing camps and makeshift settlements. Conditions became critical; basic services came under severe pressure and, according to a Médecins Sans Frontières physician based there, most people lacked clean water, shelter and sanitation, bringing the threat of disease.

Previous spread: Rohingya refugees carry their belongings as they walk on the Bangladesh side of the Naf River after fleeing Myanmar, on 2 October 2017. *Facing page*: A woman is helped from a boat as she arrives at Shah Porir Dwip, near Cox's Bazar, Bangladesh. *Above*: A boy cries as he climbs on a truck distributing aid near the Balukali refugee camp, Cox's Bazar. *Next spread*: Minara Hassan and her husband Ekramul lie exhausted on the ground on the Bangladesh side of the Naf River, after fleeing their home in Maungdaw, Myanmar.

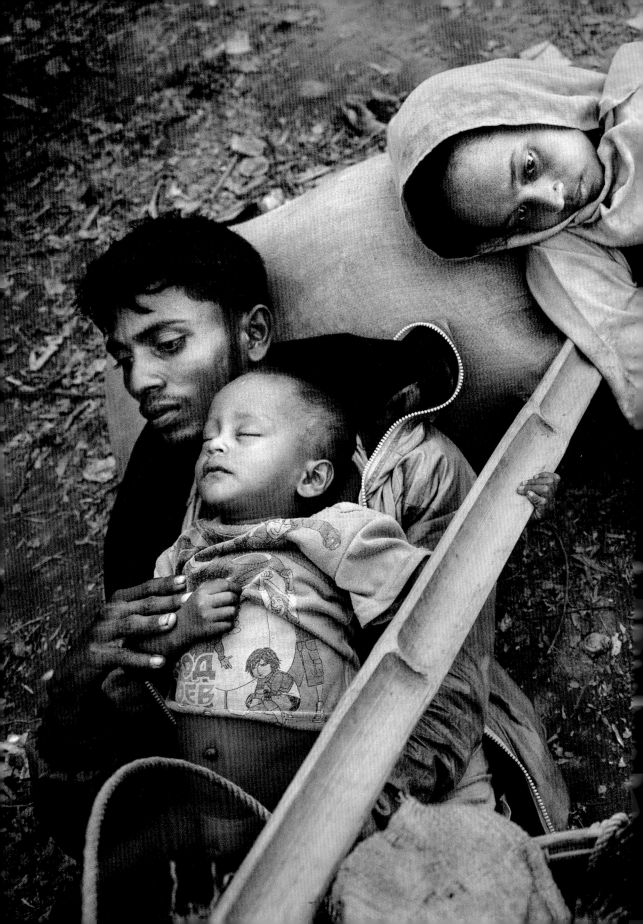

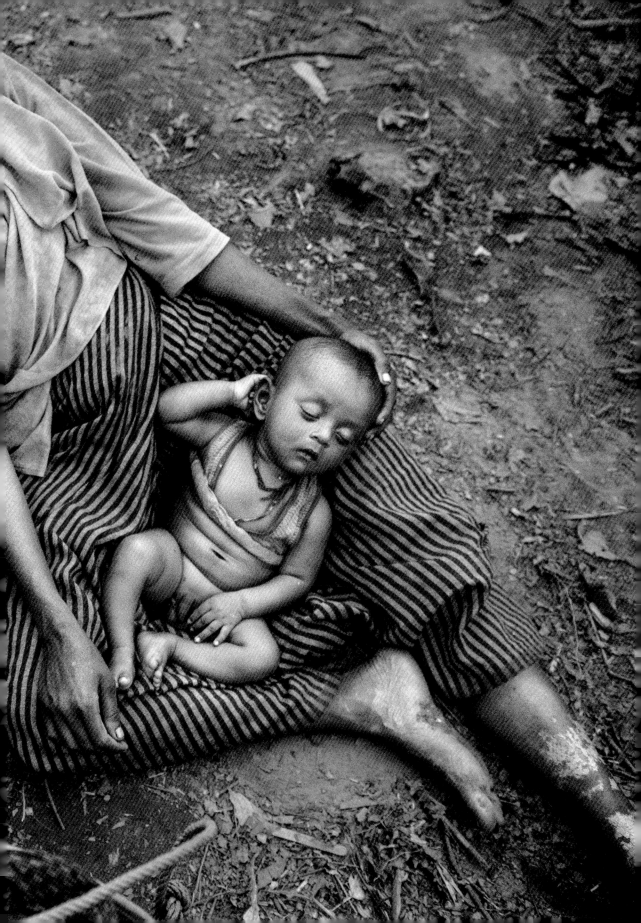

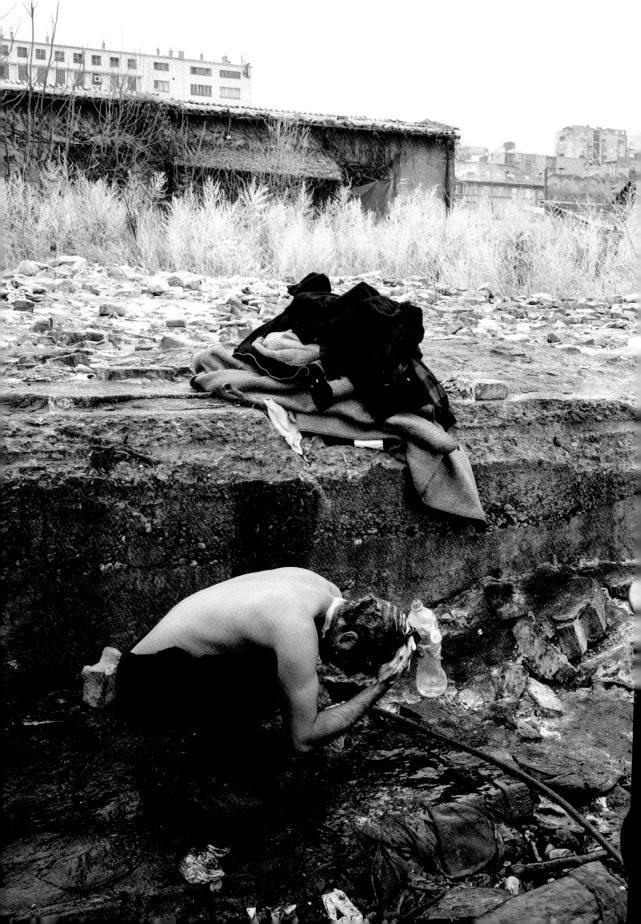

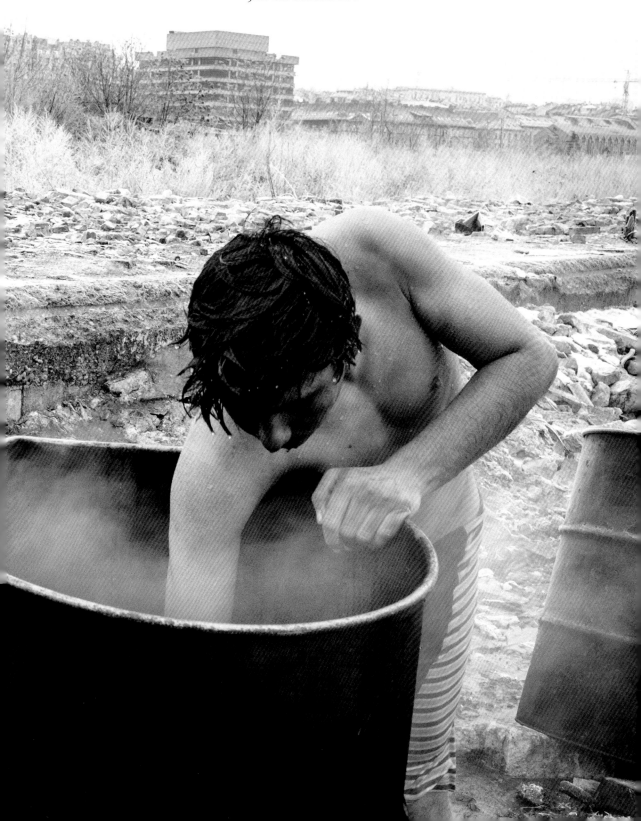

Francesco Pistilli

Italy /
3rd Prize General News

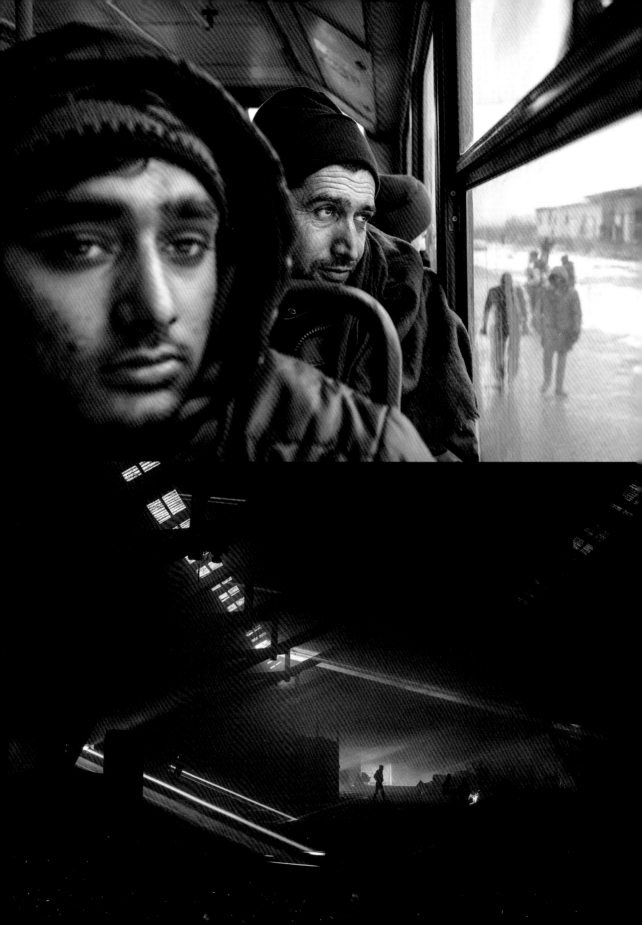

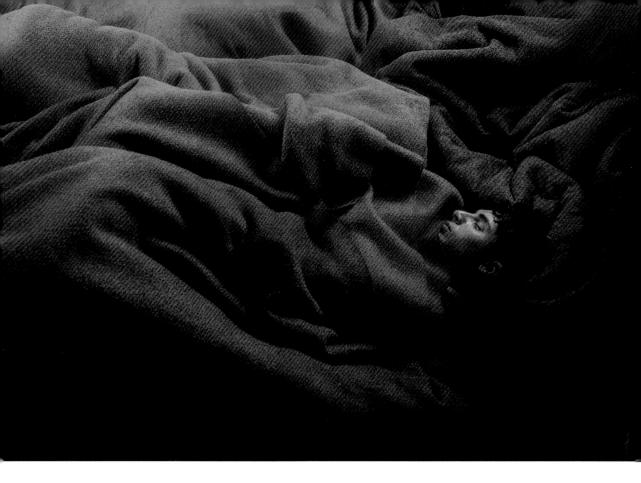

12-17 January 2017 › The tightening of the so-called Balkan route into the European Union stranded thousands of refugees attempting to travel through Serbia to seek a new life in Europe. Many spent the freezing winter in derelict warehouses behind Belgrade's main train station. The UNHCR reported that the number of refugees in Serbia had increased from 2,000 in June 2016 to more than 7,000 by the end of the year. Some 85 percent were accommodated in government facilities, most of the others slept rough in the capital.

Previous spread: Two Afghan refugees wash outdoors in Belgrade. *Facing page, top*: A group of refugees wait on a bus for transfer from the makeshift camp behind Belgrade station to a government camp outside the city. *Below*: Refugees shelter in a derelict warehouse. *Above*: Young Afghans sleep in an abandoned train wagon in Belgrade.

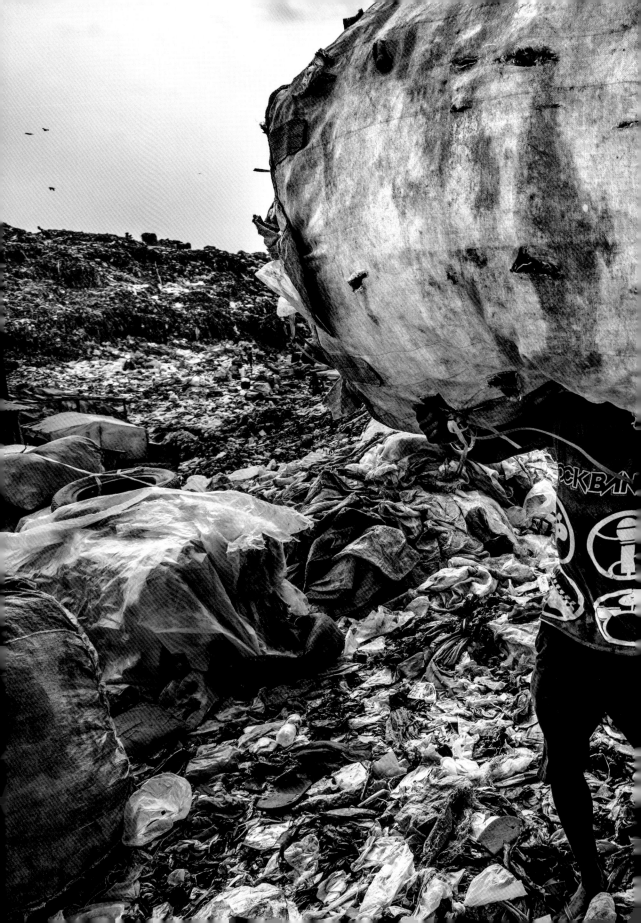

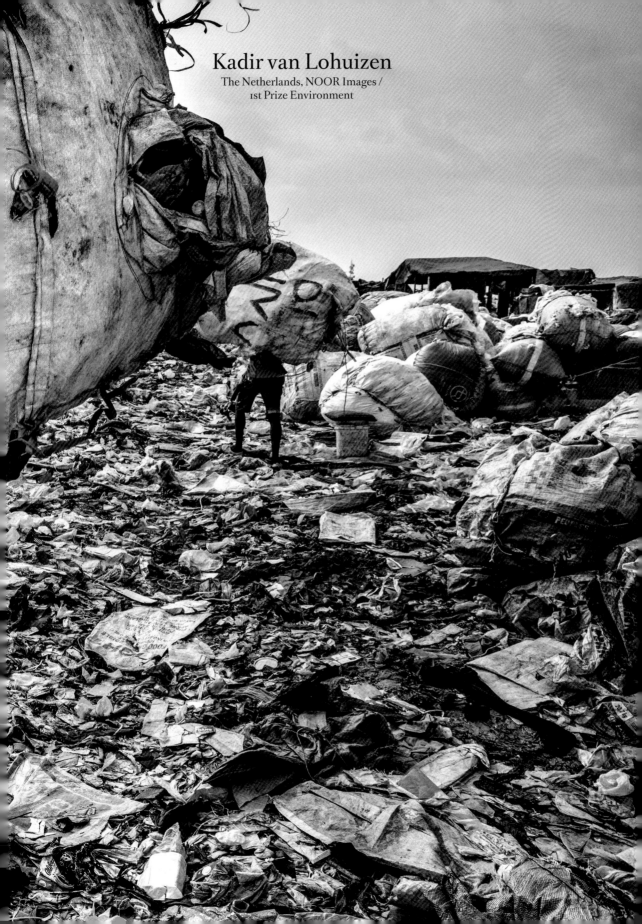

Kadir van Lohuizen

The Netherlands, NOOR Images /
1st Prize Environment

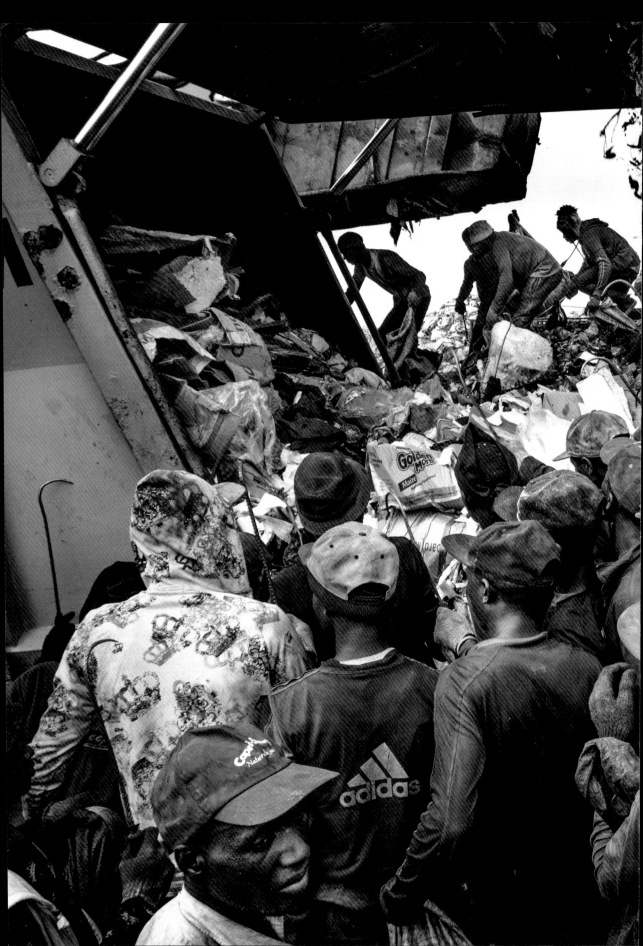

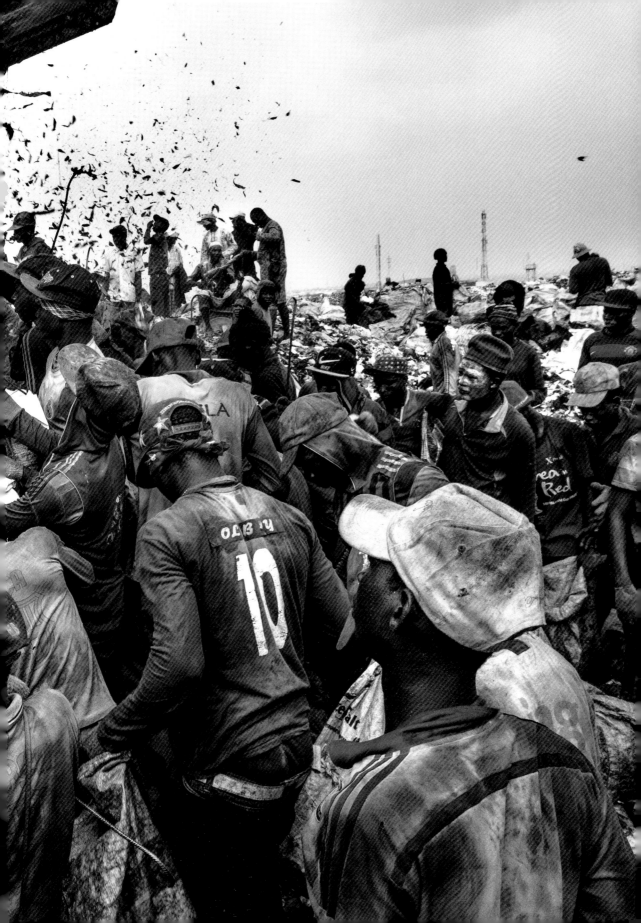

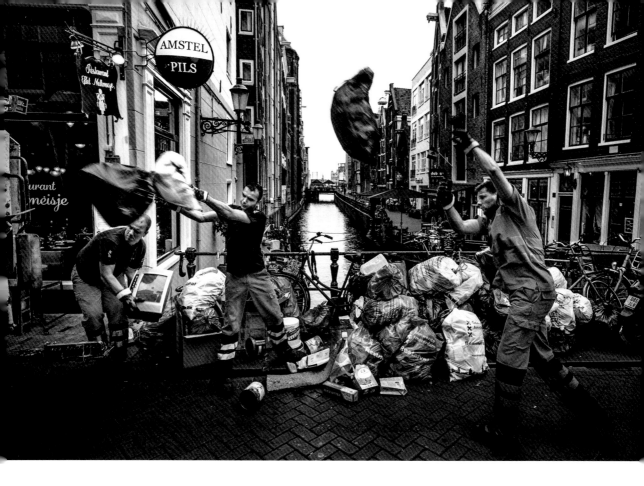

23 February 2016 - 9 July 2017 › Humans are producing more waste than ever before. According to research by the World Bank, the world generates 3.5 million tonnes of solid waste a day, ten times the amount of a century ago. Rising population numbers and increasing economic prosperity fuel the growth, and as countries become richer, the composition of their waste changes to include more packaging, electronic components and broken appliances, and less organic matter. Landfills and waste dumps are filling up, and the World Economic Forum reports that by 2050 there will be so much plastic floating in the world's oceans that it will outweigh the fish. A documentation of waste management systems in metropolises across the world investigates how different societies manage—or mismanage—their waste.

Two spreads back: A man carries a load of PET bottles for recycling, at Olusosun landfill, Lagos, Nigeria. *Previous spread*: A garbage truck arrives at the Olusosun landfill. *Above*: Garbage is collected in the center of Amsterdam, the Netherlands. *Facing page, top*: Shizai paper recycling plant, Tokyo, Japan. *Below*: Ponte Pequena waste-transfer station in São Paulo, Brazil. *Following spread*: Plastic on its way from the Bronx to a recycling plant in Brooklyn, New York, USA.

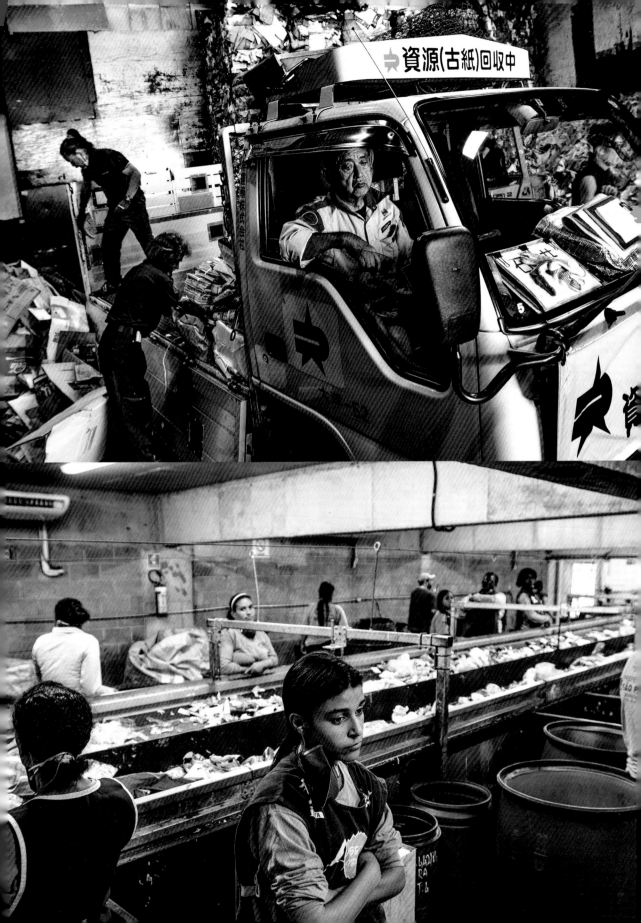

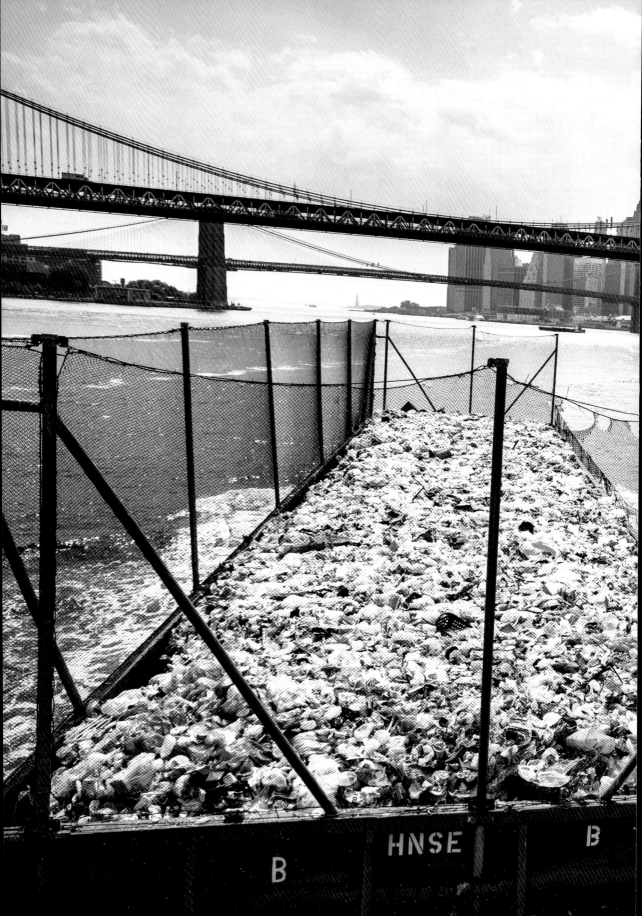

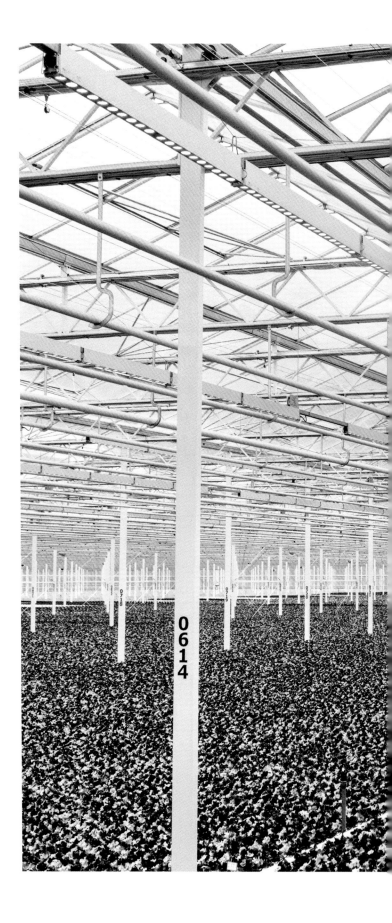

Luca Locatelli
Italy, for *National Geographic* /
2nd Prize Environment

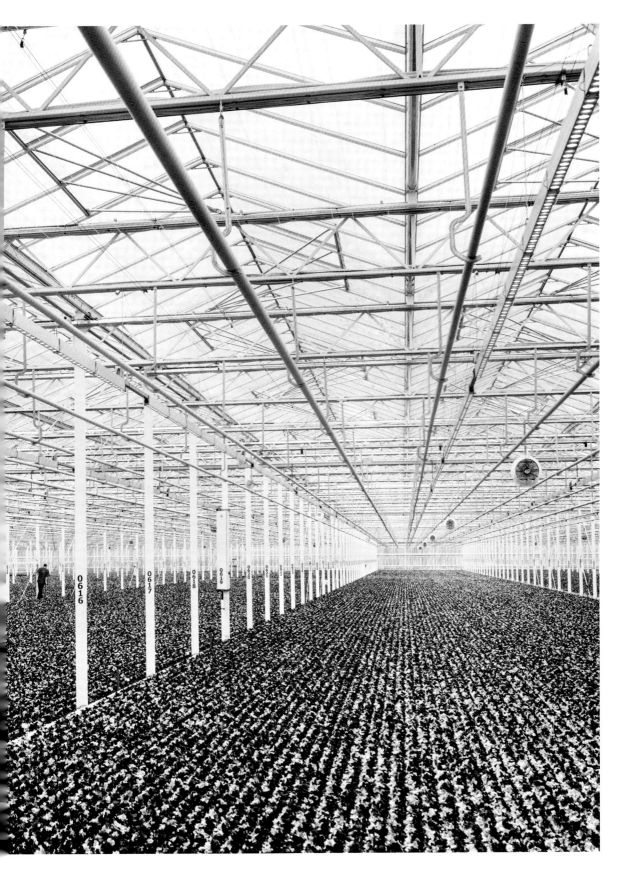

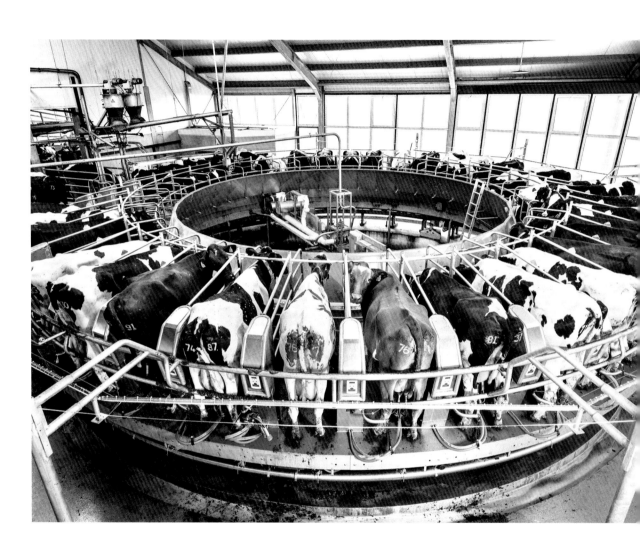

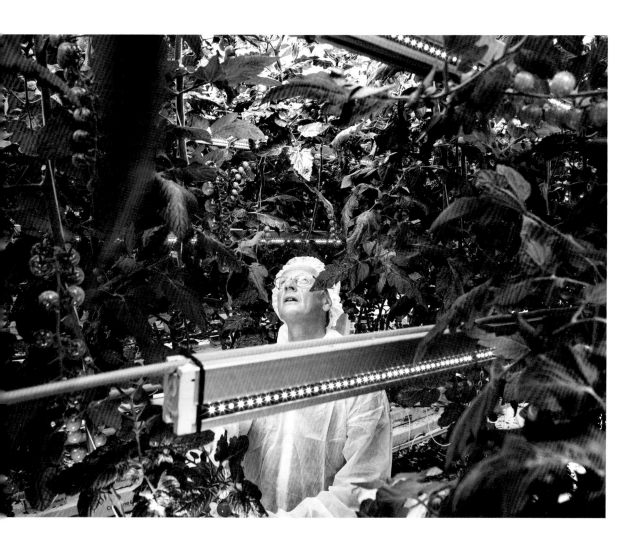

2 October 2016 - 9 March 2017 › The planet must produce more food in the next four decades than all farmers in history have harvested over the past 8,000 years. Small and densely populated, the Netherlands lacks conventional sources for large-scale agriculture but, through innovative agricultural practice, has become the globe's second largest exporter of food as measured by value. It is beaten only by the US, which has 270 times its landmass.

Previous spread: Butter lettuce grown under LED light in a 9-hectare warehouse belonging to Siberia BV. *Facing page*: A rotary milking machine that enables one operator to milk up to 150 cows an hour, at Wageningen University Dairy Campus. *Above*: Plant scientist Henk Kalkman checks tomatoes at a facility that tests combinations of light intensity, spectrum and exposures at the Delphy Improvement Centre in Bleiswijk. (*continues*)

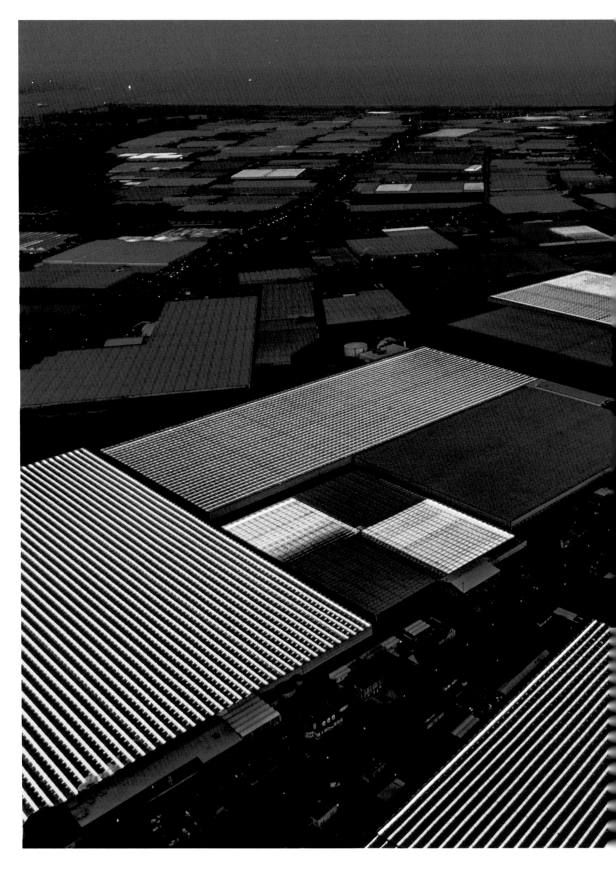

(*continued*) Since 2000, Dutch farmers have dramatically decreased dependency on water for key crops, as well as substantially cutting the use of chemical pesticides and antibiotics. Much of the research behind this takes place at Wageningen University and Research (WUR), widely regarded as the world's top agricultural research institution. WUR is the nodal point of 'Food Valley', an expansive cluster of agricultural technology start-ups and experimental farms that point to possible solutions to the globe's hunger crisis.

Left: Agricultural greenhouses in the Westland region, which with 80 percent of its cultivated land under glass is known as the greenhouse capital of the Netherlands.

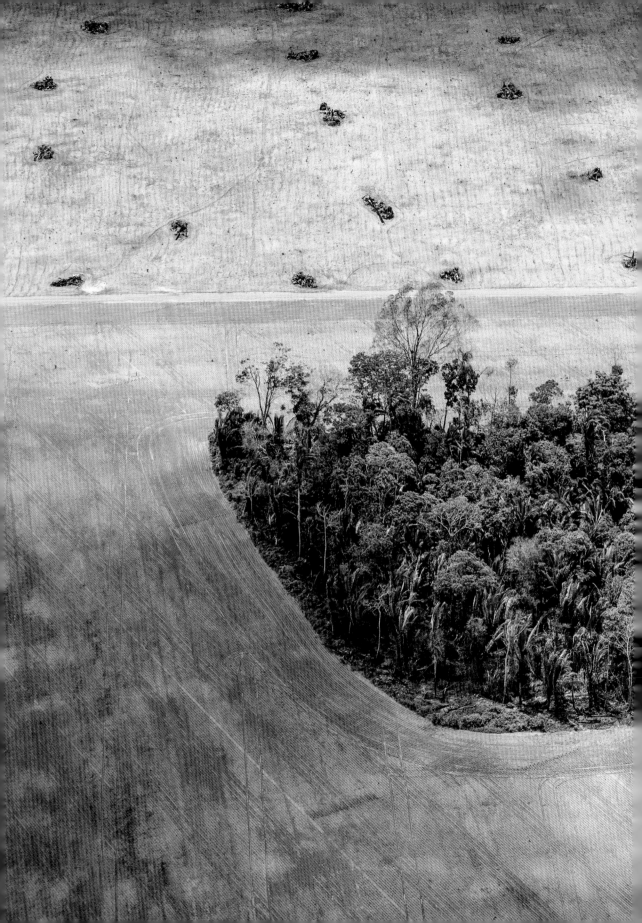

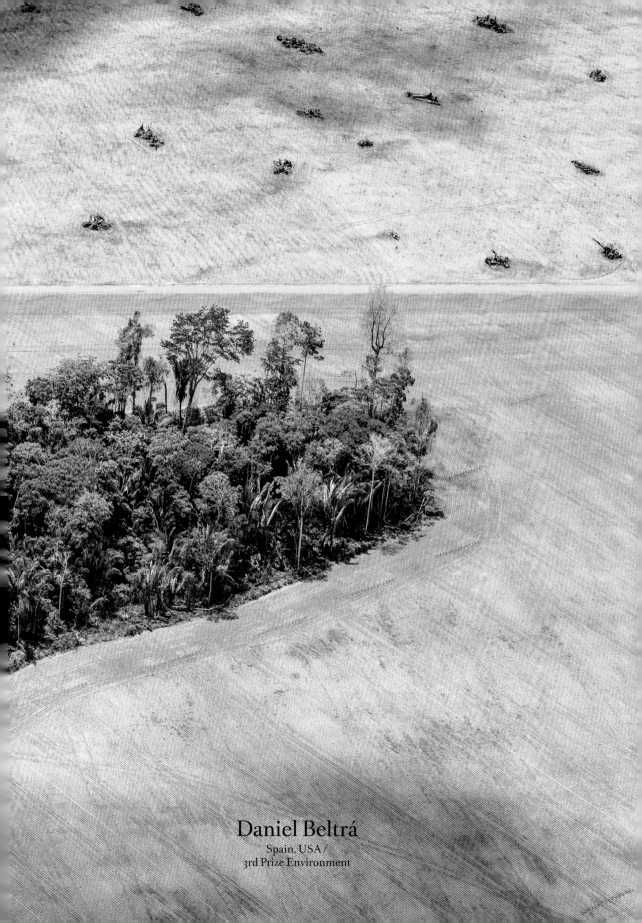

Daniel Beltrá
Spain, USA /
3rd Prize Environment

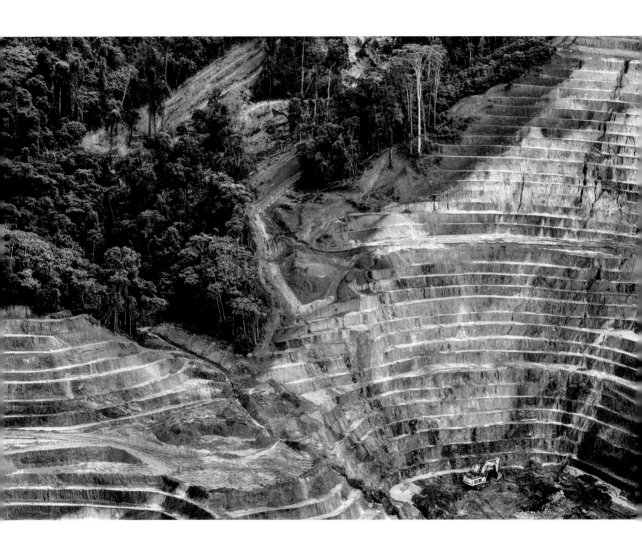

19 January - 18 February 2017 › After declining from major peaks in 1995 and 2004, the rate of deforestation in the Brazilian Amazon increased sharply in 2016, under pressure from logging, mining, agriculture and hydropower developments. The Amazon forest is one of Earth's great 'carbon sinks', absorbing billions of tonnes of carbon dioxide each year and acting as a climate regulator. Without it, the world's ability to lock up carbon will be reduced, compounding the effects of global warming.

Previous spread: A remnant of rainforest stands in fields cleared for agriculture, near the Tapajós River. *Above*: An iron ore strip mine near the Tumucumaque National Park. *Facing page*: Dead trees from forests flooded by construction of a dam on the Araguaia River. *Following spread*: Scarlet ibises fly above flooded lowlands, near Bom Amigo, Amapá state.

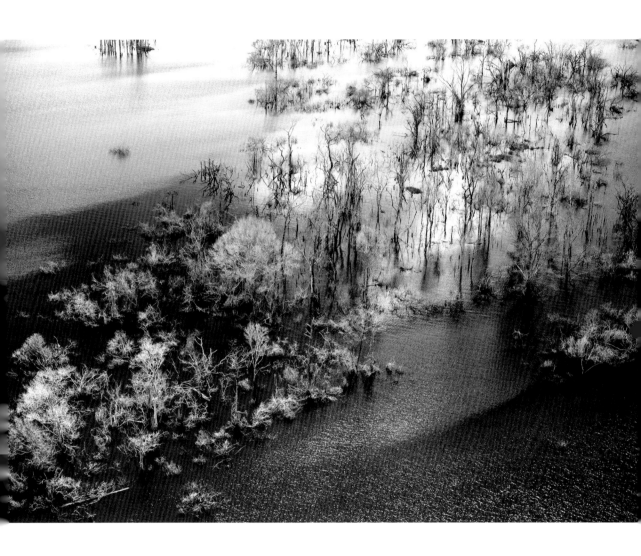

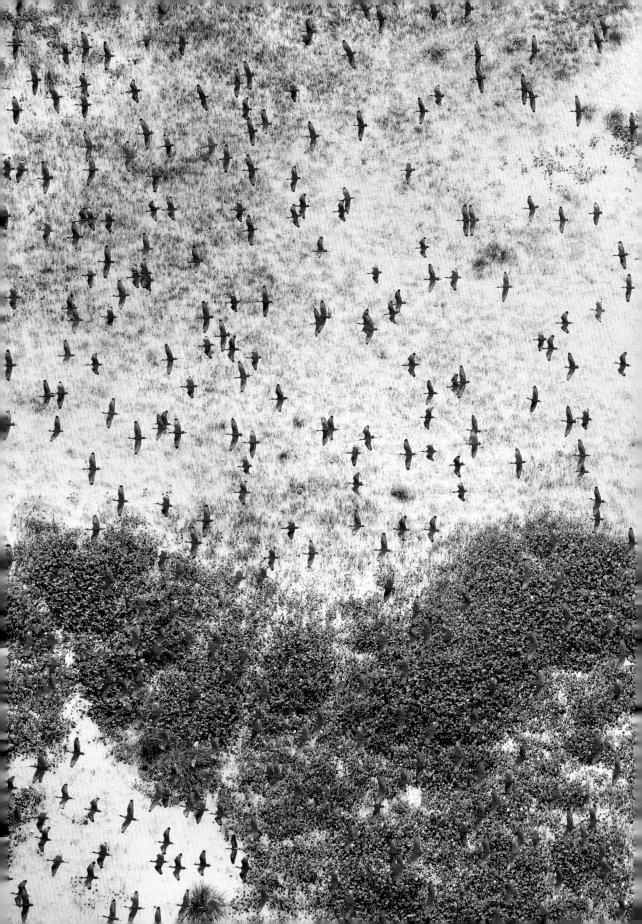

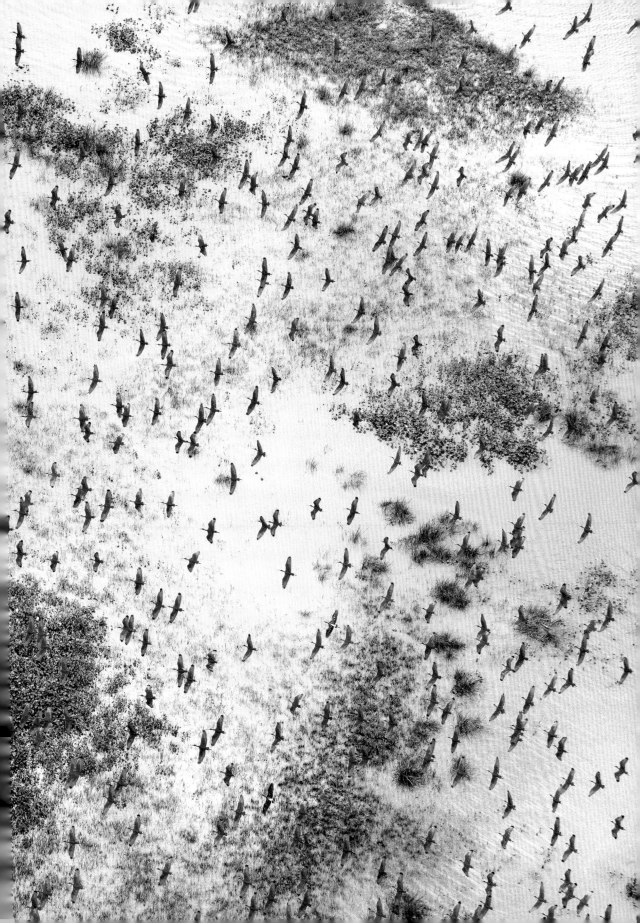

Adam Ferguson

Australia, for *The New York Times* /
1st Prize People

29 August - 22 September 2017 › Portraits of girls kidnapped by
Boko Haram militants, taken in Maiduguri, Borno State, Nigeria.
The girls were made up to look beautiful, strapped with explosives,
and ordered to blow themselves up in crowded areas, but managed
to escape and find help instead of detonating the bombs.
 Above: Maryam, aged 16. *Facing page*: Aisha, aged 14. (*continues*)

(*continued*) Boko Haram—a Nigeria-based militant Islamist group whose name translates roughly to 'Western education is forbidden'—expressly targets schools and has abducted more than 2,000 women and girls since 2014.

Above: Maimuna, aged 16. *Facing page*: Falmata, aged 15. (*continues*)

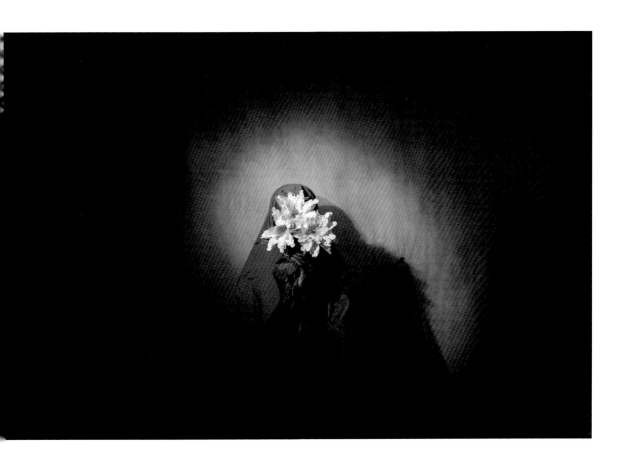

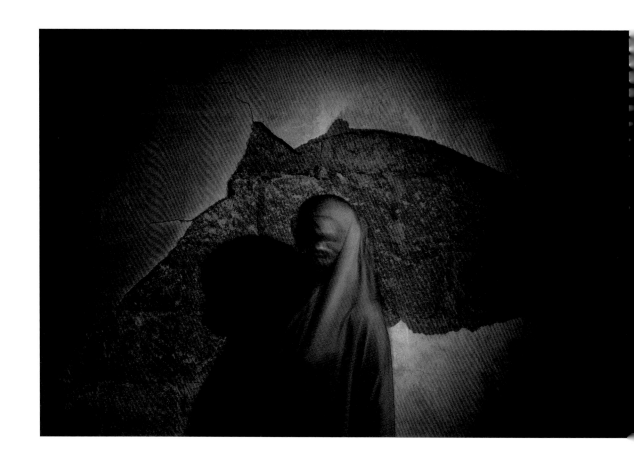

(continued) Female suicide bombers are seen by the militants as a new weapon of war. In 2016, *The New York Times* reported at least one in every five suicide bombers deployed by Boko Haram over the previous two years had been a child, usually a girl. The group used 27 children in suicide attacks in the first quarter of 2017, compared to nine during the same period the previous year.

Above: Fatima, aged 16. *Facing page*: Balaraba, aged 20, who like Fatima managed to escape instead of blowing herself and others up.

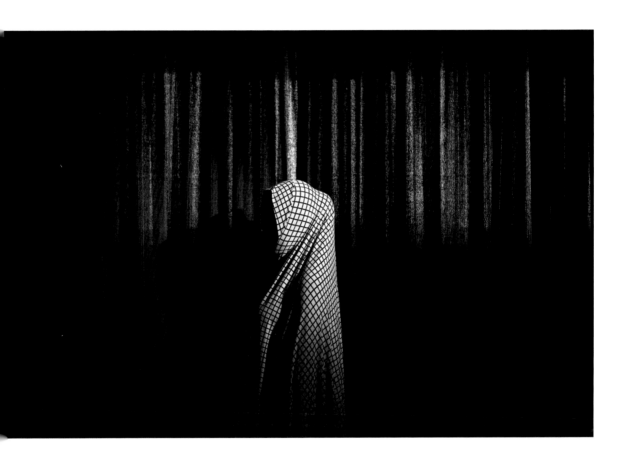

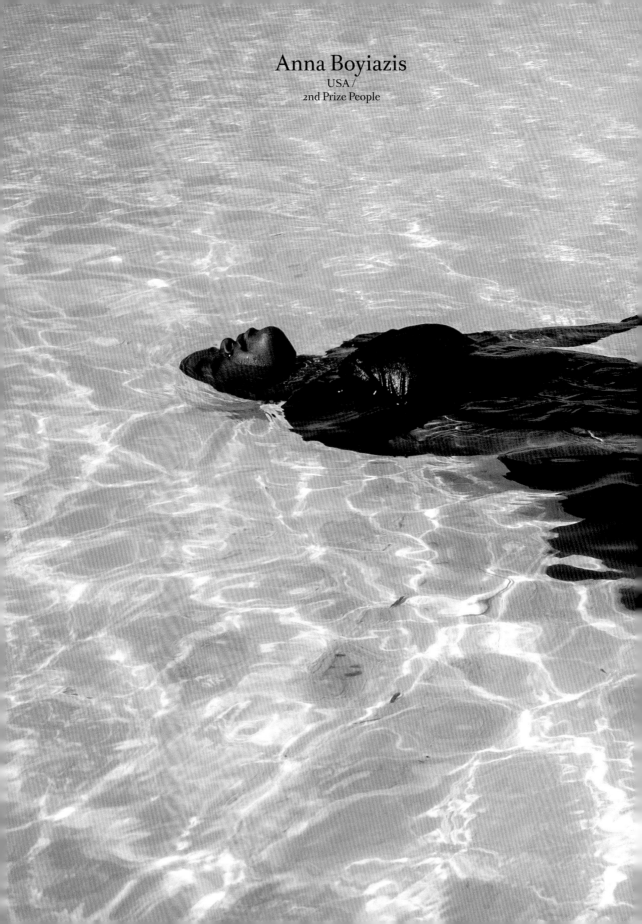

High Anna Boyiazis
USA /
2nd Prize People

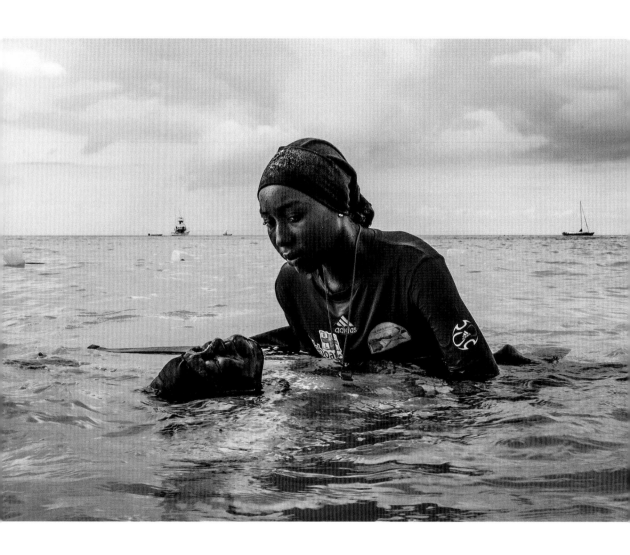

17 October – 29 December 2016 › Traditionally, girls in the Zanzibar archipelago are discouraged from learning how to swim, largely because of the strictures of a conservative Islamic culture and the absence of modest swimwear. But in villages on the northern tip of Zanzibar, the Panje Project (*panje* translates as 'big fish') is providing opportunities for local women and girls to learn swimming skills in full-length swimsuits, so that they can enter the water without compromising their cultural or religious beliefs.

Previous spread: A young woman learns to float. *Above*: Swimming instructor Siti (24) helps a young woman to float. *Facing page*: Swimming instructor Chema (17) snaps her fingers as she disappears underwater. *Following spread*: Students from the Kijini Primary School learn to swim and perform rescues.

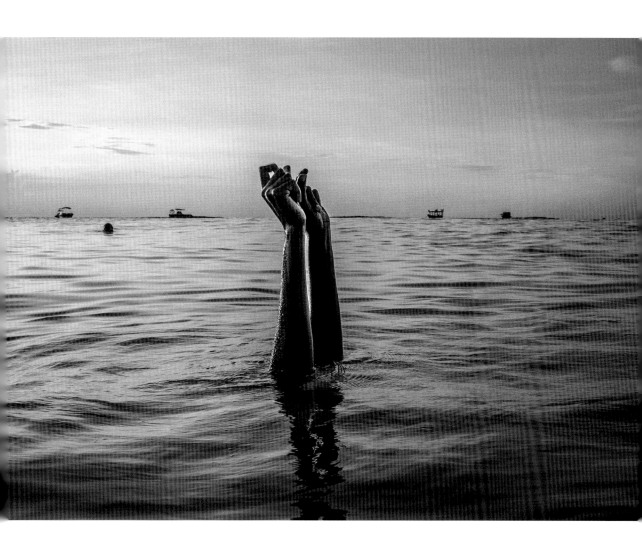

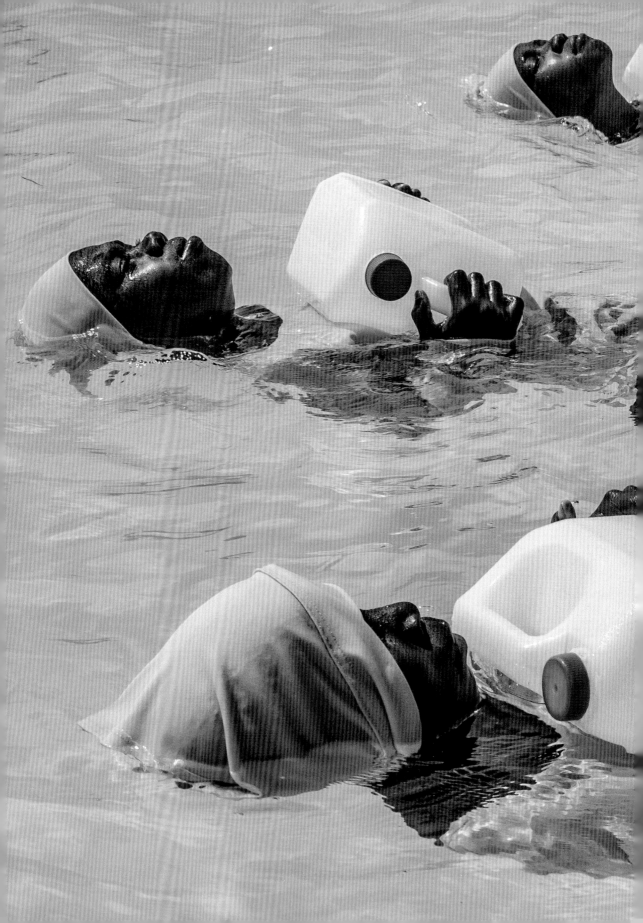

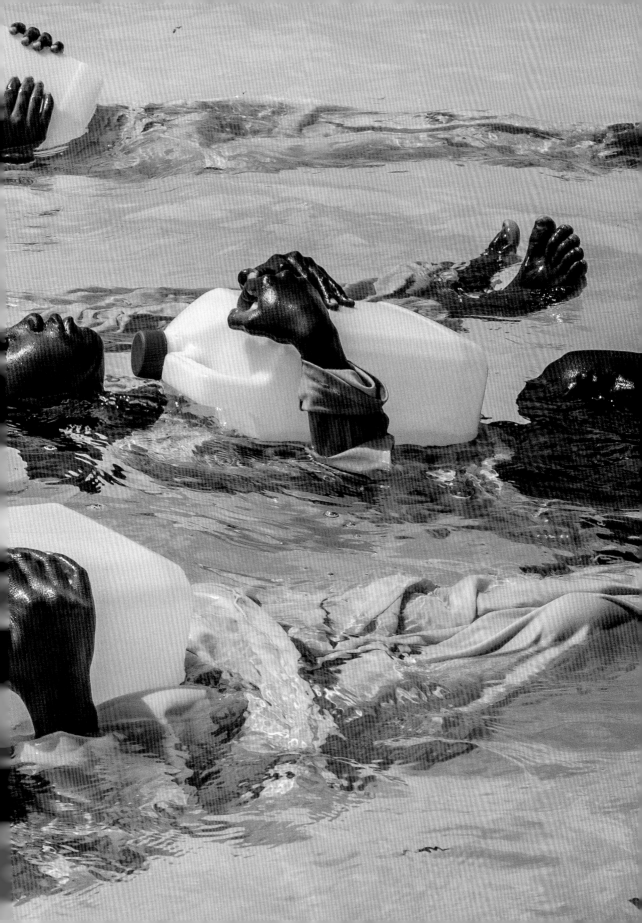

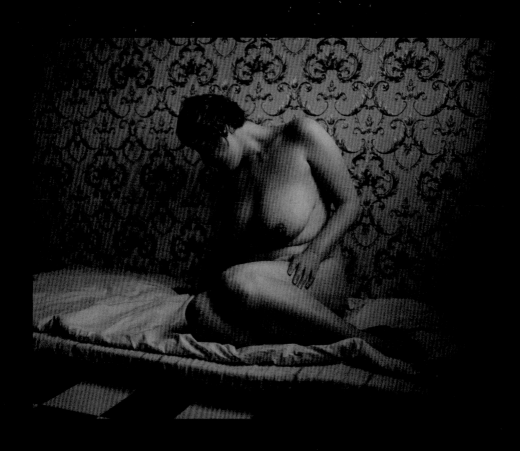

Tatiana Vinogradova

Russia /
3rd Prize People

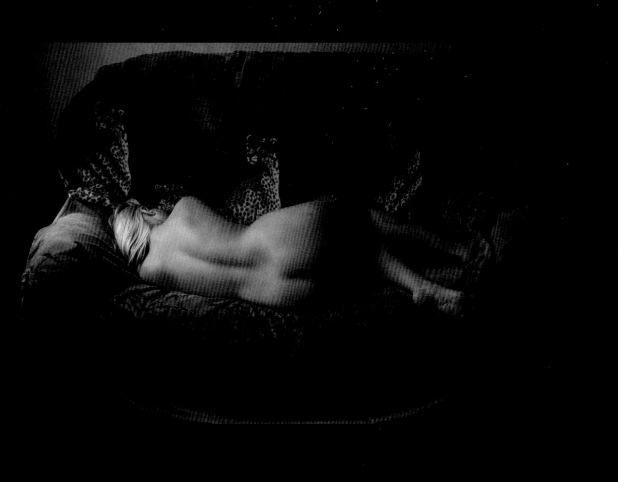

29 March - 7 December 2017 › Sex workers pictured in their apartments, in St Petersburg, Russia. Official statistics say that there are one million sex workers in Russia. Silver Rose, a St Petersburg NGO, puts that at closer to three million, with more than 50,000 women working in St Petersburg alone. Prostitution is illegal in Russia, and though fines are not large (about €28) women are open to extortion because they fear the consequences of having a criminal record.

Facing page: Alice (27) is a single mother who has been working in the sex industry for ten years, after dropping out of a fashion design course at college. She has frequently experienced police raids, criminal attacks, and violence from clients. *Above*: Alena (33) was born in Ukraine and raised in an orphanage. She moved from Donetsk to St Petersburg after the war in Ukraine, thinking that she was being offered work as an administrator in a brothel, only to find that the work was as a prostitute. (*continues*)

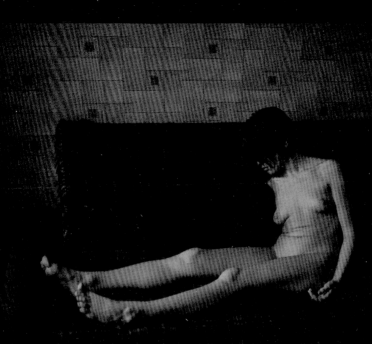

(*continued*) According to Silver Rose, despite the stereotypical view of sex workers, only a small percentage have taken to prostitution because they are addicts or living in extreme poverty. The decline of the Russian economy has led to a growing number of women—many over the age of 35—who have lost jobs in such fields as business or education becoming sex workers.

Facing page: Maya (24) was born in Bashkortostan, part of the Russian Federation, and after graduating with a qualification in sociology held numerous jobs before moving to St Petersburg, where she began work in a sex shop. Unable to live on the low salary, she became a sex worker. *Above*: Asya (30) dropped out of a course in mechanical engineering, and after going through a number of jobs ended up working as a janitor. Because the pay was so low, she sought work in the sex trade.

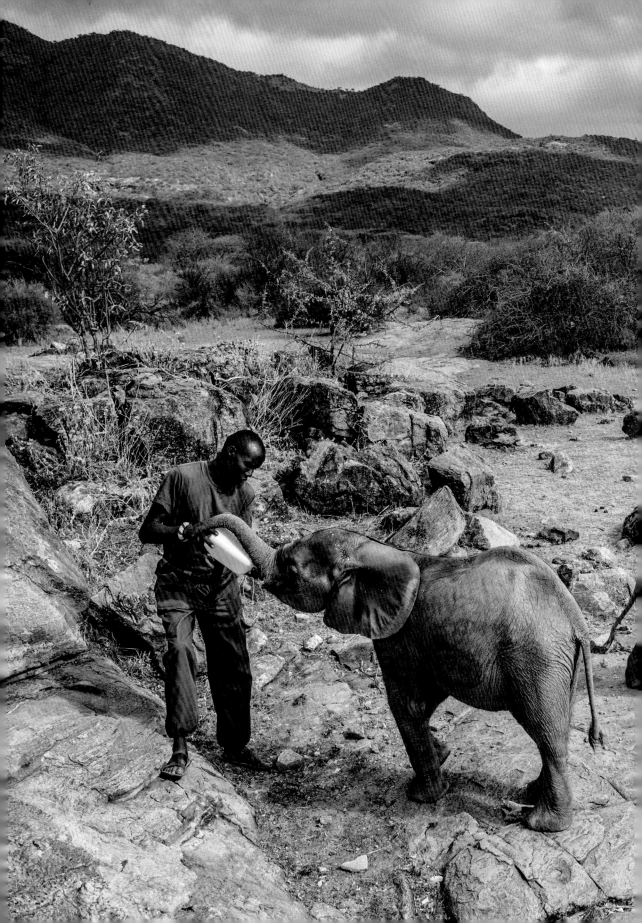

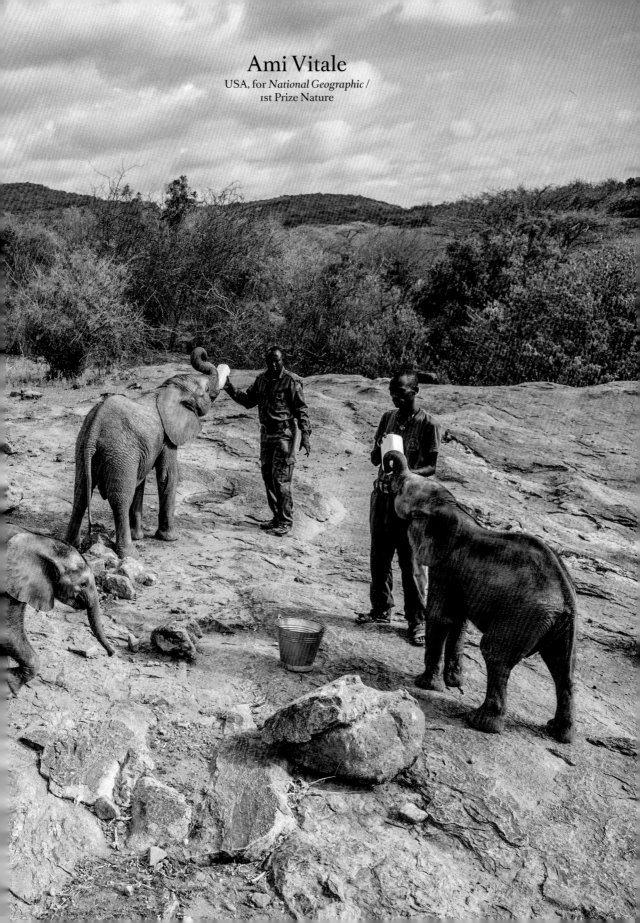

Ami Vitale
USA, for *National Geographic* /
1st Prize Nature

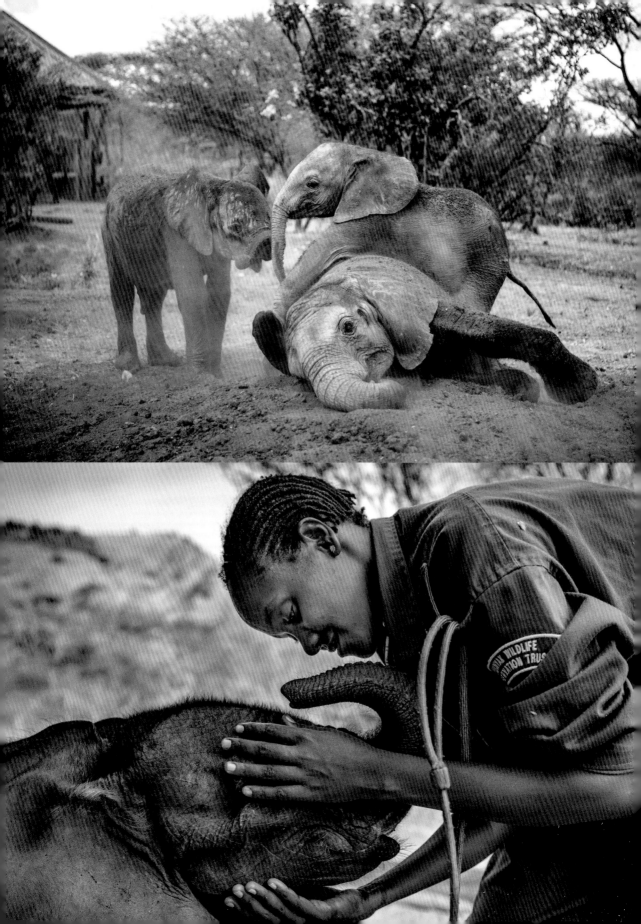

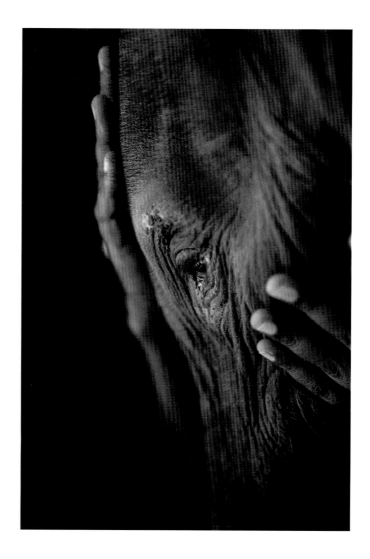

29 September 2016 - 23 February 2017 › Orphaned
and abandoned elephant calves are rehabilitated
and returned to the wild, at the community-owned
Reteti Elephant Sanctuary in northern Kenya.
The Reteti sanctuary is part of the Namunyak
Wildlife Conservation Trust, located in the ancestral
homeland of the Samburu people. The elephant
orphanage was established in 2016 by local
Samburus, and all the men working there are, or
were at some time, Samburu warriors. In the past,
local people weren't much interested in saving
elephants, which can be a threat to humans and
their property, but now they are beginning to
relate to the animals in a new way. Elephants feed
on low brush and knock down small trees, pro-
moting the growth of grasses—of advantage to
the pastoralist Samburu.

Previous spread: Keepers feed baby elephants.
Facing page, top: An older elephant shows younger
orphans how to take a dust bath. A coating of dirt
protects elephants against the sun and insects.
Below: Mary Lengees, one of Reteti's first female
keepers, caresses Suyian. Women are seen as
bringing important nurturing skills into the work-
force. *This page*: Suyian, the sanctuary's first
resident. *Next spread*: A rescued elephant calf.
Two spreads forward: Reteti staff guard the two-
week-old Kinya, rescued after falling into a well.

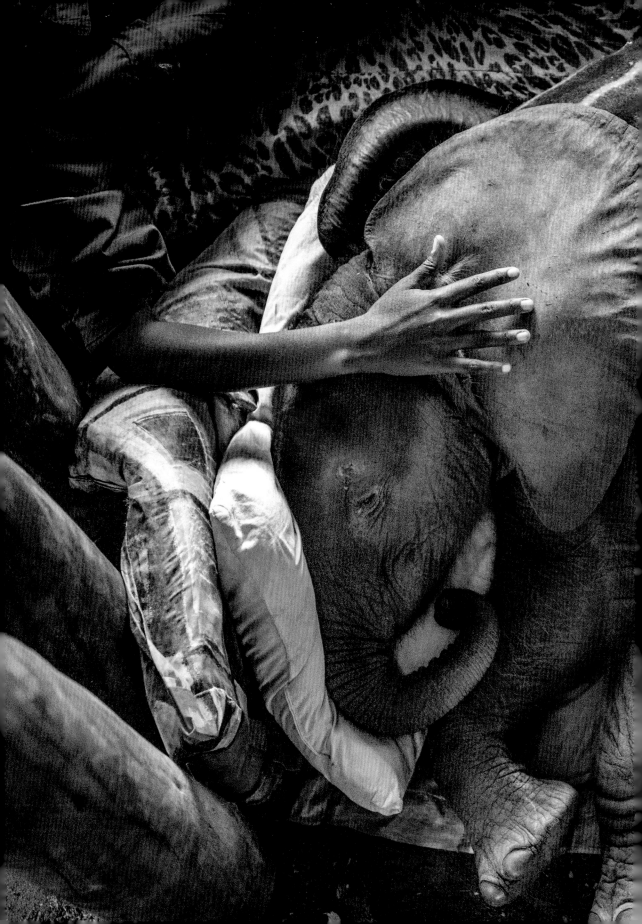

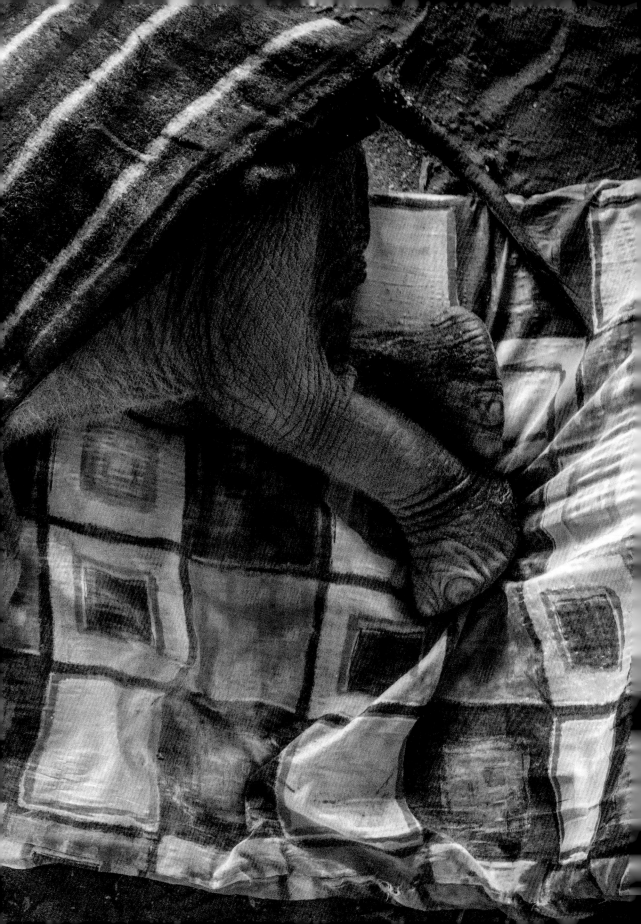

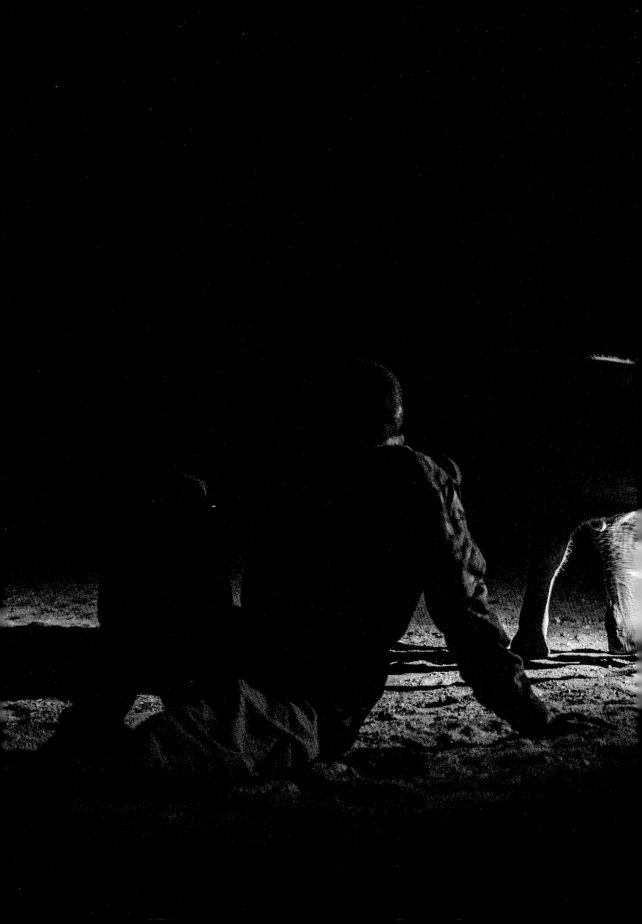

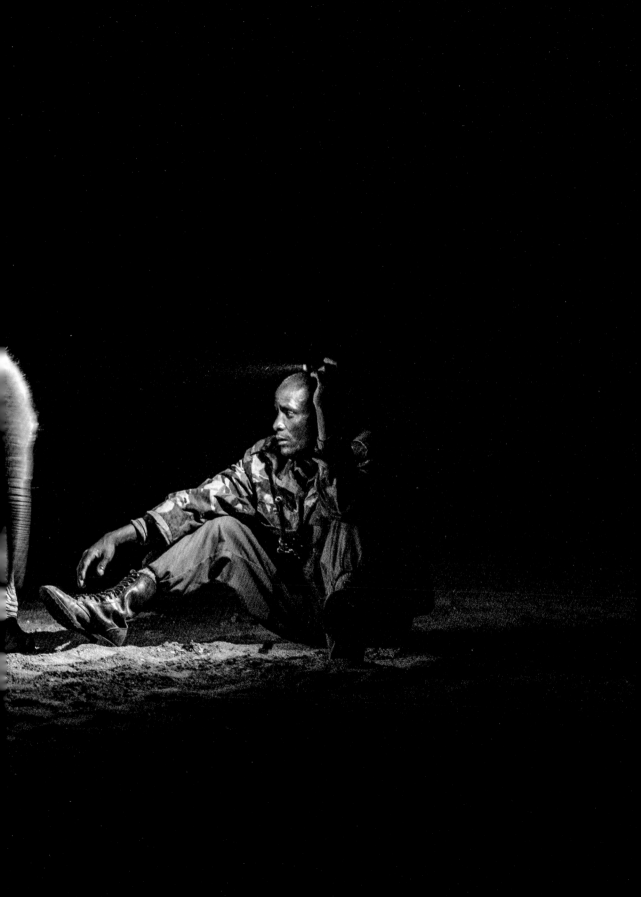

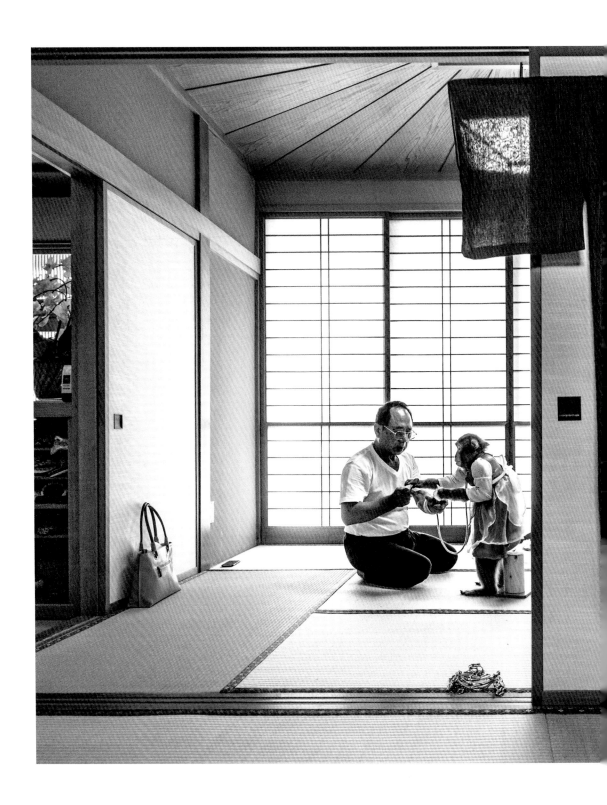

Jasper Doest
The Netherlands /
2nd Prize Nature

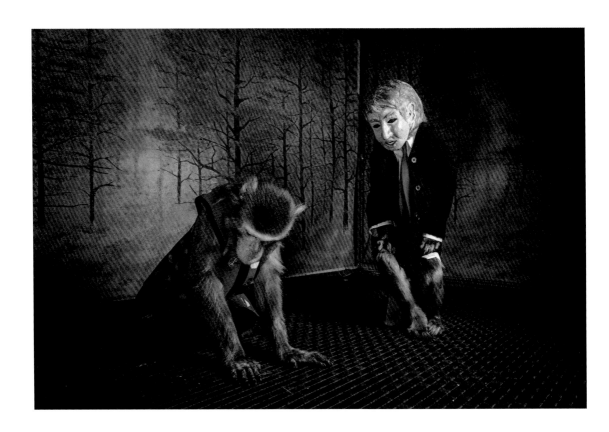

15 January 2016 - 2 October 2017 › In recent years, the Japanese macaque, best known as the snow monkey, has become habituated to humans. As the range of the macaque habitat expands, the animals have lost their fear, have taken to raiding crops, and are often seen as pests. Despite macaques being officially protected in Japan since 1947, some local laws allow them to be tamed and trained for the entertainment industry.

Previous spread: Kaoru Amagai shares his home with three macaques, which he treats as he would children. *Facing page*: Macaques at the Utsunomiya Kayabukia Tavern, north of Tokyo, perform for guests. Portrayals of famous actors and politicians are popular, with the Donald Trump mask being a favorite among visiting tourists. *Above*: Monkey trainer Yayushi performs with Hiroshi at the Nikkō Saru Gundan theater, north of Tokyo. (*continues*)

(*continued*) Once considered sacred mediators between gods and humans, monkeys in Japan also came to be seen as representing dislikable humans, deserving of ridicule. Commercial entertainment involving monkeys has existed in Japan for over 1,000 years.

Right: Mr Amakaki (left) gets ready to babysit Sakura, a macaque owned by his neighbor Mr Amagai.

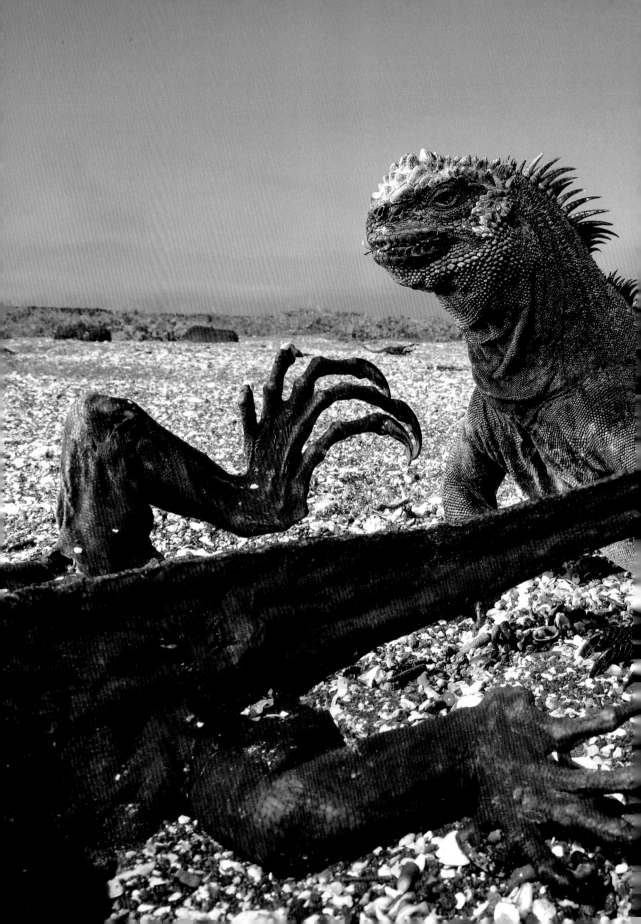

Thomas P. Peschak

Germany, for *National Geographic* /
3rd Prize Nature

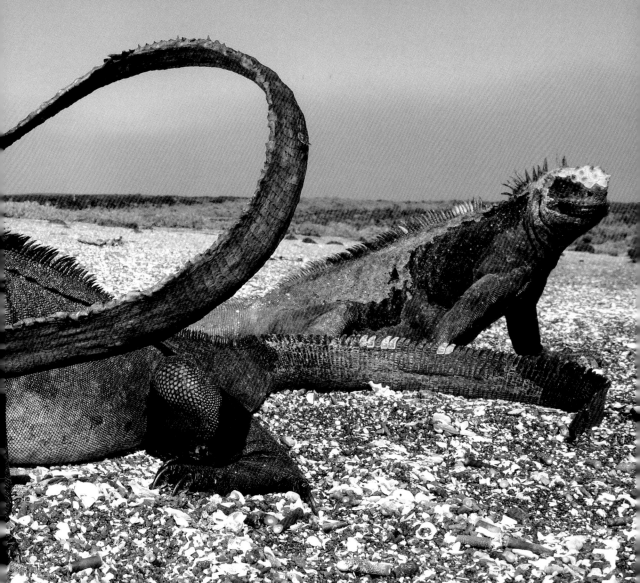

13 April - 22 August 2016 › Four major ocean currents converge along the Galapagos archipelago, creating the conditions for an extraordinary diversity of animal life. The islands are home to at least 7,000 flora and fauna species, of which 97 percent of the reptiles, 80 percent of the land birds, 50 percent of the insects and 30 percent of the plants are endemic. The local ecosystem is highly sensitive to the changes in temperature, rainfall and ocean currents that characterize the climatic events known as El Niño and La Niña. These changes cause marked fluctuations in weather and food availability. Many scientists expect the frequency of El Niño and La Niña to increase as a result of climate change, making the Galapagos a possible early-warning location for its effects.

Previous spread: Marine iguanas, the icons of the Galapagos, feed on marine algae and seaweeds, some of which die rapidly when the ocean warms. *Above*: Sally lightfoot crabs live in an intertidal habitat which could be susceptible to rising sea-levels. *Facing page, top*: A Nazca booby on rat-free Wolf Island, where the birds nest among thickets of cacti. *Below*: Marine iguanas are the world's only lizards that feed in the ocean, grazing on seaweeds. *Following spread*: Tortoises rest partially submerged in pools on a crater floor, near a volcanic fumarole.

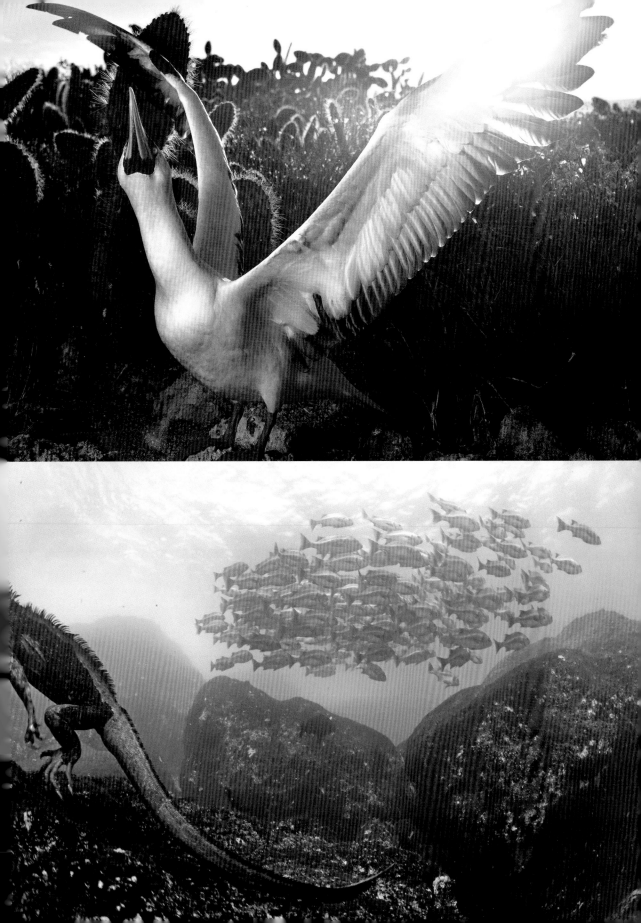

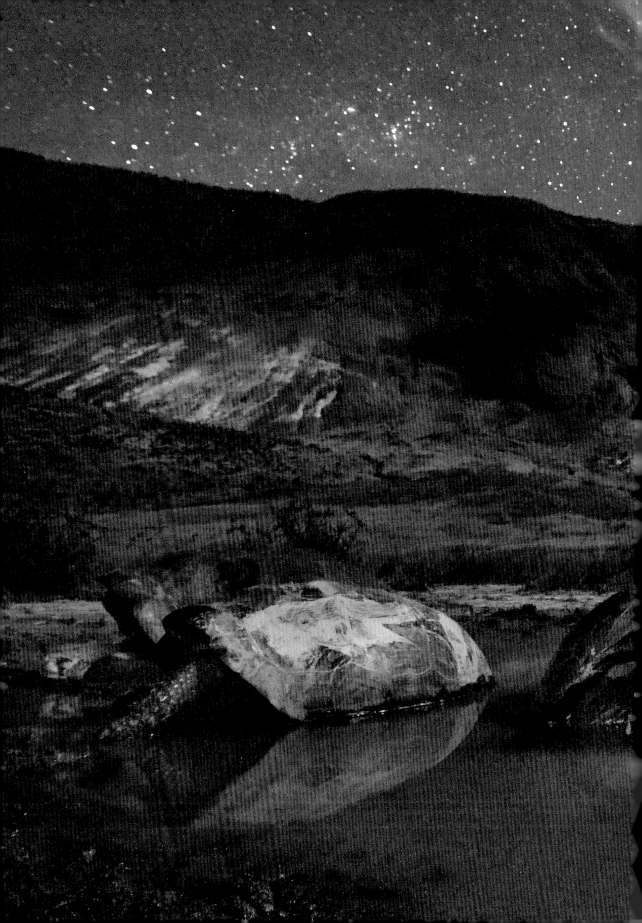

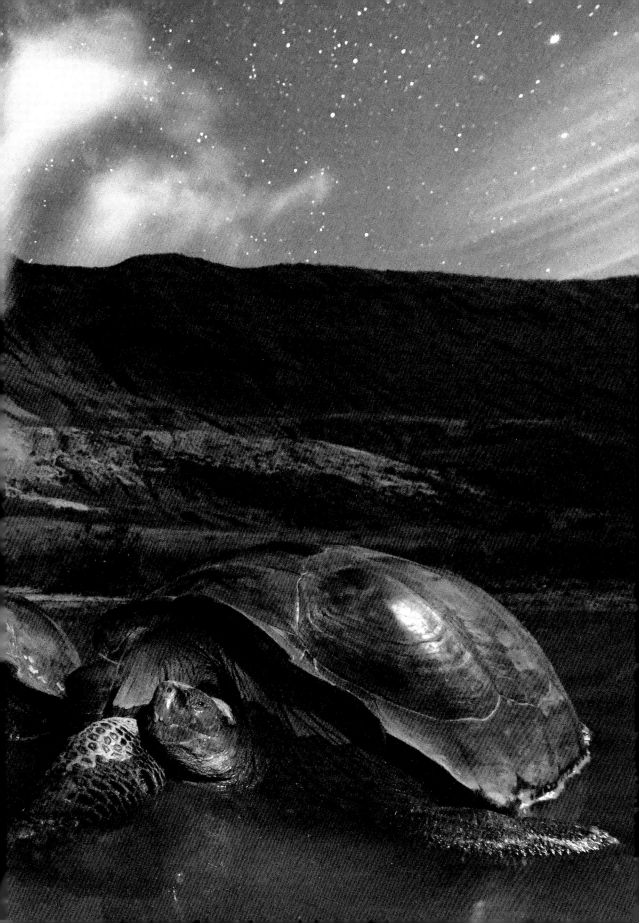

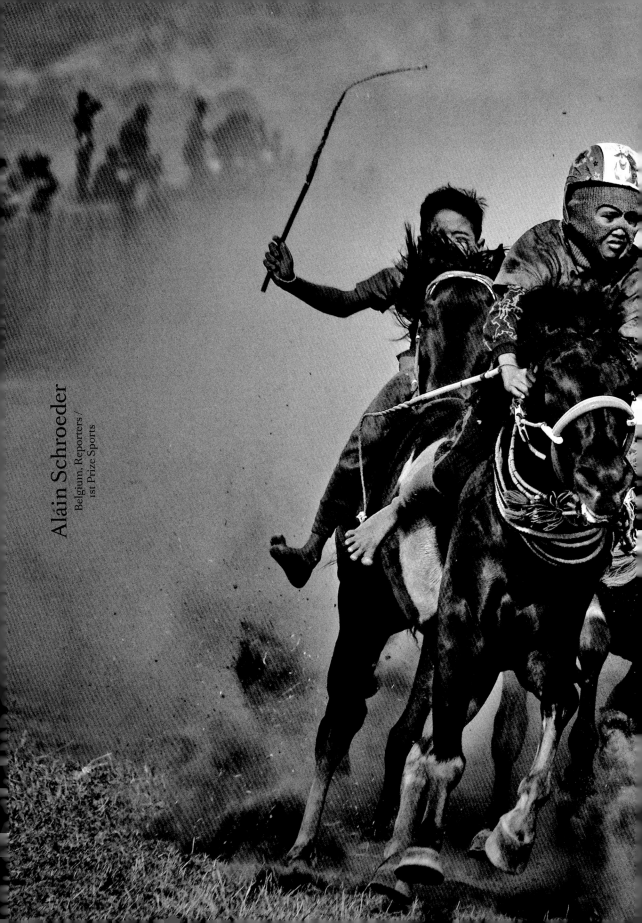

Aláin Schroeder
Belgium, Reporters /
1st Prize Sports

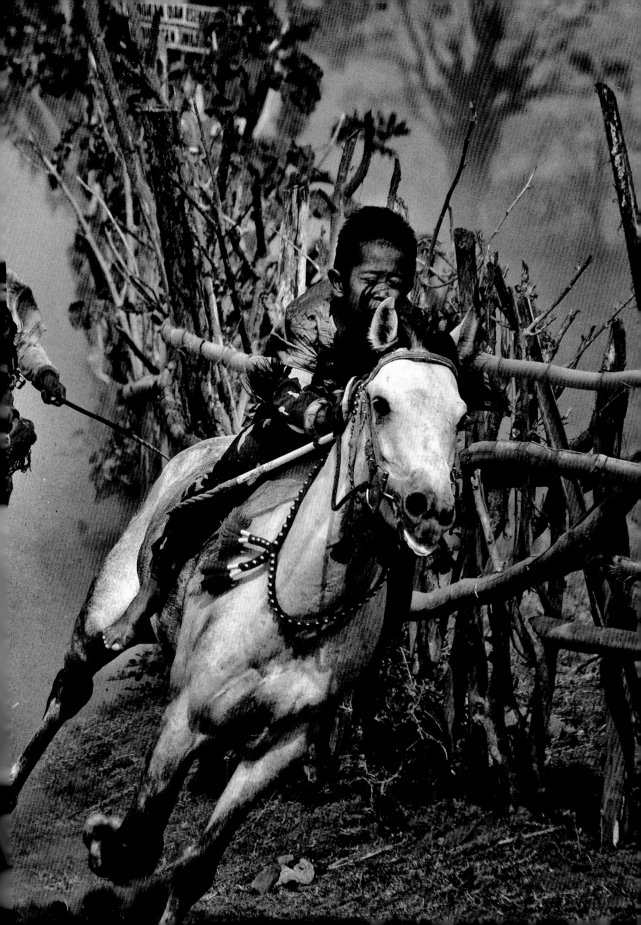

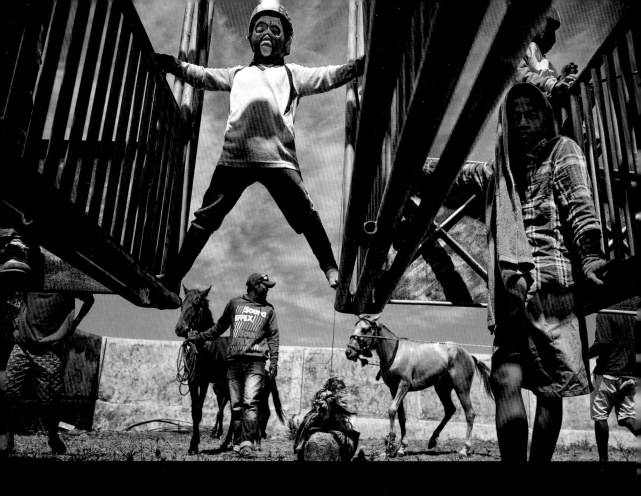

17-25 September 2017 › Child jockeys ride bareback, barefoot and with little protective gear, on small horses, during Maen Jaran horse races, on Sumbawa Island, Indonesia. Maen Jaran is a tradition passed on from generation to generation. Once a pastime to celebrate a good harvest, horse racing was transformed into a spectator sport on Sumbawa by the Dutch in the 20th century, to entertain officials. The boys, aged between five and ten, mount their small steeds five to six times a day, reaching speeds of up to 80 kilometers per hour. Winners receive cash prizes, and participants earn €3.50 to €7 per mount.

Previous spread: One of the many races of the day is underway. *Above*: A jockey straddles the starting gate in anticipation of mounting his horse. *Facing page, top*: A trainer carries a young jockey to the starting gate after he—together with his horse and numbered jersey—have been blessed by a *sandro* (spiritual healer). *Below*: A jockey readies himself for the opening of the gate, as his trainer makes final adjustments. *Next spread*: A horse is taken for a cooling bath after a day of racing.

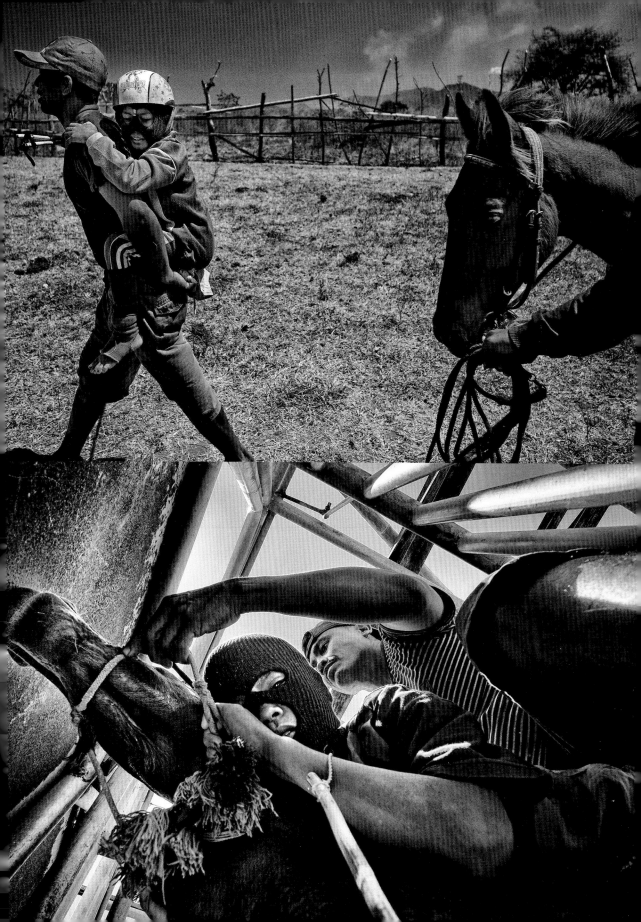

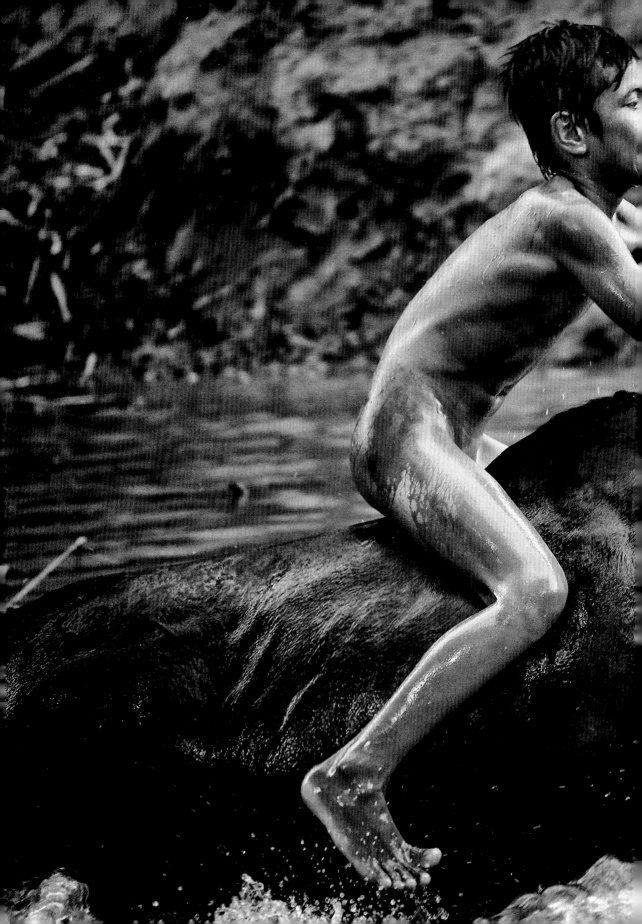

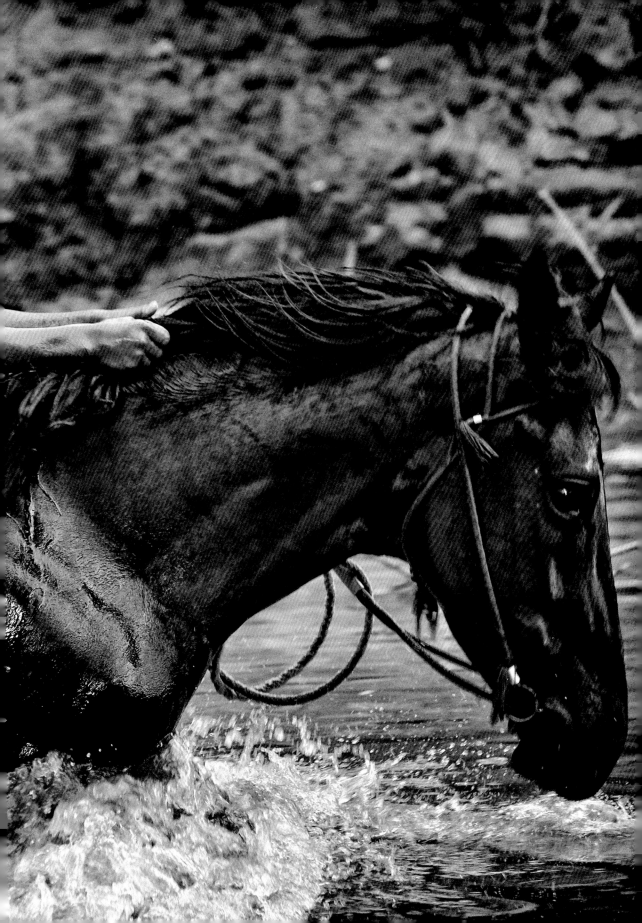

Juan D. Arredondo

Colombia /
2nd Prize Sports

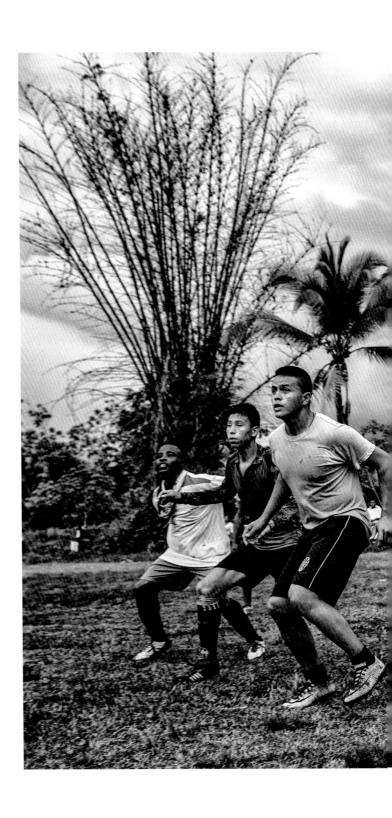

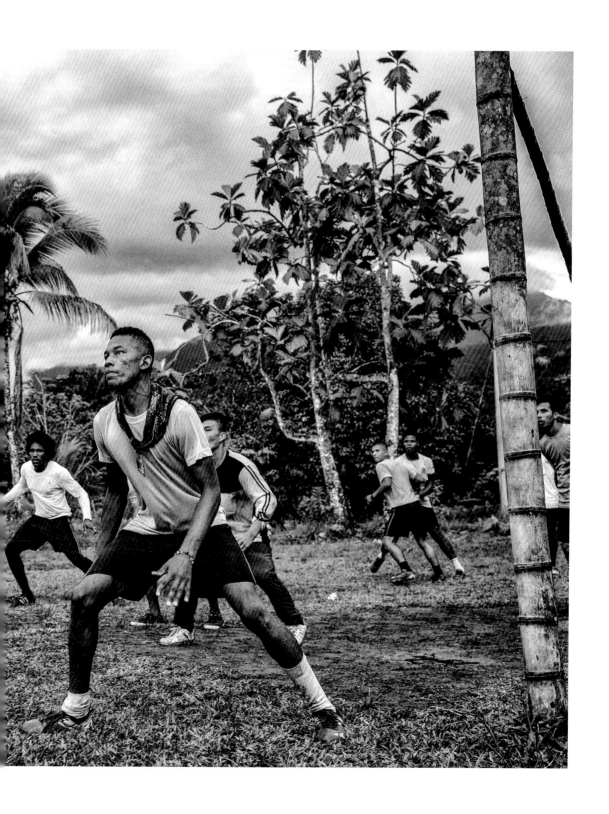

16-25 September 2017 › The Revolutionary Armed Forces of Colombia (FARC), having laid down weapons after more than 50 years of conflict in Colombia, is transforming itself into a new political party and is participating in football matches between teams made up of victims of conflict as well as former rebels. Some 7,000 former FARC guerrillas have moved from jungle camps to 'transitional zones' across the country, to demobilize and begin the return to civilian life. The plan is for the best players from transitional-zone teams to form La Paz FC (Peace FC) football team.

Previous spread: Members of the Colombian army play a friendly match with a FARC team in Vegaez, Antioquia. *Above*: Members of the FARC women's team at La Elvira transitional zone wait for instructions from their coach. *Below*: A FARC women's team (dark shirts) play against a village team from La Esperanza, at La Elvira. *Facing page, top*: Players get ready at Vigía del Fuerte. *Middle*: Players discuss tactics at a friendly match with a local team in the village of Vegaez, Antioquia. *Below*: Members from a nearby village team gather at La Elvira.

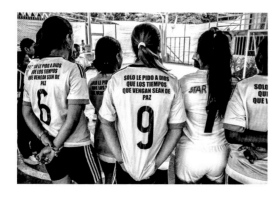

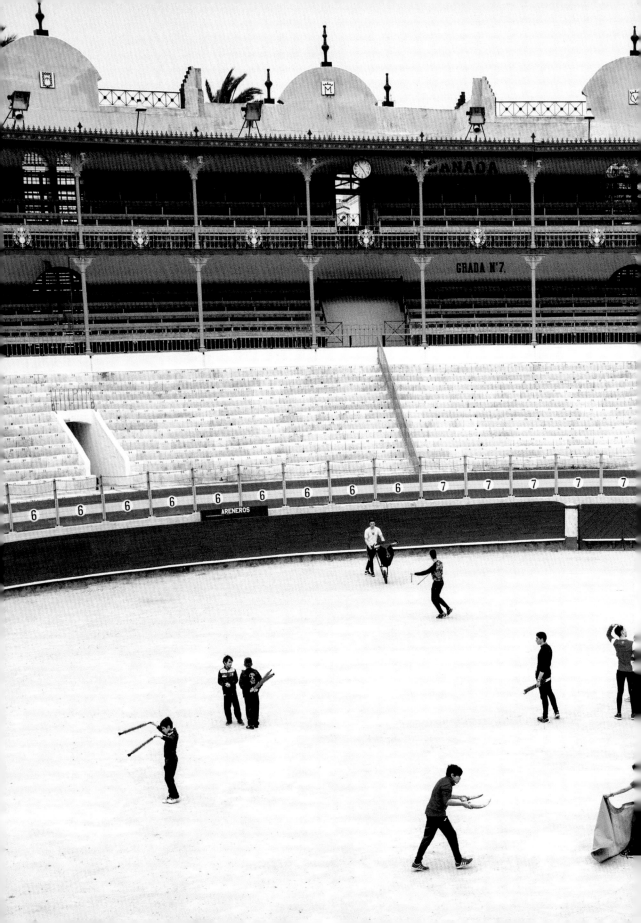

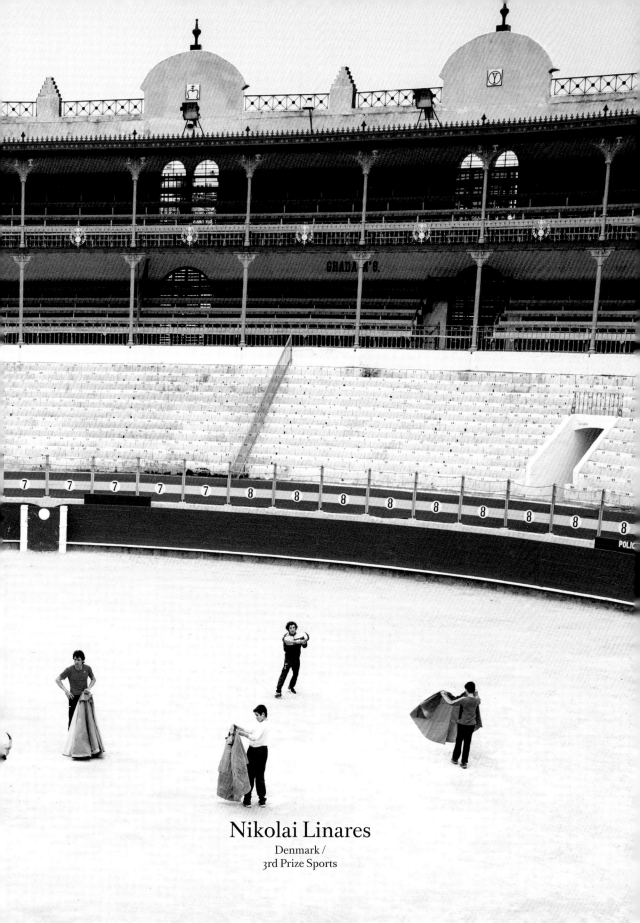

Nikolai Linares
Denmark /
3rd Prize Sports

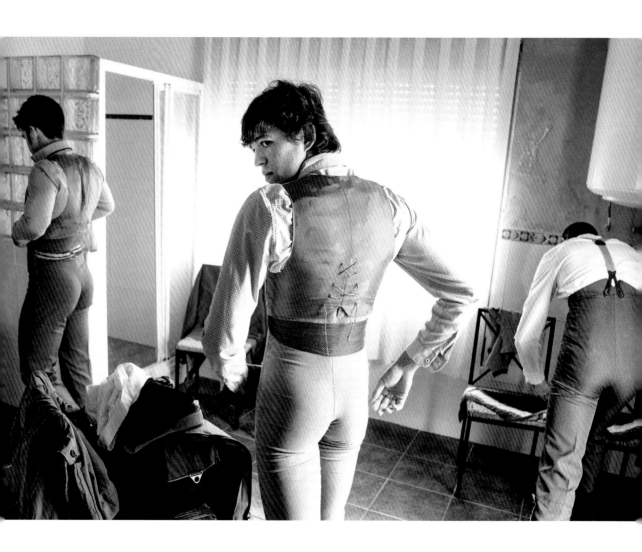

18-22 February 2017 › Bullfighting has long gener-
ated controversy and is declining in popularity,
even in Spain, yet across the country boys still
dream of stardom in the arena, and attend bull-
fighting schools to learn the requisite skills. At the
Escuela Taurina Almería, a bullfighting school in
Almería, Spain, boys aged 10 to 16 practice three
times a week. The minimum age that boys may
participate in a proper *corrida*, with a live bull, is 16.

Previous spread: A new generation of bullfighters
practice at the bullring in Almería. *Above*: Three
16-year-olds get ready to train with real bulls at
a bull ranch. *Facing page*: Quique, Danni and Emilio,
all 12, wear the outfits traditional for young trainee
bullfighters. *Next spread*: Two boys from the
bullfighting school practice on the street at night.

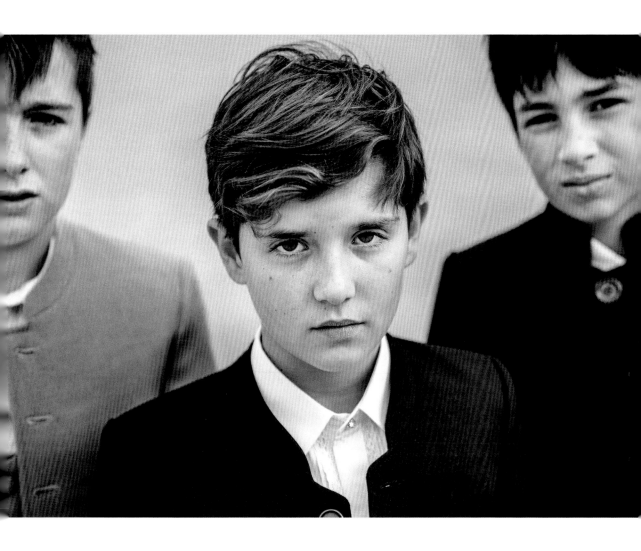

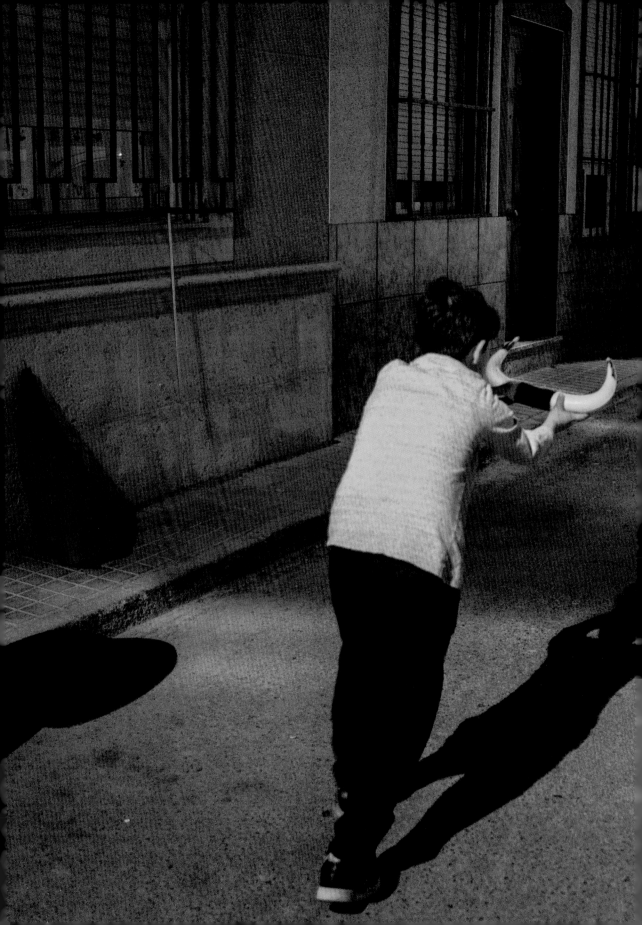

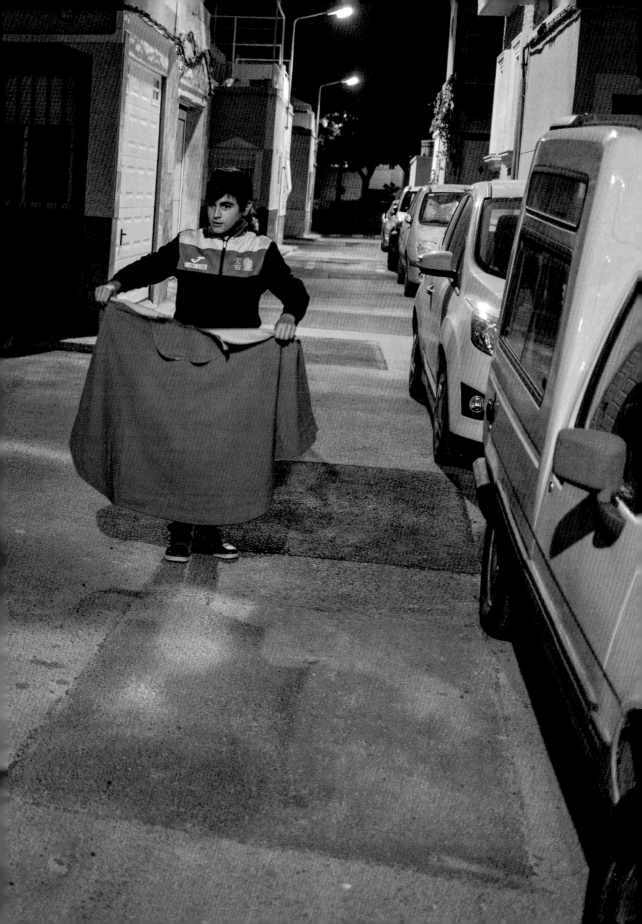

The 2018
Long-Term Projects

Carla Kogelman

The Netherlands /
1st Prize

I am Waldviertel

19 July 2012 - 29 August 2017 › Hannah and Alena are two sisters who live in Merkenbrechts, a bioenergy village of around 170 inhabitants in Waldviertel, an isolated rural area of Austria, near the Czech border. The girls have two older brothers, but spend much of their time together in a carefree life, swimming, playing outdoors and engrossed in games around the house. A bioenergy village is one which produces most of its own energy needs from local biomass and other renewable sources.

 The photographer has been photographing Hannah and Alena since 2012. She visits them for a few weeks, usually at summertime, every year, watching them growing up and spending time together.

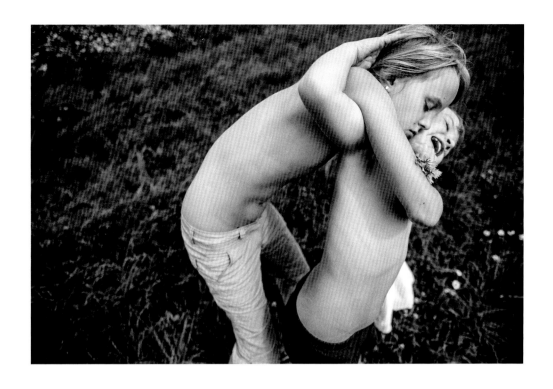

Above: Alena and Hannah, in 2012. *Below*: Hannah tries to watch TV.
Next spread: Hannah, and Sonja's navel.

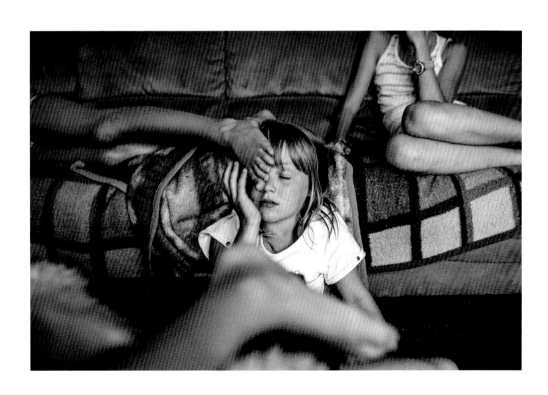

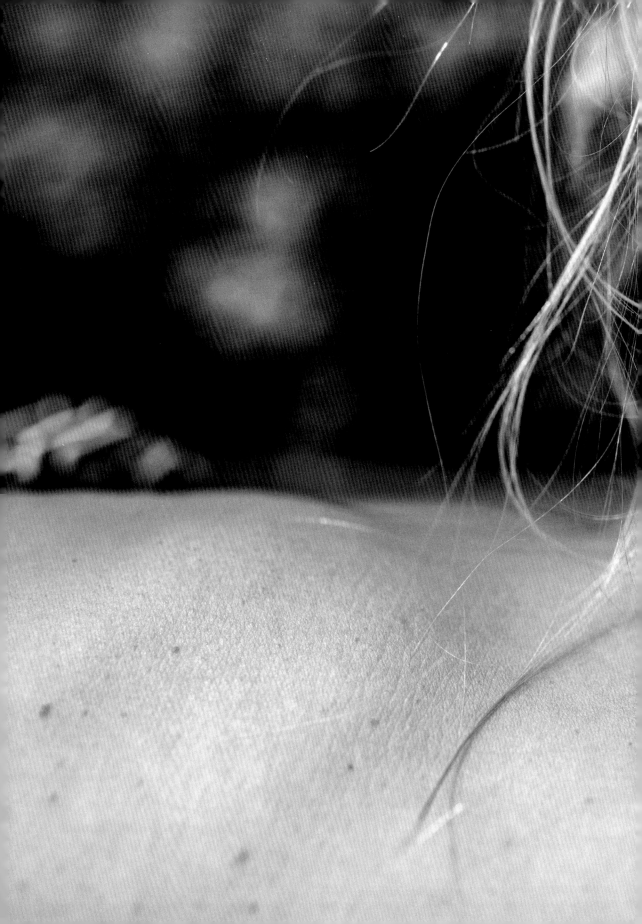

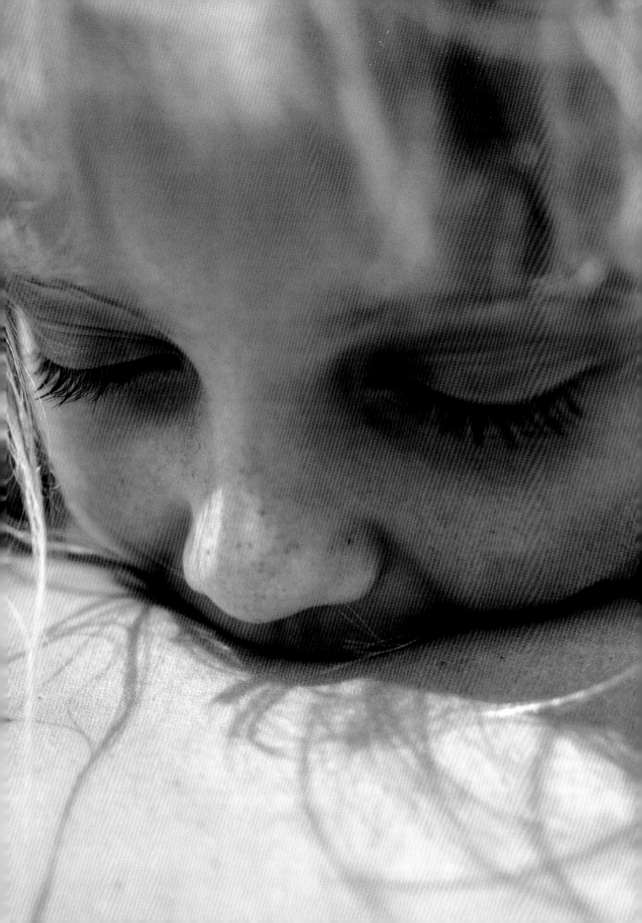

Above: Hannah, in 2014. *Below*: Alena and Steffi play in the sand. *Facing page*: Hannah with Pipsi, a bird found in a nearby field. Although the girls cared for Pipsi tenderly, he died that summer and was given a lovely funeral. *Next spread*: Martin and Christian (brothers who spend their summer holidays in Waldviertel) watch Alena in one of the barns.

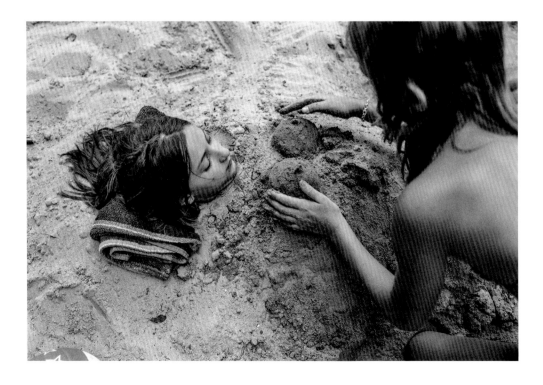

Two spreads back: Hannah having a bath. *Previous spread*: Hannah and Dominik play in the fields, in 2016. *Above*: Hannah and a friend, Ivana. *Below*: Alena and Ivana. *Facing page*: Hannah and Alena in 2017. *Following spread*: Hannah and Alena watch TV with Anna and Isabel, two friends.

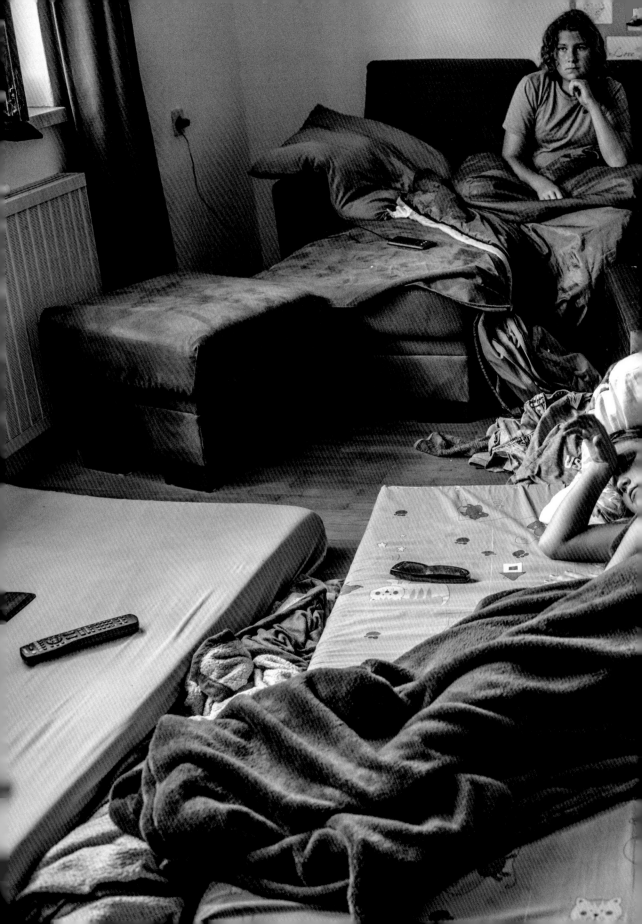

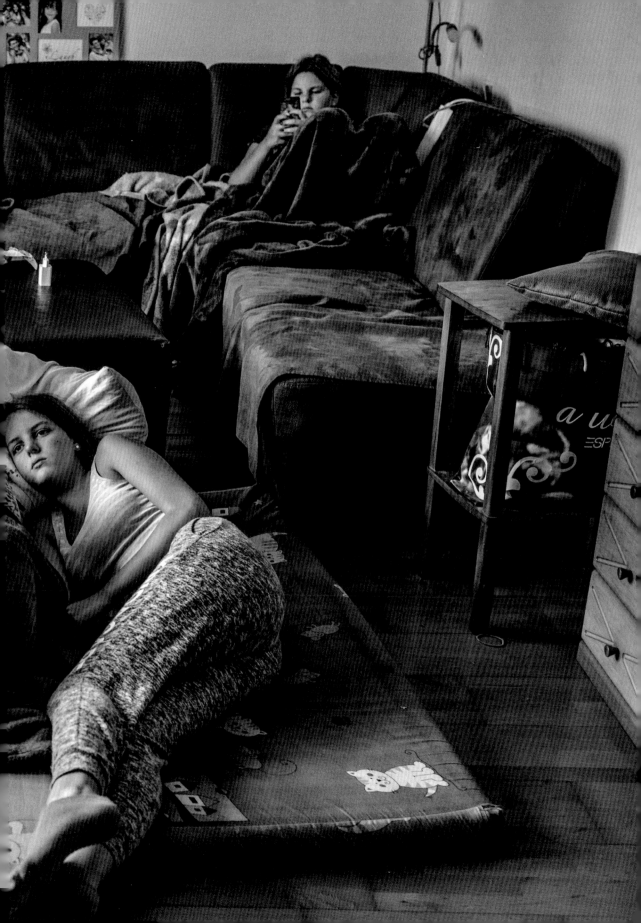

Fausto Podavini

Italy /
2nd Prize

Omo Change

24 July 2011 - 24 November 2017 › Ethiopia is in the midst of an economic boom, with growth averaging 10.5 percent a year—double the regional average. One of the areas most impacted by this is the Omo Valley, an area of extraordinary biodiversity along the course of the Omo River, which rises in the central Shewan highlands and empties into Lake Turkana, on the border with Kenya. Some 200,000 people of eight different ethnicities live in the Omo Valley, with another 300,000 around Lake Turkana in Kenya. Many are reliant on the river for their food security: on fish in the river and lake, and on crops and pastures grown in the fertile soil deposited by annual natural floods.

Gibe III Dam—at 243 meters the tallest in Africa, and generating some 1,800 MW of hydroelectric power—was built with a dual aim: to provide energy for the booming economy and for export, and to deliver an irrigation complex for high-value agricultural development. It was also said that the dam would become a tourist attraction, of socio-economic benefit. Both Ethiopian and Kenyan governments support the dam and have disputed claims of a negative environmental impact, but critics point to such adverse effects as the cessation of natural floods, diminishing biodiversity, falling water levels in Lake Turkana, and the displacement of traditional peoples who have lived for centuries in delicate balance with the environment.

The photographer visited the Omo Valley during the final years of the dam's construction, with the aim of producing a meditation on how important investments can nonetheless put the human-environment balance at risk, and on how the changes brought about by the presence of such large amounts of money disrupt existing equilibrium.

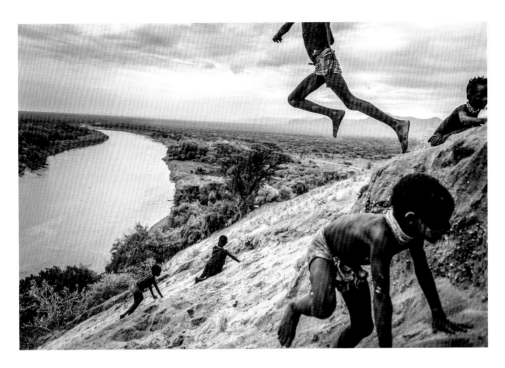

Indigenous Karo children play in the sand on the banks of the Omo River. The Karo people are entirely dependent on the river for food: both for fish and crops grown in fertile flood soil. The forest seen in the background was cleared to make way for commercial cotton plantations.

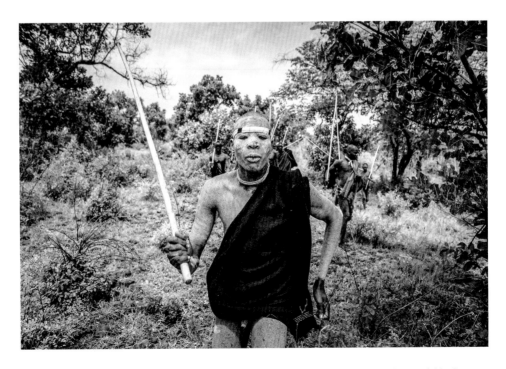

A man from the Mursi ethnic group prepares for a traditional stick-fighting contest against a neighboring village. For the past two decades the Mursi have been singled out for visits by tour companies. The Mursi surround tourist vehicles, are photographed, and ask for money. *Following spread*: The Gibe III Dam.

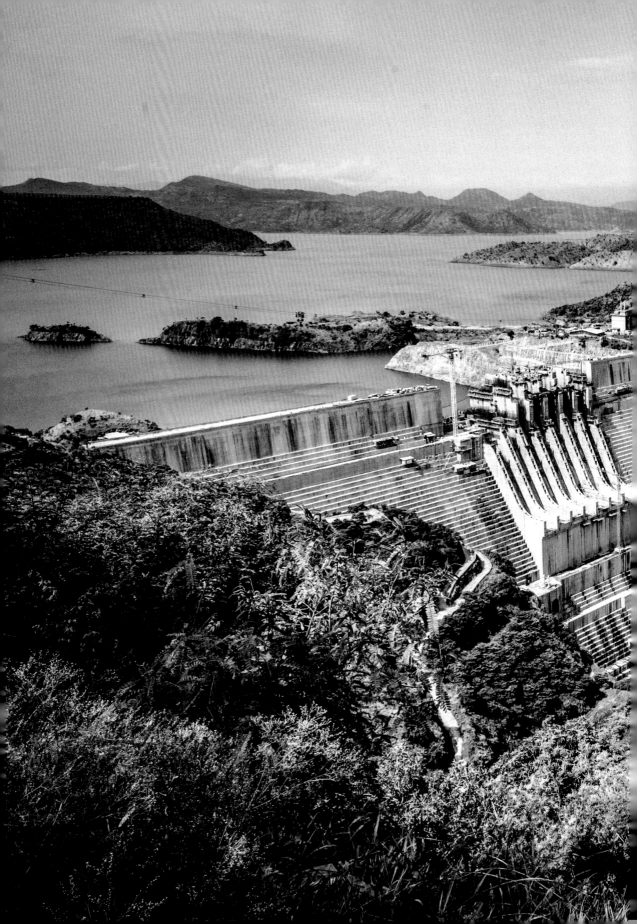

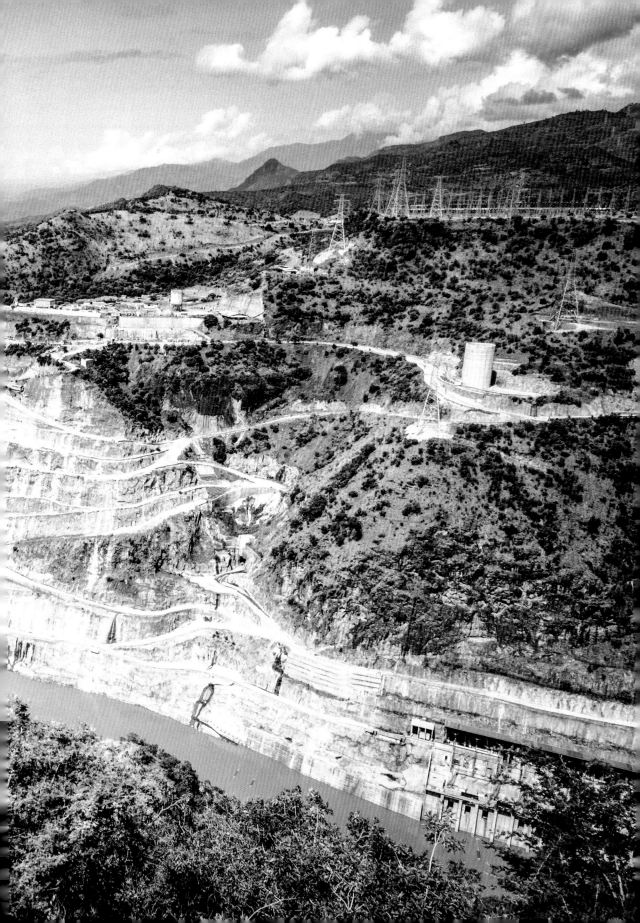

Pipes suck water from the Omo to irrigate cotton plantations. Exposed tree roots indicate the extent of the drop in water levels.

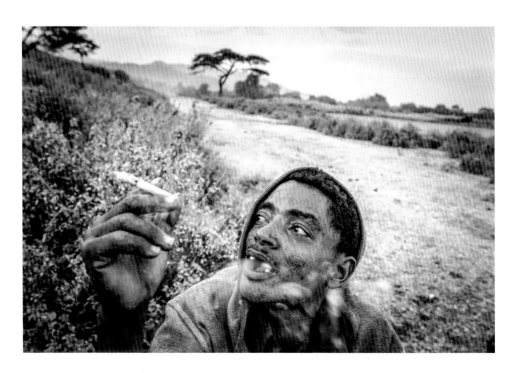

A member of the Konso ethnic group smokes beside the road to Arba Minch, the chief transit city for tourists visiting the Omo Valley. The development of the area and of Arba Minch has not yet brought substantial benefit to the local population.

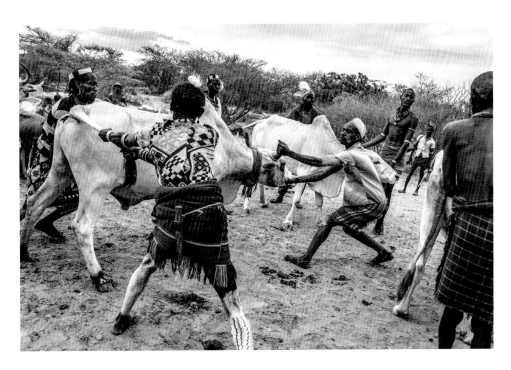

Hamar men drive their cattle to pasture near the town of Turmi. Some Hamar boundaries have been redrawn and their land cleared for sugar cane.

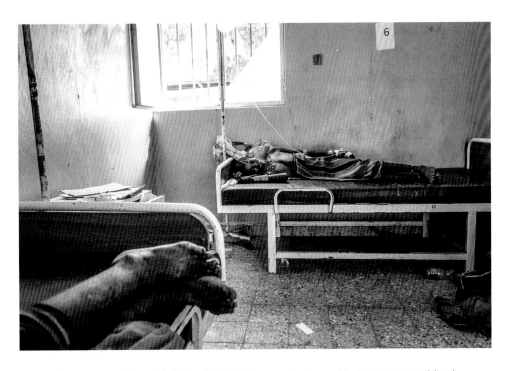

Hamar women with malaria lie in a clinic in the town of Turmi. The Ethiopian government claimed that Gibe III would help reduce incidence of malaria by regulating water flow, but local data do not back this up. *Following spread*: The Omo River Delta, where the river feeds into Lake Turkana.

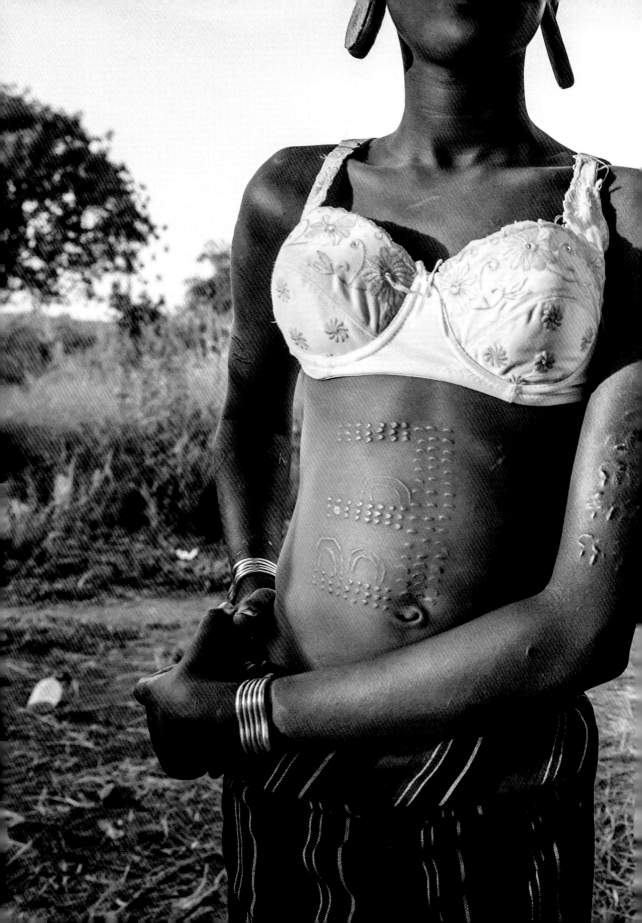

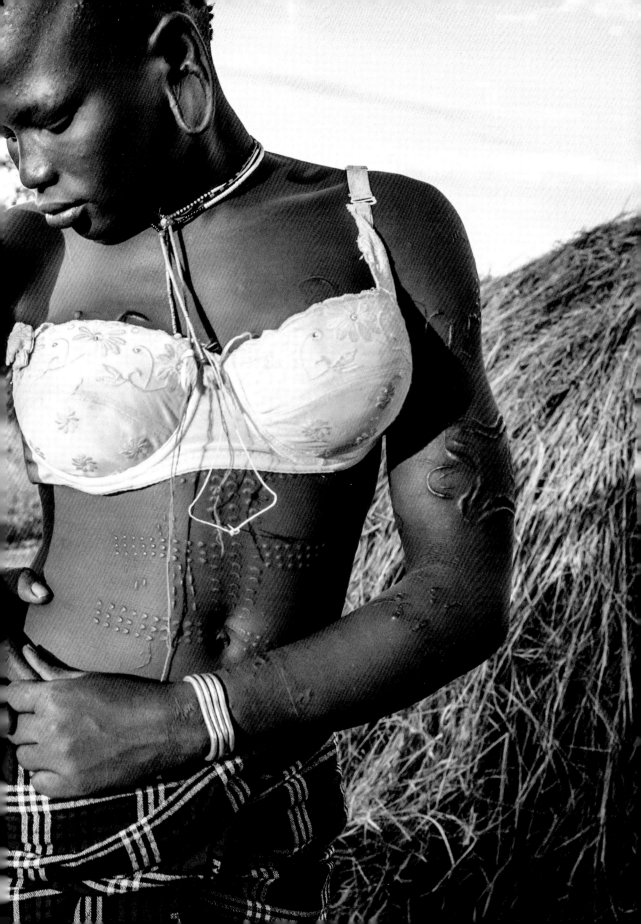

Previous spread: Mursi women, wearing bras given them by tourists, return to their village after fetching well water. *Above*: Bales of dried fish in a market in Kalokol, on the shores of Lake Turkana. Market owners complain of a 30 percent fall in business in recent years as a result of shrinkage of the lake.

Pastoral Dassanech people drive a herd across the main road to the Kenyan border. A report released by The Oakland Institute in California points to the devastating effect of Gibe III on pastoral communities whose lands are dependent on the nutrients brought by seasonal flooding.

Dassanech children look on as a road passing just a few hundred meters from their village is asphalted. The road network in the Omo Valley was largely financed by Chinese investment, as was the dam.

Construction workers chew *khat*—a natural drug with euphoric effects—at the end of a working day. *Following spread*: Nyangatom men bathe in the Omo near a bridge that will link their territory to that of the Karo.

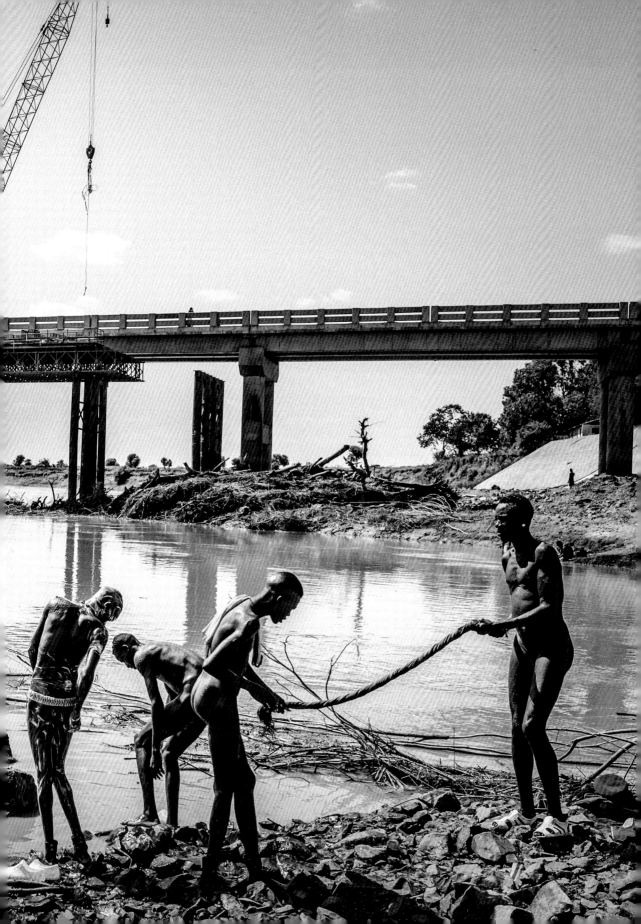

Javier Arcenillas

Spain, Luz /
3rd Prize

Latidoamerica

5 August 2010 - 12 August 2017 › After years of experiencing social chaos, drugs trafficking and political corruption, many Latin Americans are determined to resist the violence afflicting their homelands. Armed conflict and socio-economic collapse in a number of Latin American countries in the latter part of the 20th century forcibly displaced hundreds of thousands of people, both to neighboring states and northwards to the US. Stricter US policies in the mid-1990s led to the deportation of members of *maras*, Hispanic gangs formed on the streets of cities such as Los Angeles, and fueled gang warfare across Latin America. This, and violence associated with both the drugs trade and the so-called War on Drugs, has led to a number of Latin American cities ranking with the most violent in the world outside of a conflict zone.

This project describes the fear, anger and impotence of victims amidst the daily terror of street gangs, murder and thievery in Honduras, El Salvador, Guatemala and Colombia. The photographer wanted to document the heart of uncontrolled violence in Latin America, and the social and political factors that aggressively reinforce that violence, as well as the determination to end it.

Facing page, top and below: The crime scene in the upscale Zona Viva hotel and nightlife district i Guatemala City, Guatemala, after 31-year-old Karina Marlene had been gunned down by six shot fired from a taxi. *Following spread*: People cry out after a street shooting in a neighborhood of Sa Pedro Sula, Honduras.

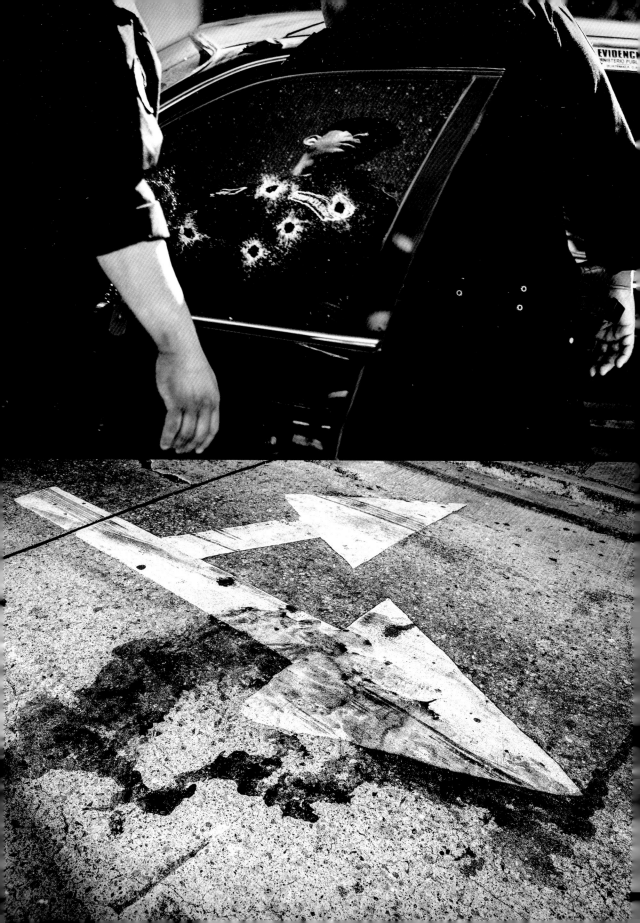

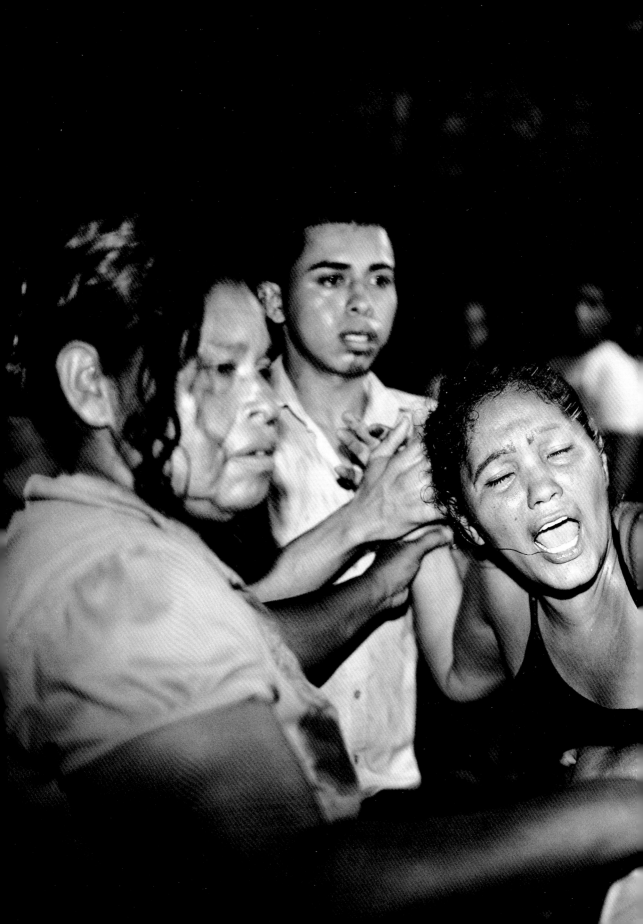

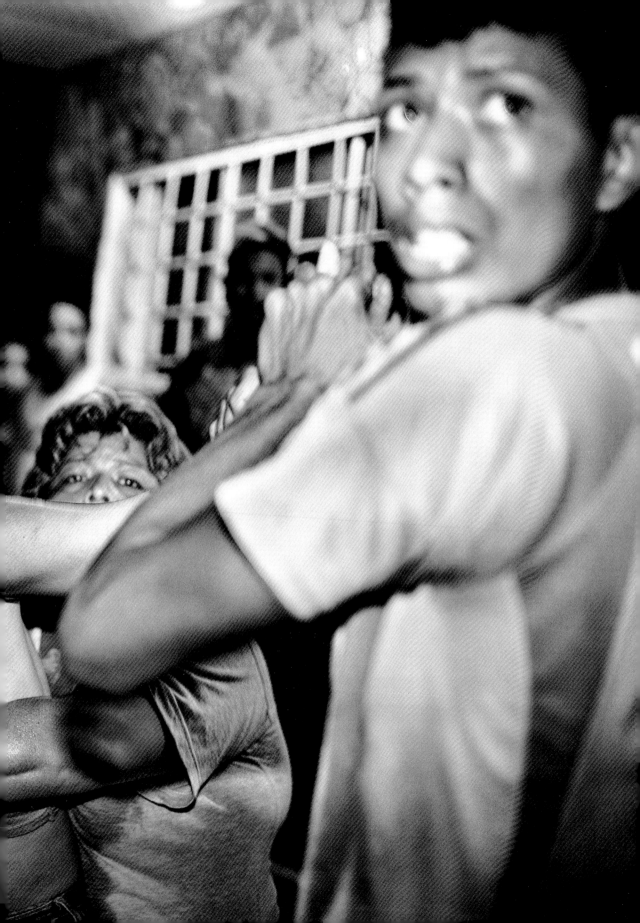

ious spread: A member of a street gang arrives at a pre-trial detention center in Usulután,
lvador. Facing page, top: A hawker sells prints by Colombian artist Fernando Botero, in the
a Botero, Medellín, Colombia. *Below*: A member of a *mara*, in San Pedro Sula, Honduras.
page, top: Victor Alvarado, pictured after a knife attack and robbery in San Pedro Sula.
w: A street in the Barrio de la Milagrosa, Medellín.

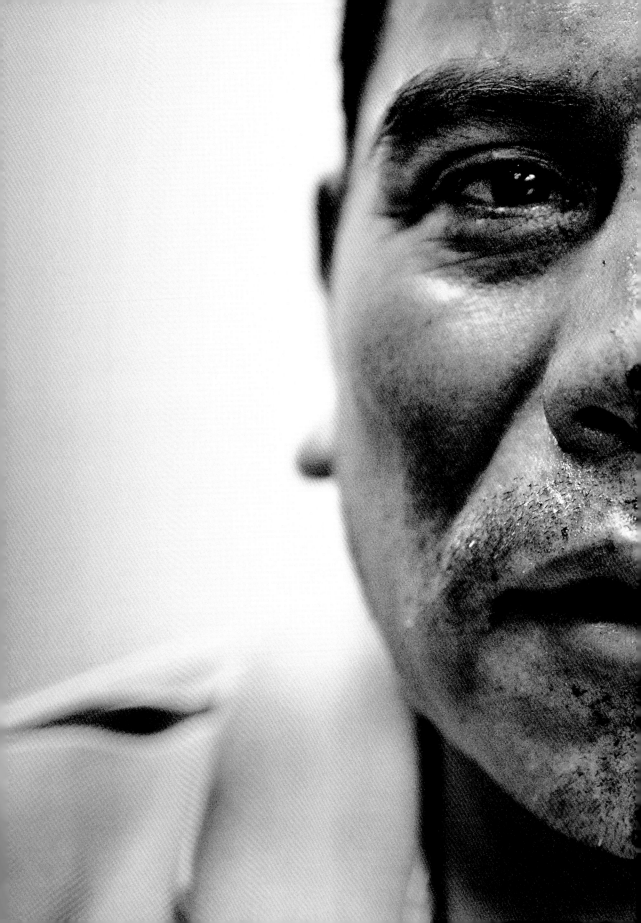

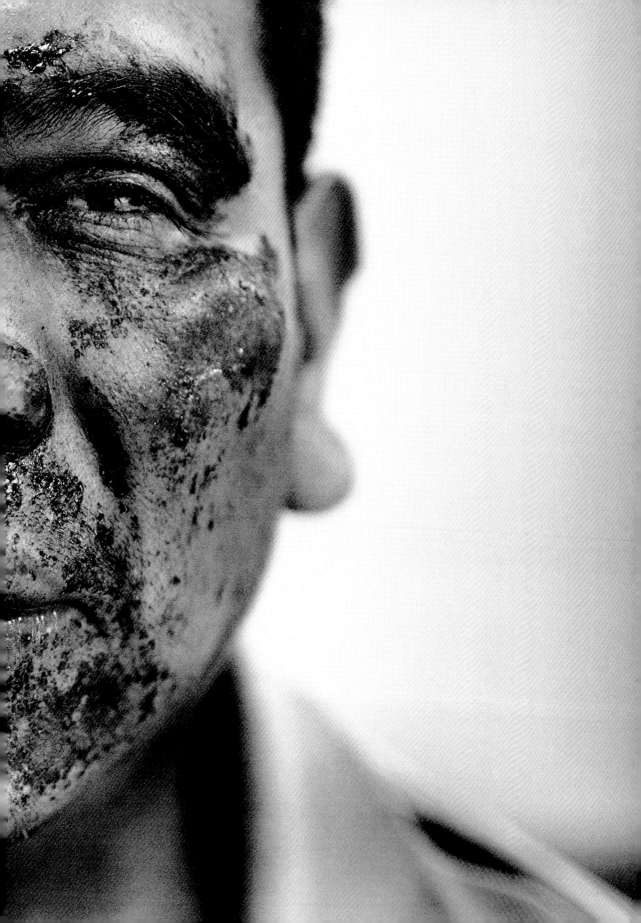

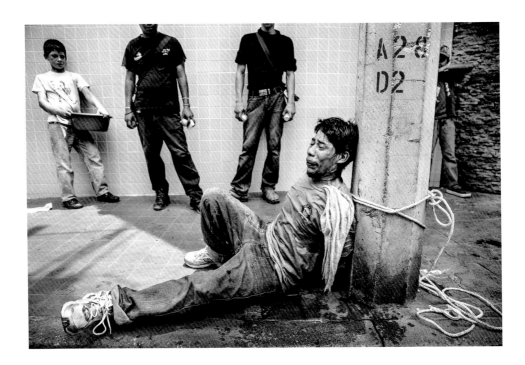

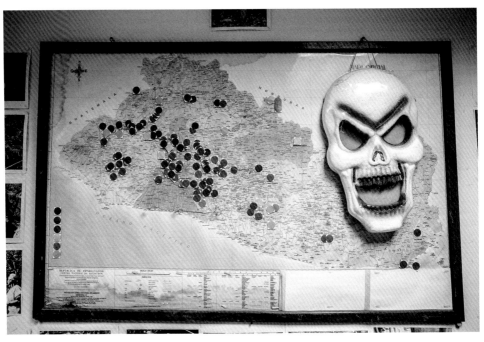

Previous spread: A man who betrayed accomplices to the police, portrayed after apparently having received a heavy beating. *This page, top*: An alleged thief, tied up in a street in San Pedro Sula, Honduras. He later died of a drug overdose. *Below*: A map on the wall of Israel Ticas, El Salvador's only forensic archaeologist. *Facing page, top*: Juveniles under detention for possession of marijuana in Tegucigalpa, Honduras. *Below*: A street in Zone 7, one of the most dangerous neighborhoods in Guatemala City. *Following spread*: Street graffito commemorating a girl abused by a pedophile priest, on the Boulevard de los Héroes, San Salvador, El Salvador.

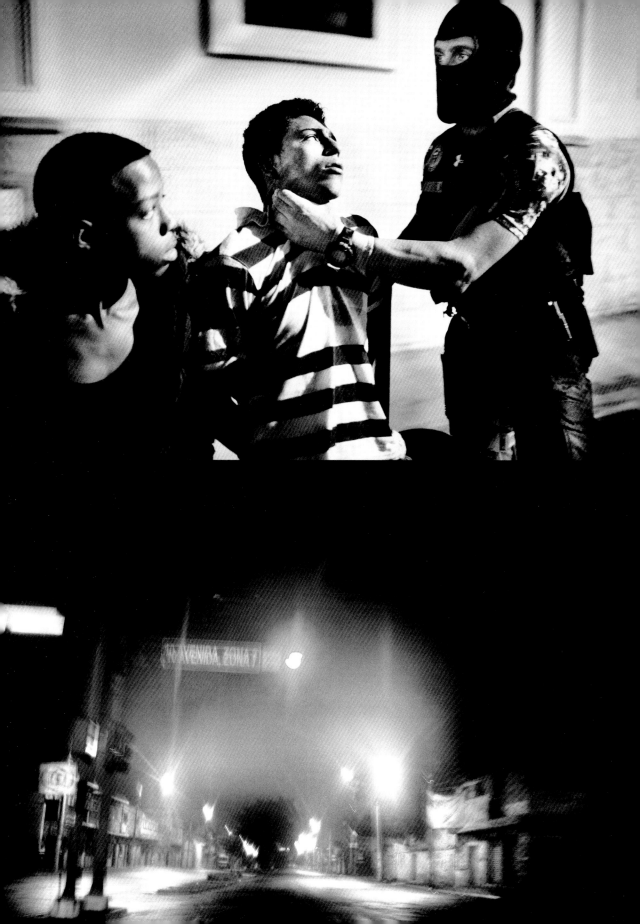

The 2018 Jury

Chair: Magdalena Herrera, France, director of photography *Geo* France
Zohra Bensemra, Algeria, chief photographer NW Africa Reuters
Thomas Borberg, Denmark, photo-editor-in-chief *Politiken*
Marcelo Brodsky, Argentina/Spain, visual artist
Simon Bruty, UK, photographer
Joana Choumali, Ivory Coast, photographer
Jérôme Huffer, France, head of photo department *Paris Match*
Britta Jaschinski, Germany, photographer and co-founder Photographers Against Wildlife Crime
Whitney C. Johnson, USA, deputy director of photography National Geographic
Jon Jones, UK, independent photography editor and curator
Bulent Kiliç, Turkey, chief photographer Turkey Agence France-Presse
Alice Martins, Brazil, photojournalist
Wong Maye-E, Singapore, photojournalist
Eman Mohammed, Palestine, photojournalist
Carla van de Puttelaar, the Netherlands, photographer and art historian
Laurence Tan, Singapore, assignment editor Getty Images
Tony Wu, USA, photo-naturalist

Secretaries:
David Griffin, USA, owner DGriffinStudio
Silvia Omedes, Spain, independent curator/director Photographic Social Vision Foundation

Participants

2018, 4,548 photographers from 125 countries
omitted 73,044 images in the photo contest.
e participants are listed here according to
ionality, as filled in by them in the entry
istration system.

ghanistan
dayatullah Amid / Barat Ali Batoor /
hammad Ismail / Wakil Kohsar / Omar
ohani / Shah Habib Zada

ania
gelos Barai / Blerta Kambo

eria
lane Bestaoui / Ferhat Bouda

gentina
rigo Abd / Martin Acosta / Lujan Agusti /
mberto Lucas Alascio / Pittaro Angel /
undo Arrizabalaga / Walter Astrada / Diego
bel / Carlos Barria / Nicolás Carvalho Ochoa /
andro Catani / Gustavo Cherro / Ignacio Colo /
rio De Fina / Fernando de la Orden / Adrian
tias Escandar / Augusto Famulari / Emmanuel
nandez / Juan Manuel Foglia / Oscar Fridman /
sastian Gil Miranda / Ileana Andrea Gómez /
gio Gabriel Goya / Daniel Jayo / Alejandro
chuk / Andres Kudacki / Micou Luis /
ximiliano Carlos Luna / Esteban MacAllister /
m Medina / Lucía Laura Merle / Emiliana
uelez / Hernán Nersesian / Hugo Passarello
a / Pablo Ernesto Piovano / Natacha
arenko / Constanza Portnoy / Héctor
andro Rio / Jerónimo Rivero / Joaquín
guero / Andrés Emilio Salinero / Romina Ines
tarelli / Mario Raul Sayes / Cristian
tellaro / Eduardo Soteras / José Ariel Subirá /
n Manuel Tesone / Hernan Zenteno

enia
ik Armenakyan / Anush Babajanyan / Eric
orian / Yulia Grigoryants / Davit Hakobyan /
hit Hayrapetyan / Davit Nersisyan

tralia
m Baidawi / Jorge Bechara / Darian Daniel
ehulak / Justin Brierty / Patrick Brown /
gie Burin / Robert Carew / Rémi Chauvin /
Clayton / Brett Costello / Michael Coyne /
Currie / Sam Edmonds / Alex Ellinghausen /
dan Esposito / Adam Ferguson / Andrea
colini / Kate Geraghty / Ashley Gilbertson /
g Golding / Philip Gostelow / Carla Gottgens /
d Gray / Toni Greaves / Mathias Heng / Phil
ard / Ian Alfred Hitchcock / Heath Holden /
stopher Hopkins / Dave Kan / Rohan Kelly /
n Knott / Mark Ian Kolbe / Dean Lewins /
ia Liber / Glenn Lockitch / Ted McDonnell /
s McGrath / Justin McManus / Andrew
ry / Palani Mohan / Nicholas Moir / Angus
dant / Fiona Morris / Dean Mouhtaropoulos /
an Muir / David Dare Parker / Martine
et / Ryan Pierse / Jenny Pollard / Adam
ty / Andrew Quilty / Mark Ralston / Asanka
ayake / Victoria Reid / Warren James
ardson / Quinn Rooney / Dean Sewell /
xo Sommer / Cameron Spencer / Adrian
n / David Tacon / Darrian Traynor / Aidan
ie Williams / Lisa Maree Williams / Tracie
ams / Toby Zerna

Austria
Heimo Aga / Milad Alaei / Heinz-Peter Bader /
Joachim Bergauer / Christian Bruna / Helmut
Graf / Hans Hochstöger / Christoph Kellner /
Gregor Kuntscher / Miroslav Kuzmanovic /
Christoph Lingg / Josef Polleross / Florian
Rainer / Marc Stickler / Heinz Stephan Tesarek /
Aram Voves / Christian Walgram / Michael
Winkelmann / Martin Zinggl

Azerbaijan
Majid Aliyev

Bangladesh
Abir Abdullah / Md. Maruf Hasan Abhi / Rabbi Al
Mubin Adit / Kaisar Ahamed / Parvez Ahmad /
Salahuddin Ahmed / Yusuf Ahmed / Monirul
Alam / S H M Mushfiqul Alam / Shahidul Alam /
Shafayet Hossain Apollo / K. M. Asad / Zakir
Hossain Chowdhury Auniket / Khandaker Azizur
Rahman / Rasel Chowdhury / Turjoy Chowdhury /
Suvra Das / Faiham Ebna Sharif / Ismail
Ferdous / Indrajit Kumer Ghosh / Abu Ala Hasan /
Enamul Hasan / Mohammad Rakibul Hasan /
Mohammad Ponir Hossain / Mohammad Nazrul
Islam Chowdhury / Fahad Kaizer / Zahidul Karim /
Md Rafayat Haque Khan / Md Shahnewaz Khan /
Md Zakirul Mazed Konok / Alamin Leon /
Mamunur Rashid Mamun / Siraj Md.Shahjahan /
Rahat Musaddek Ahmed / Khan Naymuzzaman /
Alam Noor / Suman Paul / Tapash Paul / Rohat
Ali Rajib / Sony Ramany / Probal Rashid / Kazi
Riasat Alve / MD Tanveer Hassan Rohan / Azim
Khan Ronnie / Jashim Salam / Md. Abdus
Salam / Naman Protick Sarker / Shakawat
Hossen Shakil / Shariful Islam Sharif / Md
Masfiqur Akhtar Sohan / Reaz Ahmed Sumon /
Rahul Talukder / Ashraful Alam Tito / M Yousuf
Tushar / A K M Shehab Uddin / MD. Hadi Uddin /
Munir Uz Zuman / A.N.M Zia / Mohammad
Hasan Zobayer

Belarus
Sergey Balay / Anton Dotsenko / Sergei Gapon /
Alexandr Kandybo / Dmitrij Leltschuk / Oksana
Manchuk / Pavel Martsinchyk / Eugene
Reshetov / Andrei Shauliuha / Leonid Shchahlou /
Tatsiana Tkachova / Aliaksandr Vasiukovich /
Oksana Veniaminova / Ivan Yaryvanovich

Belgium
Claire Allard / Pauline Beugnies / Frederik
Buyckx / Michael Chia / Marleen Daniels /
Patrick De Roo / Peter de Voecht / Marika Dee /
Colin Delfosse / Alexander Dumarey / Karoly
Effenberger / Thomas Freteur / Maxime
Gyselinck / Nick Hannes / Yorick Jansens /
Roger Henkens / Gaëlle Job / Bart Lenoir /
Maxime Matthys / Virginie Nguyen Hoang /
Vincent Peal / Léonard Pongo / Alain Schroeder /
Gaël Turine / Liza Van der Stock / Katrijn van
Giel / Sébastien Van Malleghem / Kristof Van
Meirvenne / Geert Vanden Wijngaert / David
Verberckt

Bolivia
Gonzalo Contreras del Solar / Patricio Crooker /
Manuel Seoane Salazar

Bosnia and Herzegovina
Jasmin Brutus / Sljivo Husein / Haris Memija /
Midhat Poturovic / Damir Sagolj

Brazil
Marcos Agrelli / João Alberto / Jose Carlos
Alexandre / Wagner Almeida / Raphael Alves /
Paulo Amorim / Keiny Andrade / Eduardo Anizelli /
Carolina Arantes / Alberto César Araújo / Jorge
Araújo / Avener Prado / Avener Nogueira Prado /
Guilherme Bergamini / Guilherme Bergamini /
Marlene Bergamo / Julio Bittencourt / Yan
Boechat / Ricardo Borges / João Cajazeira
Alvarez / Dennis Calçada / Luciano Candisani /
Emiliano Capozoli / Katia Carvalho / André
Augustus Coelho Cardoso / Leonardo Correa /
Marizilda Cruppe / Edmar Da Silva Barros /
Felipe Dana / Erick Dau / Carlos Eduardo de
Almeida / Jarbas Oliveira De Araújo / Diego de
Campos Padgurschi / Givaldo De Lima Barbosa /
Aline de Lima / Rezende Carneiro Da Silva / Raul
De Melo Spinassé Cavalcanti / Eduardo Lima de
Oliveira / Mastrangelo de Paula Reino / Pedro De
Queiroz Cattony Neto / Thiago Dezan / Marcio
Antonio Dias Pimenta Machado / Fábio
Evangelista / Evelson Rodrigues De Freitas /
Bruno Falcão / Antonio Carlos Faria / Ana
Carolina Fernandes / Marcelo Figueiredo
Theobald / Felipe Fittipaldi Freire de Carvalho /
Flavio Forner / Zanone Fraissat /Fernando
Frazão De Queiroz / Hans Georg / Luiz Carlos
Gomes / Cláudio Guedes Bocchese / Diego
George Herculano Cabral De Barros / Eduardo
Knapp / Antonio Pereira Lacerda Junior / Marcia
Laurene Foletto / Luisa Lauxen Dörr / José
Mauro Leandro Pimentel / Mauricio Lima / Paulo
Lopes / Jose Lucena / Luciano Belford Luciano
Da Silva Faria / Ellan Lustosa Godoy / Cezar
Magalhaes / Alexandre Magno Brum da Luz /
Andre Mantelli / Ueslei Marcelino Da Silva /
Daniel Soares Marenco / Amanda Martinez
Nero / Fernando Aldo Martinho Torres / Paulo
Martins Pinto / Danilo Mello / José Ricardo
Mello / Ana Mendes / Alexandre Meneghini /
Henry Milleo / Ricardo Moraes / Sebastião
Moreira / Lucas Mourão Tavares / Valda
Nogueira / Pablo Nogueira Jacob / Carlos
Oliveira / Isabela Pacini / Rodrigo Antonio Paes
Dias / Paulo Henrique Pampolin / Paulo
Ermantino Paulo Ferreira Da Silva / Amanda
Perobelli / Andre Pimentel / André Porto / Jane
Eyre Queiroz De Goes / Sergio Ricardo Oliveira /
Domingos Rodrigues Peixoto / Yolanda Simone
Salomão Mêne / Wagner Santana / Isabella
Santos Lanave / Antonio Scorza / João Manoel
Da Silva Neto / Daniel Soeiro De Abreu Castelo
Branco / Andre Sousa Borges / Rogerio Stella
Santos / Fabio Alarico Teixeira / Ricardo Teles /
Danilo Verpa / André Felipe Vieira / Franco
Weimer de Carvalho / Paulo Brandao Whitaker /
Adriana Zehbrauskas

Bulgaria
Mehmed Aziz / Dimitar Dilkoff / Anna Filipova /
Boryana Katsarova / Dimitar Kyosemarliev /
Stoyan Nenov / Yana Paskova / Hristo Rusev /
Anastas Tarpanov / Victor Troyanov / Boris
Voynarovitch

Canada
Tamara Abdul Hadi / Kiran Ambwani / Tyler
Anderson / Vladimir Antaki / Alexis Aubin /
Serguei Bachlakov / Stan Behal / Mathieu
Belanger / Tanya Bindra / Mark Blinch /
Normand Blouin / Christopher Bobyn / Julien
Bois / Greg Bos / Amber Bracken / Bernard

229

Brault / Cole Burston / Darren Calabrese / Anatoliy Cherkasov / Paul Chiasson / Yves Choquette / Andrew Clark / Shaylin Conroy / Barbara Davidson / Pieter De Vos / Radu Diaconu / Chris Donovan / Darryl Dyck / Stephanie Foden / Jason Franson / Kevin Frayer / Brett Gundlock / Naomi Harris / Kiana Hayeri / Louis Helbig / Leah Rae Hennel / Sara Hylton / Marta Iwanek / David Jackson / Emiliano Joanes / Yonathan Kellerman / Marko Kokic / Nick Kozak / Esmond Lee / Rita Leistner / Jean-François Lemire / Roger Lemoyne / Fred Lum / Douglas MacLellan / Liam Maloney / Jody Martin / Valérian Mazataud / Jo-Anne McArthur / Allen McInnis / Jeff McIntosh / Lance McMillan / Muse Mohammed / Christinne Muschi / Finbarr Colin Patrik O'Reilly / Jen Osborne / Ed Ou / Renaud Philippe / Wendell Phillips / Andrea Pritchard / Cody Punter / Jennifer Roberts / Robin Rowland / John Simpson / David Maurice Smith / Nayan Sthankiya / Meera Sulaiman / Adrienne Surprenant / Pooyan Tabatabaei / Larry Towell / Martin Tremblay / Alexa Vachon / Aaron Vincent Elkaim / Chris Wattie / Ian Willms / Larry Wong / Scott Woodward / Iva Zímová

Chile

Ivan Alvarado / Danny Alveal Aravena / Tomas Fernandez / Fernando Gallardo Sanz / Mariola Bernarda Guerrero Sepulveda / Roderik Henderson / Luis Alexis Hidalgo Parra / Fernando Lavoz / Tamara Merino / Tomás Munita Philippi / Carlos Newman / Alejandro Olivares / Cristobal Olivares Araya / Guillermo Salgado / Alejandro Zoñez Venegas

China

Yin A / Xiping An / Yuan An / Shuzhen Bai / Xue Bai / Lixin Bi / Wang Bing / Daizheng Cai / Shengxiang Cai / Yichong Cai / Zhi Zheng Cao / Guangwen Cao / JianXiong Cao / Jingbin Cao / Jun Cao / Liming Cao / Zhongyang Cao / Yicen Che / Liang Chen / Zhongqiu Chen / Dong Chen / Dongdong Chen / Fan Chen / Gang Chen / Geng Sheng Chen / Gengsheng Chen / Jian Chen / Jianyuan Chen / Jianzhen Chen / Jie Chen / Lijie Chen / Qing Chen / Ruiqiang Chen / Weiguo Chen / Wenjian Chen / Wenjin Chen / Yan Chen / Yangfu Chen / Yongheng Chen / Yuanming Chen / Zhengjun Chen / Zhiwei Chen / Gang Cheng / Guimin Cheng / Yiheng Cheng / Gang Cui / Jun Cui / Li Cui / Lingluo Cui / Nan Cui / Songge Cui / Xinyu Cui / Lixia Dai / Jia Dai Feng Fei / Dongfeng Deng / Hua Deng / Huosheng Deng / Liangming Deng / Huanxin Ding / Ni Dong / Ning Dong / Yalin Dong / Qing Du / Jinxing Du / Hua Fan / Juemian Fan / Liyong Fan / Shangzhen Fan / Yulei Fan / Ping Fang / Sheng Fang / Yunfeng Fang / Tian Fei / Mubo Feng / Qiang Fu / Yongjun Fu / Yin Gang / Lu Gao / Wenxiu Gao / Xiaoming Ge / Guohua Geng / Mali Geng / Bing Gong / Gongwenbin Gong / Haojie Gong / Jianhua Gong / Zijie Gong / Fengquan Gu / Jia Gu / Shan Hong Gu / Song Gu / Weiqiang Gu / Yi Gu / Ying Gu / Chen Guo / Ji Dong Guo / Jianliang Guo / Jiansheng Guo / Jijiang Guo / Jing Guo / Xiaolong Guo / Xin Guo / Ying Guo / Yongsheng Guo / ZhiHua Guo / Qiang Han / Yan Han / Zhiming Hang / He Hao / Yi Hao / Canling He / Haiyang He / Yuanquan He / Ou He / Ruiming He / Xiaodon He / Yi He / Zhong He / Qiangcheng Hong / Cong Hu / Guoqing Hu / Lingyuo Hu / Tiexiang Hu / Weiguo Hu / Yuejian Hu / Yang Hua / Zhigang Hua / Beishun Huang / Guofu Huang / Han Huang / Zhe Huang / Jianming Huang / Le Ting Huang / Lian Huang / Qipeng Huang / Shiguang Huang / Songhe Huang / Yaoquan Huang / Yiqing Huang / Yue Huang / Yuyang

Huang / Qiang Huo / Shaoqin Ji / Guorong Jia / Lei Jia / Yanan Jia / Sheng Jia Peng / Hao Jiang / Mingjun Jiang / Wenhua Jiang / Xinhe Jiang / Shengfu Jiao / Liwang Jin / Justin Jin / Min Jin / Siliu Jin / Wang Jing / Hu Jinxi / Guangcai Ju / Zhao Kang / Xu Kangping / Huimin Kuang / Hongguang Lan / Sanfeng Lan / Shuchen Lang / Hong Lei / YaPing Lei / Yuting Lei / Aimin Li / Bo Li / Caidi Li / Celiang Li / Fan Li / Feng Li / Gang Li / Haifeng Li / He Li / Huaifeng Li / Jiangsong Li / Jianfeng Li / Jiangang Li / Jiangwen Li / Jianping Li / Jidong Li / Junhui Li / Li Jian Lin Li/ Wei Li / Xin Li / Linlin Li / Liyan Li / Meihua Li / Ming Li / Muzi Li / Pin Li / Pinxiang Li / Qianhao Li / Rong Wei Li / Rongrong Li / Rui Li / Shujing Li / Tao Li / Tieqiang Li / Weiguang Li / Wentao Li / Xiangbo Li / Xiangyu Li / Yan Li / Yanan Li / Yingjie Li / Yong Li / Yushan Li / Yuze Li / Zhong Li / Huizhen Liang / Ying Fei Liang / Meng Liang / Ming Liang / Yilong Liang / Zhentang Liang / Pan Liao / Shilong Liao / Wenxiong Liao / Xiong Liao / Zhengyan Liao / Shi Lifei / Baocheng Lin / Chen Lin / Minming Lin / Qiaosen Lin / Shanming Lin / Shi Fang Lin / Tianli Lin / Wu Dan Lin / Wu Wang Lin / Yun Lin / Bingsheng Liu / Changchun Liu / Changmin Liu / Changming Liu / Dajia Liu / Debin Liu / Guanguan Liu / Guilin Liu / Guoxing Liu / Hongyu Liu / Jian Liu / Jian'an Liu / Jianhong Liu / Jiani Liu / Jichang Liu / Jinbing Liu / Jun Liu / Lei Liu / Yan Ao Liu / Zhongcan Liu / Risheng Liu / Rongqin Liu / Ruifeng Liu / Shuailiang Liu / Song Liu / Tao Liu / Tong Liu / Xingzhe Liu / Xinzhong Liu / Youzhi Liu / Yujie Liu / Yun Liu / Yuyang Liu / Zheng Liu / Zhihao Liu / Zhongjun Liu / He Long / Wei Long / Yongping Lou / Fanjing Lu / Guang Lu / Li Lu / Ming Lu /Minqiang Lu / Weidong Lu / Xubo Lu / Yu Lun / Hua Luo / Pinxi Luo / Jiming Lv / Ning Lv / Hao Lyu / Chungbin Ma / Jie Ma / Xiaobo Ma / Huiqiao Man / Zhang Mao / Fei Maohua / Xipeng Miao / Yong Miao / Jianfei Ming / Jiwu Mu / Fengliang Ni / Li Xiang Ni / Yongxing Nie / Feng Ning / Zhouhao Ning / Bo Niu / Weijian Ou / Haisong Pan / Yongqiang Pan / Yu Pan / Nian Peng / Rui Cheng Peng / Dongfeng Pu / Xiaoxu Pu / Hui Qi / Lin Qi / Shihui Qi / Haifeng Qian / LuBin Qian / Weizhong Qian / Li Qianjin / Jianguo Qiao / Bin Qin / Zhao Qing / Donghui Qiu / Lingling Qiu / Weirong Qiu / Yan Qiu / MengJun Ran / Wen Ran / Yongxia Rao / Shi Chen Ren / Xi Ren / Yong Ren / Yiqing Rong / Gen Shun Shang / Huage Shang / Zhanxiang Shao / Liya Shen / Min Jue Shen / Hui Shen / Yinlong Shen / Yu Shen / Zhijun Shen / Hongxu Sheng / Bai Shi / Fangfan Shi / Jianhua Shi / Jing Shi / Tao Shi / Shuangfeng Shi / Weimeng Shi / Yangkun Shi / Yunping Shi / Zhanguo Shi / Yunlai Shou / Aly Song / Li Song / Pingyao Song / Wei Tao Song / Qiaojiang Su / Xiaoming Su / Guoshu Sun / Jie Sun / Jun Sun / Junbin Sun / Lin Sun / Xiaoyi Sun / Sunhuajin Sunhuajin / Qingju Tan / Qiumin Tan / Wendong Tan / Zhaobin Tan / Mingzhen Tang / Yijun Tang / Dibiao Tao / Ke Tao / Liu Tao / Huan Tao / Yuan Tao / Baoxi Tian / Haiguang Tian / Jian Tian / Min Tian / Yuzhuang Tian / Deliang Tong / Mang Wan / Min Wan / Nan Wan / Aimin Wang / Baifeng Wang / Baozhong Wang / Bingcheng Wang / Bingxiang Wang / Changshu Wang / Chaoying Wang / Chen Wang / Conghai Wang / Dabin Wang / Fanqi Wang / Haoyu Wang / He Wang / Hongqiang Wang / Hongsong Wang / Hui Wang / Jian Wang / Jianguo Wang / Jianing Wang / Jianjun Wang / Jin Lei Wang / Jun Wang / Lei Wang / Lili Wang / Liqiang Wang / Mianli Wang / Ming Wang / Naigong Wang / Pan Wang / Ruobang Wang / Shibo Wang / Taiheng Wang / Tiejun Wang / Pingsheng Wang / Wangzhen Wang / Wei Wang /

WeiTao Wang / Xiao Wang / Xiaobing Wang / Xingjian Wang / Xinke Wang / Xiwei Wang / Yanbin Wang / Yanggang Wang / Yi Wang / Yixuan Wang / Yong Wang / Yueguo Wang / Yuheng Wang / Yunfei Wang / Zehong Wang / Zhouxi Wang / Zhuangfei Wang / Zilin Wang / Liang Wei / Xue Min Wei / Yongqing Wei / Zhen Wei / Bo Wen / Wsir Wsir / Bin Wu / Changqing Wu / Di Wu / Duanhong Wu / Fang Wu / Hong W Huang Wu / Jianhua Wu / Jiaxiang Wu / Jie Wu Jin Wu / Junjie Wu / Junsong Wu / Linhong Wu Shubu Wu / Wengang Wu / Yue Wu / Xiao Rong Wu / Xiaoyun Wu / Yong Gang Wu / Yong Gang W Zhangjie Wu / Zhuang Wu / Zhenhua Xi / Bin Xia Weicong Xia / PengCheng Xia / Yang Xia / Yijun Xia / Li Xiang / Cheng Xiao / Langping Xiao / M Xiao / Shulian Xiao / Yi Xiao / Li Xiao Gang / Heping Xie / Longxiang Xie / Minggang Xie / Ya Xin / Bin Xu / Chen Xu / Cong Jun Xu / Haifeng X Hongbing Xu / Jingxing Xu / Ping Xu / Shiwei X YuBin Xue / Bailiang Yan / Jianhua Yan / Mingyuan Yan / Ping Yan / Yin Yan / Bo Yang / Chenglong Yang / Donghui Yang / Huafeng Yan Hui-quan Yang / Jiahui Yang / Jihong Yang / Jinghong Yang / Jun Yang / Kejia Yang / Lijun Yang / PengWei Yang / Tongjiang Yang / Xiying Yang / Yan Yang / Tongyu Yang / Yang Yang / Yaoye Yang / Yijun Yang / Youde Yang / Yuxian Yang / Zhanfeng Yang / Zhonghua Yang / Shuyong Ye / Wei Ye / Xingjun Ye / Jianguo Yi / Yonghong Yin / YongZhi Chu / Bin Yu / Huaqian Yu / Jijian Yu / Liyan Yu / Ningtai Yu / Ping Yu Tong Yu / Ying Yu / Yonghua Yu / Hongzhong Yuan / Peide Yuan / Peng Yuan / Weiliang Yua Xiangyang Yuan / Yuhua Yuan / Hong Jun Yue Song Yueting / Hongbo Yun / Cao Yv-Qing / Junshang Zeng / Mei Zeng / Shaoxi Zeng / Yipeng Zeng / Jian Zhai / Jianfeng Zhai / Yan Zhan / Yu Zhan / Airui Zhang / Changming Zha Chongsheng Zhang / Chuansong Zhang / Con Zhang / Cuncheng Zhang / Dekui Zhang / Fen Zhang / Renfeng Zhang / Jie Zhang / Jingguo Zhang / Jiping Zhang / Kuiwu Zhang / Lei Zhan Lei Zhang / Lide Zhang / Liren Zhang / Peijian Zhang / Qiang Zhang / Shaofeng Zhang / She Zhang / Tao Zhang / Tianming Zhang / Wei Zha Weichun Zhang / Xiaoyu Zhang / Xingyong Zha Yan Zhang / Yi Zhang / Yiwen Zhang / Youqior Zhang / Yuan Zhang / Yujie Zhang / Chengbin Zhang / Hongwei Zhang / Zhang Jian Zhang / Jinqi Zhang / Zhou Zhang / Zong Zhang / Chaojun Zhao / Chongyi Zhao / Di Zhao / Het Zhao / Jiancheng Zhao / Jiangning Zhao / Jingdong Zhao / Jingwei Zhao / Jun Zhao / M Zhao / Wang Zhao / Wenjian Zhao / Yong Zha Zhannan Zhao / Yi Zhao / Xuebao Zhen / Ji Zheng / Min Zheng / Pingping Zheng / Xiaom Zheng / Xiaoqun Zheng / Xinqia Zheng / Yingb Zheng / Dong Lin Zheng / Sun Zhijun / Zhenb Zhong / Zhitang Zhong / Zhiying Zhong / Lim Zhong / Wang Zhong Ju / Cunyun Zhou / Guk Zhou / Guoqiang Zhou / Jianguang Zhou / Jincheng Zhou / Lihe Zhou / Shengli Zhou / Wenmin Zhou / Xiao Zhou / Xin Zhou / Xinghu Zhou / Xuejun Zhou / Yin Zhou / Zongyi Zhou Baofu Zhu / Dan Zhu / Fenglei Zhu / Gecheng Zhu / Haiou Zhu / Hongbo Zhu / Li Zhu / Ling Zhu / Xingxin Zhu / Xiyong Zhu / ZhiHui Zhu / Jialei Zhu / Dongxiong Zou / Hong Zou / Sen Z Zheng Zou

Colombia

Cristhian Agudelo / Luis Henry Agudelo Cano Juan D. Arredondo / Juan Manuel Barrero Bue Nelson Oswaldo Cárdenas Ferreira / Abel Enr Cardenas Ortegon / Carlos Andres Cordero Pe Juan Diego Buitrago Cano / Carlos Duran Arau Juanita Escobar / Christian Escobar Mora /

ym Fayad / Guillermo José González Pedraza /
dio Gonzalez Soler / Miguel Rodolfo Gutiérrez
tiérrez / Iván Herrera / Mauricio Leon
orzano / Camilo Leon-Quijano / Jose
rnando Llano M. / Alberto Mira Mora /
uricio Morales / Jorge Eliecer Orozco Galvis /
me Perez Munevar / Juan Pablo Pino Vargas /
derico Rios / Luis Robayo / Henry Romero /
essa Del Carmen Romero Estrada / Manuel
vador Saldarriaga Quintero / Javier Vanegas /
ctor Fabio Zamora Pabón

sta Rica
fael Pacheco Granados / Mayela López /
briela Vargas Téllez

atia
onio Bronic / Fjodor Klarić / Vlado Kos /
ar Kurschner / Dragan Pavlovic / Sanjin
ukic

ba
n Aristides Otamendiz / Kirstin Schmitt

rus
xandros Demetriades / Andreas Iacovou

ch Republic
rik Bartuska / Lukas Biba / Michal Cerveny /
a Connor / Eduard Erben / Michael Hanke /
omír Hanzlík / Renata Hasilová / Vojtěch
ych / Filip Jandourek / Michal Kamaryt /
tin Kozak / Jiří Královec / Antonin Kratochvil /
nislav Krupar / Lukáš Mach / Dan Materna /
iela Matulova / Jan Němeček / Kalhous
ek / Martin Sidorjak / Filip Singer / Jarmila
kova / David Tesinsky / Petr Topič / Jan Veber /
ra Vlčková / Tomáš Vocelka / Roman
drouš / Petr Wagenknecht / Adolf Zika

mark
s Ahlmann Olesen / Sisse Graabech Stroyer
erse / Nicolas Asfouri / Lasse Bak Mejlvang /
reas Beck / Søren Bidstrup / Marcus
paud Bjørn / Jeppe Bøje Nielsen / Laerke
ch Posselt / Jakob Carlsen / Filip
dzewicz / Casper Dalhoff / Jakob Dall /
am Dalsgaard / Astrid Dalum / Rasmus
nbol / Michael Drost-Hansen / Jacob
bahn / Joakim Eskildsen / Lene Esthave
ersen / Simon Bruun Fals / Ulrik Hasemann /
e Gudmundsen-Holmgreen / Marie Hald /
a Busk Hansen / Andreas Haubjerg / Ken
mann / Louise Herrche Serup / Lars Horn /
Høst-Aaris / Emil Hougaard Bertelsen /
a Kastrup / Sofie Amalie Klougart / Lars
be / Asger Ladefoged / Joachim Ladefoged /
nas Lekfeldt / Nikolai Linares / Bax
hardt / Mathias Løvgreen Bojesen /
ammed Massoud Morsi / Lars Moeller
en / Nanna Navntoft / Mads Nissen / Mikkel
Pedersen / Rasmus Flindt Pedersen /
n Skipper Christiansen / Carsten Snejbjerg /
ten Stricker / Michael Svenningsen / Gregers
o / Mathias Svold / Kaspar Wenstrup

inican Republic
e Manuel Cruz Diaz / Miguel Angel
aleon Lizardo

dor
s Bustamante / Alfredo Cárdenas / Isadora
a Romero Paz y Mino / Misha Vallejo

t
ed Mostafa Abd El-gwad / Alaa Ahmed /
Alfiky / Roger Anis / Ahmed Hamed Awwad /
El Refai / Ibrahim Hendy / Mohamed

Mahmoud Hossam El-Din / Mahmoud Khaled /
Heba Khamis / Fareed Kotb / Mohamed Mahdy /
Ayman Aref Saad El-Din / Nader Saadallah /
Islam Safwat / Asmaa Waguih

El Salvador
Jose Cabezas / Menly Cortez / Josué Abisaí
Guevara Flores / Lissette Esperanza Lemus
Sánchez / Víctor Osvaldo Martínez Peña /
Frederick Meza Díaz / Lissette Monterrosa /
Jessica Orellana / Fred Ramos

Estonia
Dmitri Kotjuh / Tairo Lutter / Joosep Martinson /
Erik Prozes / Birgit Püve / Eero Vabamägi

Ethiopia
Maheder Haileselassie

Faroe Islands
Benjamin Rasmussen

Finland
Tatu Blomqvist / Kirsi Kanerva / Sami Kero /
Kimmo Räisänen / Petteri Kokkonen / Janne
Körkkö / Maria Mäki / Niklas Meltio / Juhani
Niiranen / Sakari Piippo / Heidi Piiroinen / Timo
Pyykkö / Janne Riikonen / Akseli Valmunen /
Markus Varesvuo / Silla Simone Virmajoki /
Juuso Westerlund

France
Cyril Abad / Antoine Agoudjian / Guilhem
Alandry / Arnaud Andrieu / Olivier Anrigo /
Florence At / Rodrigo Avellaneda / Hugo Aymar /
Eric Baccega / Bruno Bade / Laurent Ballesta /
Pascal Bastien / Francois Baudin / Pascal
Beaudenon / Joel Benguigui / Jean-Jacques
Bernard / Martin Bertrand / Guillaume Binet /
Didier Bizet / Caroline Blumberg / Jérôme
Bonnet / Pierre Andre Boutier / Eric Bouvet /
Thomas Bregardis / Pedro Brito Da Fonseca /
Axelle Budan de Russé / Michael Bunel / Martin
Bureau / Anne-Laure Camilleri / Alvaro Canovas /
Francesco Carella / Pariat Carole / Sarah Caron /
Madeleine Carrouée / Vincent Catala / Fabrice
Caterini / Lionel Chamoiseau / Patrick Chapuis /
Nathanael Charbonnier / Antoine Chauvel /
Mehdi Chebil / Olivier Chouchana / Olivier
Corsan / Pierre Crom / Denis Dailleux / Julien
Daniel / William Daniels / Guillaume Darribau /
Nicolas Datiche / David David Reygondeau /
Béatrice de Géa / Pierre-Elie De Pibrac /
Veronique de Viguerie / Jeromine Derigny /
Bénédicte Desrus / Stephen Dock / Fred Dufour /
Edouard Elias / Laurent Emmanuel / Alain
Ernoult / Fabrice Caterini / Dominique Faget /
Stanislas Fautré / Bruno Fert / Franck Fife /
Benjamin Filarski / Corentin Fohlen / Jonathan
Fontaine / Timothee Franco / Roberto
Frankenberg / Eric Gaillard / Matilde Gattoni /
Jean-Matthieu Gautier / Laurence Geai / Jérôme
Gence / Gaëlle Girbes / Baptiste Giroudon /
Stephan Gladieu / Pierre Gleizes / Julien
Goldstein / Matthieu Gorisse-Mondoloni /
Samuel Gratacap / Alain Grosclaude / Charles
Louis Guerin / Aude Guerrucci / Ivan Guilbert /
Jeoffrey Guillemard / Valery Hache / Guillaume
Herbaut / Boris Horvat / Nathalie Houdin / Chris
Huby / Claire Jeantet / Arnold Jerocki / Olivier
Jobard / JR / François Xavier Klein / Jean
Philippe Ksiazek / Olivier Laban-Mattei /
Frédéric Lafargue / Eric Lafforgue / Jean-
François Lagrot / Hien Lam Duc / Ian Langsdon /
Romain Laurendeau / Etienne Laurent /
Sebastien Lebègue / Rosen Lecat / Zen Lefort /
Benjamin Legier / Herve Lequeux / John
MacDougall / Pascal Maitre / David Mareuil /

François Xavier Marit / Pierre Marsaut / Etienne
Maury / Nadège Mazars / Isabelle Merminod /
Nicolas Messyasz / Denis Meyer / Patricio
Michelin / Camille Millerand / Gilles Mingasson /
Bruno Morandi / Tuul Morandi / Thomas Morel-
Fort / Olivier Morin / Aurélien Morissard / Jean-
Claude Moschetti / Gilles Nicolet / Sebastien
Nogier / Frederic Noy / Jeff Pachoud / Denis
Palanque / Romain Perrocheau / Frédéric
Poplimont / Anita Pouchard Serra / Lionel Préau /
Mathieu Pujol / Zacharie Rabehi / Eric
Rechsteiner / Maxime Riche / Erwan Rogard /
Alexis Rosenfeld / Guillaume Ruoppolo / Lizzie
Sadin / Jean Pierre Sageot / Yves Salaun / Erik
Sampers / Alexandre Sattler / Franck Seguin /
Adrien Selbert / Christophe Simon / Jeremie
Souteyrat / Benoit Stichelbaut / Frederic Stucin /
Myriam Tangi / Pierre Terdjman / Benjamin
Thouard / Antonin Thuillier / Gia-Dinh To /
Quentin Top / Patrick Tourneboeuf / Eric Travers /
Théophile Trossat / Gerard Uferas / Emilien
Urbano / Laurent Van Der Stockt / Eric
Vandeville / Eric Vazzoler / Loïc Venance /
Florent Vergnes / Marylise Vigneau / Christophe
Viseux / Franck Vogel / Antonin Weber / Mélanie
Wenger / Laurent Weyl / Patrick Willocq /
Philippe Wojazer / Raphael Yaghobzadeh

Georgia
Daro Sulakauri

Germany
Valeska Achenbach / Emine Akbaba / Ingo Arndt /
Lajos Eric Balogh / David Baltzer / Lars Baron /
Gil Bartz / Leonora Baumann / Peter Bauza /
Marius Becker / Norman Behrendt / Fabrizio
Bensch / Lars Berg / Peter Bialobrzeski / Toby
Binder / Henning Bode / Joerg Boethling /
Sebastian Bolesch / Stefan Boness / Wolfgang
Born / Hubert Brand / Hermann Bredehorst /
Roland Breitschuh / Ulrich Brinkhoff /
Hansjürgen Britsch / Andreas Buck / Dominik
Thomas Butzmann / Antonino Condorelli /
Christina Czybik / Jacobia Dahm / Stefan Dauth /
Jesco Denzel / Hauke Dressler / Birgit-Cathrin
Duval / Johannes Eisele / Ahmed El Tamboly /
Micha Ende / Andreas Endermann / Stephan
Engler / Daniel Etter / Stefan Falke / Maria Feck /
Alina Fedorenko / Christina Feldt / Bettina
Flitner / Florian Florian Bachmeier / Susanne
Fromm / Sascha Fromm / Jürgen
Fromme / Dirk Gebhardt / Christoph Gerigk /
Mario Gerth / Miquel Gonzalez / Niklas Grapatin /
Stefan Gregor / Mareike Guensche / Julia
Gunther / Corinna Guthknecht / Patrick Haar /
Miguel Hahn / Matthias Hangst / Jan-Christoph
Hartung / Alexander Hassenstein / Birgit
Haubner / Gerhard Heidorn / Marc Heiligenstein /
Axel Heimken / Katja Heinemann / Nanna
Heitmann / Melanka Helms / Andreas Herzau /
Katharina Hesse / Karl-Josef Hildenbrand/
Hirschfeld Hirschfeld / Lisa Hoffmann /
Rebecca Hoppé / Sandra Hoyn / Claudia Janke /
Judith Jockel / Hannes Jung / Rainer Jysch /
Sebastian Kahnert / Enno Kapitza / Corinna
Kern / Dagmar Kielhorn / Björn Kietzmann /
David Klammer / Felix Kleymann / Karolin
Klüppel / Alexander Koerner / Christian Kosak /
Lukas Kreibig / Ksenia Kuleshova / Moritz
Küstner / Florian Ernst Johannes Lang / Bartek
Langer / Ralf Lienert / Kai Löffelbein / Werner
Mansholt / Noel Matoff / Jens Meyer / Robert
Michael / Fabian Mondl / Lena Mucha / Mark
Muehlhaus / Bernd Robert Müller / Johannes
Müller / Wolfgang Noack / Peter Noßek / Jens
Oellermann / Anja-Verena Arabella Ott / Ingo
Otto / Sarah Pabst / Ralph Pache / Jens Palme /
Michael Penner / Ladislav Perenyi / Thomas P.

Peschak / Carsten Peter / Thomas Peter / Jan Helge Petri / Kai Oliver Pfaffenbach / Daniel Pilar / Helge Prang / Baz Ratner / Sascha Rheker / Sascha Richter / Stefan Richter / Astrid Riecken / Jens Rosbach / Martin Rose / Kaveh Rostamkhani / Helena Schaetzle / Peter Schatz / Dietmar Scherf / Jan Scheunert / Roberto Schmidt / Kirstin Schmitt / Walter Schmitz / Sven Schomens / Thomas Schreyer / Joerg Schueler / Olaf Schuelke / Lukas Schulze / Jens Schwarz / Hartmut Schwarzbach / Yvonne Seidel / Olga Slach / Bertram Solcher / Andy Spyra / Bente Marei Stachowske / Martin Steffen / Sascha Steinbach / Björn Steinz / Patrik Stollarz / Julian Stratenschulte / Selim Sudheimer / Nikita Tereshin / Michael Terhorst / Deepak Tolange / Murat Türemis / Manuel Tysarzik / Jürgen Veits / Philipp von Ditfurth / Anke Waelischmiller / Tim Wagner / Lucas Wahl / Qing Wang / Uwe Weber / Oliver Weiken / Fabian Weiss / Christian Werner / Detlef Westerkamp / Mario Wezel / Sebastian Widmann / Arnd Wiegmann / Ronald Wittek / Ann-Christine Woehrl / Nadja Wohlleben / Jan Woitas / Jonas Wresch / Solvin Zankl / Sven Zellner

Ghana
Nyani Quarmyne

Greece
Yannis Behrakis / Evangelos Bougiotis / Thomas Daskalakis / Petros Giannakouris / Angelos Giotopoulos / Alexandros Katsis / Gerasimos Koilakos / Nikos Kokkas / Yannis Kolesidis / Alkis Konstantinidis / Yiannis Kourtoglou / John Liakos / Konstantinos Mantziaris / Ayhan Mehmet / Aris Messinis / Giorgos Moutafis / Vasailas Ntamplis / Anna Pantelia / Myrto Papadopoulos / Giannis Papanikos / Kostas Pikoulas / Olga Stefatou Papakonstantopoulou / Konstantinos Tsakalidis / Sofia Tsampara / Angelos Tzortzinis / Aristidis Vafeiadakis / Maria Verli / Eirini Vourloumis

Guam
Ed Crisostomo

Guatemala
Carlos Manuel Duarte García / Luis Echeverria / Guillermo Esteban Estrada Biba / Sergio Izquierdo / Danilo De Jesús Ramírez Miranda

Guinea
Mamadi Doumbouya

Honduras
Gustavo Amador

Hong Kong
Lam Chun Tung / Hoi Kin Fung / Chung Ming Ko / Yik Fei Lam / On Man Kevin Lee / Siu Wai Lui / Chuen Sung Ma / Tyrone Man Chiu Siu / Shen Wang

Hungary
Zoltán Balogh / Andras Bankuti / Krisztián Bócsi / János Bődey / Maximiliano Gabriel Braun Ibanez / András Cséfalvay / Istvan Derencsenyi / Balazs Gardi / Norbert Hartyanyi / Ákos Hegedűs / Sánta István Csaba / Istvan Andras Juhasz / Marton Kallai / István Kerekes / Tamas Kovacs / Márton Magócsi / Bence Mate / Radisics Milán / Zoltan Molnar / Márton Mónus / Simon Móricz-Sabján / Sándor Márton Nagy / András Polgár / Bálint Pörneczi / Tamas Revesz / Bianka Rostás / Lajos Soos / Akos Stiller / Ivan Szabolcs / József Szaka / Robert Szaniszlo / Laszlo Szirtesi / Marton Tordai / Bela Varadi

Iceland
Eva Björk Aegisdottir / Ólafur Steinar Gestsson

India
Adnan Abidi / Piyal Adhikary / A.M. Ahad / Bijuraj AK / Abhijit Alka Anil / Oinam Anand / Tamim Ahmad Baba / Pratik Dutta Babu / Anand Bakshi / Pritam Bandyopadhyay / Debsuddha Banerjee / Bhagirath Basnet / Salil Bera / Faisal Bhat / Muzamil Bhat / Supratim Bhattacharjee / Biju Boro / Balarka Brahma / CK Thanseer Chakkalakkunnan / Rana Chakraborty / Amit Chakravarty / V.S. Vijaya Bhaskara Rao Chalasani / Bhanu Prakash Chandra / Arun Chandrabose / Suresh Kumar Chinnasamy / Kamakhya Kumar Choudhary / Rupak Chowdhuri / Ridhin Damu / Mohd Yasin Dar / Javed Dar / Shantanu Das / Sudipto Das / Supranav Dash / Arko Datto / Nirav Dave / Karen Dias / Devendra Dube / Akhil E S Enchikkalayil House / Anushree Fadnavis / Mijannur Rahaman Gazi / Sayantan Ghosh / Dev Gogoi / Prodip Guha / Ashish Shankar Gupta / Rajat Gupta / Ramakrishna Gurram / Sanjay Arjun Hadkar / Neha Hirve / Idrees Abbas Idrees Abbas / Sultan Javed / Manoj Kumar K / Farooq Javed Kahn / Deepak Kamana Ramesh / Sanjay Kanojia / Aditya Kapoor / Emmanual Karbhari / Ahmer Khan / Faisal Khan / Shadab Khan / Chandan Khanna / Praveen Khanna / Nayan Khanolkar / Anita Khemka / Sasi K Kollikal / Ajit Krishna / Asit Kumar / Durgesh Kumar / Zishaan Akbar Latif / Atul Loke / Periasamy M / Amit Madheshiya / Saqib Majeed / Francis Adrian Mascarenhas / Shivang Mehta / Riyasannamanada Mohamedreyas / Samir Mohite / Vidhuraj MT / Anindito Mukherjee / Indranil Mukherjee / Muzamil Shafi Mattoo / Prashant Nadkar / Abhishek Chinnappa Nagarally / Rakesh Nair / Showkat Nanda / Anupam Nath / Sudharmadas Nr Neelamkulangara / Nidhish Krishnan Nidhish / N P Jayan Niravath / Jagadeesh Nv / Nagesh Ohal / Sudharak Olwe / Hemant Padalkar Ravindra / Ravindra Babu Paidimukkala / Raminder Pal Singh / Josekutty Panackal / Vijay Pandey / Eeshan Peer / P. Ravikumar Perumalappan / Ravi Posavanike / Anshuman Poyrekar / Altaf Qadri / Ashish Raje Subhash / Pattabi Raman / Arati Rao / Ravi Choudhary Ravi / Vicky Roy / SL Shanth Kumar / Sambasivam Leela / Sajeesh Sankar / Partha Protim Sarkar / Arijit Sen / Gautam Sen / Showkat Shafi / Russell Shahul / Mahesh Shantaram / Arun Sharma / Smita Sharma / Raju Mahadev Shinde / Sagar Shiriskar / Danish Siddiqui / Sharath Babu Siddoju / Bandeep Singh / Satpal Singh / Anantha Subramanyam.K. / J Suresh Jayaprakash / Waseem Andrabi Syed Nabi Ahmad Andrabi / Ramana T Shilpa / T P Sooraj Thaniyulla Parambil / Sanesh A Thekkethil / Tashi Tobgyal / Deepak Turbhekar Motiram / Umar Ganie Umar / Ritesh R Uttamchandani / Sriharsha Vadlamani / Aravind Venugopal / Prashanth Vishwanathan / Chirag Wakaskar / Abdul Majeed Wani / Danish Ismail Wani / Ubaidullah Wani / Umer Asif Zargar

Indonesia
Sutanta Aditya / Yuniadhi Agung / Fahreza Ahmad / Arie Basuki / I Gusti Bayu Ismoyo / Beawiharta Bea / Suwandi Chandra / Muhammad Fauzi Chaniago / Anis Efizudin / Muhammad Fadli / Masyudi Firmansyah / Anton Gautama / Hariandi Hafid / Junaidi Hanafiah / Boy Harjanto / Afriadi Hikmal / Donal Husni / Ulet Ifansasti / Ferganata Indra Riatmoko / Dhana Kencana / Iqbal Kusumadireza / Pujianto Johan Leo /

Abriansyah Liberto / Ali Lutfi / Chaideer Mahyuddin / Basri Marzuki / Irsan Mulyadi / Ma Nagi / Yoppy Pieter / Denny Natanael Pohan / Idris Prasetiawan / Ramdani Ramdani / Aman Rochman / Dasril Roszandi / Agoes Rudianto / Yuli Seperi / Arief Setiadi / Agus Susanto / Defi Tanjung / Jefri Tarigan/ Albertus Vembrianto / Marifka Wahyu Hidayat / B D Kentjono Seto Wardhana / I Putu Sayoga Wicaksana / Lastri Berry Wijaya / Jessica Helena Wuysang / Idha Zakaria / Rony Zakaria / Zulkifli Zulkifli

Iran
Navid Abdolghaderi Bookani / Mona Abdollahpour Araghi / Gholamreza Ahmadi / Mostafa Akbari Moghadam Azad / Forough Ala Saghar Amir Azimi / Azin Anvar Haghighi / Am Aslan Arfa Kaboudvand / Enayat Asadi / Mazy Asadi / Farhad Babaei / Fatemeh Behboudi / Azadeh Besharati / Mohammad Hossein Dehghanian / Yasaman Dehmiyani / Mahnaz Dezhban / Adis Easagholian / Sajjad Ebrahim Javad Erfanian Aalimanesh / Masoud Fardian Hossein Fatemi / Mohammad Mehdi Fazlolla Caren Firouz / Arez Ghaderi / Hassan Ghaedi Mojgan Ghanbari / Borna Ghasemi / Mehdi Ghasemi / Mohammad Golchin Kouhi / Reza Golchin Kouhi / Alireza Goudarzi / Ahmadreza Halabisaz / Ali Hamed Haghdoust / Majid Hamed Haghdoust / Mehran Hamrahi / Seyed Hamid Hashemi / Mohammad Hassan Zadeh Abdollah Heidari / Marziyeh Heydarzadeh Aghdam / Majid Hojati / Mona Hoobehfekr / Seyed Mahmood Hosseini / Fatemeh Jabbari Mehri Jamshidi Kondori / Khashayar Javanma Morteza Kanani / Atta Kenare / Asghar Khams Younes Khani / Ali Khara / Danial Khodaie / Shahriar Khonsari / Amir Hossein Khorgooei Ghazal Mafakheri / Mohamad Javad Maktab Behrouz Mehri / Ahmad Moeini Jam / Hamzel Mohammad Hosseini / Ali Mohammadi / San Mohammadi / Amirhosein Mohammadkarimi Yazdi / Shaghayegh Moradian Nejad / Amir Narimani / Shahab Naseri / Amin Nazari / Hamed Nazari / Mohammad Nazary / Mehdi Nazeri Gahkani / Javid Nikpour / Ebrahim Noroozi / Javad Parsa / Adel Pazyar / Mosleh Pirkhezranian / Maryam Rahmanian / Mohse Rashidi / Kimiya Rashidi Nik / Majid Saeedi / Masoumeh Saeidollahi / Sajad Safari / Behn Sahvi / Nousha Salimi / Abolfazl Salmanzade Mohsen Sanei Yarandi / Hashem Shakeri / A Shakibafar / Jalal Shamsazaran / Ali Sharifza Seyed Madyar Shojaeifar / Mohammad Reza Soltanitehrani / Mamad Tajik / Newsha Tavakolian / Farshid Tighehsaz / Omid Vahabzadehasbaghi / Mohamad Hossin Velayati / Soheil Zandazar / Bahman Zarei

Iraq
Ahmad Al Rubaye / Mortda M Almusawi / Ali Arkady / Teasir Khetheir / Ahmed Saad / Tha Al-Sudani

Ireland
Laurence Boland / Deirdre Brennan / Matt Browne / Cyril Byrne / Ramsey Cardy / Micha Chester / James Crombie / Lauren Crothers Denis Doyle / Nic Dunlop / Darragh Field / Brenda Fitzsimons / David Hayes / Thomas Honan / Steve Humphreys / John Kelly / Clo Kilcoyne / Eric Luke / Dara Mac Dónaill / Stephen McCarthy / Andrew McConnell / Jo McDermott / Cathal McNaughton / Charles McQuillan / Brendan Moran / Seamus Murp David O' Flynn / Kenneth O'Halloran / Joe O'Shaughnessy / Ivor Prickett / Ray Ryan / B Smyth / Morgan Treacy / Eamon Ward

ael

vi Aharon / Eli Atias / Dan Bar Dov / Denis
chel / May Castelnuovo / Gil Cohen Magen /
tan Dvir / Alexey Ershov / Roie Galitz / Kobi
leon / Roei Greenberg / Nitzan Hafner / Tomer
h / Gilad Kavalerchik / Ziv Koren / Felix Lupa /
d Malka / Shay Mehalel / Lior Mizrahi / Jorge
vominsky / Guy Prives / Daniel Reiter / Roy
chlin / Roman Ronny Rozenberg / Adi Segal /
kam Seri / Avishag Shaar-Yashuv / Yonatan
del / Abir Sultan / Daniel Tchetchik / Oded
genstein / Eyal Warshavsky / Kobi Wolf / Gili
ri / Ilia Yefimovich / Yehoshua Yosef / Oren
/ Ronen Zvulun / Ohad Zwigenberg

ly

uro Agnesoni / Edoardo Agresti / Andrea Alai /
a Alcalde Patane / Salvatore Alibrio /
vatore Allegra / Massimo Allegro / Marco
ozzi / Francesco Anselmi / Giuseppe Ardica /
chele Ardu / Matteo Armellini / Roberto
nocida / Giampiero Assumma / Luigi
ntaggiato / Luciano Baccaro / Martina
cigalupo / Diana Bagnoli / Luigi Baldelli /
ilo Balducci / Jacob Marcus Balzani Lööv /
ssimo Barberio / Pietro Baroni / Alessandro
teletti / Matteo Bastianelli / Ciro Battiloro /
urra Becherini / Francesco Angelo Bellina /
iele Belosio / Beniamino Beniamino Pisati /
a Squarci Benjamin Petit / Valerio Berdini /
ssimo Berruti / Leonello Bertolucci / Giorgio
nchi / Giulia Bianchi / Emanuele Biggi/
ejman Bijedić / Valerio Bispuri / Simona
ianno / Isabella Bonotto / Federico Borella /
dia Borgia / Michele Borzoni / Alfredo Bosco /
tteo Bottanelli / Marco Bottelli / Majlend
mo / Roberto Brancolini / Leonardo Brogioni /
amaria Bruni / Talos Buccellati / Fabio
ciarelli / Mario Bucolo / Fulvio Bugani /
tteo Buonomo / Vittore Buzzi / Roberto
curi / Jean-Marc Caimi / Salvatore Calafato /
anuele Camerini / Cinzia Canneri / Marco
tile / Massimo Capocci / Federico Caponi /
vanni Capriotti / Alessandro Carboni / Angelo
coni / Giuseppe Carotenuto / Davide Casella /
tina Casotto / Gianluca Cecere /
francesco Celada / Giancarlo Ceraudo /
nluca Checchi / Alessandro János Chialá /
nardo Chiarabini / Alfredo Chiarappa / Jean-
de Chincheré / Giuseppe Chiucchiu /
ncesco Cilli / Alessandro Cinque / Michele
lo / Tomaso Clavarino / Alessio Coghe /
cy Colombo / Emanuela Colombo / Marco
ombo / Francesco Comello / Matteo
gregalli / Emiliano Cribari / Alessio Cupelli /
ssandro D Angelo / Bruno D'Amicis / Giacomo
lando / Albertina d'Urso / Simone Dalmasso /
ara Dazi / Giovanni De Angelis / Edgard De
o / Stefano De Luigi / Giovanni Del Brenna /
ano del Castillo / Giovanna del Sarto / Elio
a Ferrera / Andrea Depaoli / Giovanni Di
ca / Jacopo Di Cera / Emanuele Di Cesare /
ro Di Giambattista / Antonio Di Laurenzio /
ando Di Loreto / Gianluigi Di Maio / Danilo
ia Di Meo / Maria Chiara di Pace / Giulio Di
co / Alfonso Di Vincenzo / Giovanni
denti / Alessandro Digaetano / Chiara
nede / Simone Donati / Linda Dorigo /
riele Duchi / Karim El Maktafi / Marco Erba /
tina Esposito / Salvatore Esposito / Antonio
cilongo / Alessandro Falco / Andrea Falcon /
eppe Fama / Andrea Fantini / Linda Ferrari /
simo Ferrero / Angelo Ferrillo / Gerardo
camo / Vito Finocchiaro / Gaetano Fisicaro /
a Forno / Alessandro Franzetti / Andrea
zetta / Nicola Frioli / Roberto Fumagalli /
Fusco / Gabriele Galimberti / Alessandro
dolfi / Marco Garofalo / Stephanie Gengotti /

Alessandro Genovese / Enrico Genovesi /
Stefano Gerardi / Riccardo Ghilardi / Luca
Gianetti / Alfonso Angelo Giannotti / Antonio
Gibotta / Fabrizio Giraldi / Chiara Goia / Claudia
Gori / Alessandro Grassani / Annibale Greco /
Eugenio Vincenzo Rosario Grosso / Marco
Gualazzini / Stefano Guidi / Giulio Ielardi /
Alessandro Iovino / Roberto Isotti / Angelica
Kaufmann / Oskar Landi / Silvia Landi / Michele
Lapini / Mario Laporta / Salvatore Laporta /
Mattia Leonardi / Fabrizio Leonarduzzi / Stefano
Lista / Nicola Lo Calzo / Giovanni Lo Curto / Luca
Locatelli / Carlo Lombardi / Martino Lombezzi /
Marco Longari / Nicola Longobardi / Davide
Lopresti / Guillermo Luna / Luca Lupi / Elvio
Maccheroni / Diego Maggioni / Francesca
Magnani / Giancarlo Malandra / Francesco
Malavolta / Federica Mameli / Alessio Mamo /
Beatrice Mancini / Karl Mancini / Romano
Antonio Maniglia / Christian Mantuano /
Gianmarco Maraviglia / Davide Marcesini / Paolo
Marchetti / Giulia Marchi / Fausto Marci / Alberto
Maretti / Nicola Marfisi / Enrico Mascheroni /
Alex Masi / Antonio Masiello / Pietro Masturzo /
Edoardo Melchiori / Ugo Mellone / Lorenzo
Meloni / Myriam Meloni / Giovanni Mereghetti /
Erik Messori / Vincenzo Metodo / Simone Marco
Migliaro / Stefano Miliffi / Matteo Minnella /
Christian Runi Minelli / Fabio Mirulla / Dario
Mitidieri / Pierpaolo Mittica / Siegfried Modola /
Diego Mola / Vincenzo Montefinese / Stefano
Montesi / Stefano Morelli / Agnese Carlotta
Morganti / Beatrice Moricci / Sergio Morra /
Lorenzo Moscia / Sara Munari /Antonio Nardelli /
Annalisa Natali Murri / Luca Neve / Stefano
Nocchi / Giuseppe Nucci / Antonello Nusca /
Piero Oliosi / Alessio Paduano / Graziano Panfili /
Maria Pansini / Gianmarco Panucci / Marco
Panzetti / Savino Paolella / Pietro Paolini /
Massimo Paolone / Paolo Patrizi / Carlo
Pellegrini / Alessandro Penso / Viviana Peretti /
Claudio Peri / Simone Perolari / Graziano Perotti /
Leonardo Perugini / Raffaele Petralla / Luciana
Petti / Valentina Piccinni / Emiliano Pinnizzotto /
Piergiorgio Pirrone / Giulio Piscitelli / Francesco
Pistilli / Alberto Pizzoli / Fausto Podavini /
Massimo Podio / Francesca Pompei / Antonio
Salvatore Presta / Tommaso Protti / Andrea
Provenzano / Marco Raccichini / Tommaso Rada /
Carlo Rainone / Roselena Ramistella /
Alessandro Rampazzo / Giuseppe Rampolla /
Andrea Rizzi / Paolo Robaudi / Alessio Romenzi /
Italo Rondinella / Rocco Rorandelli / Fabio Rossi /
Massimiliano Rossi / Nicolo Filippo Rosso /
Alessandro Rota / Patrick Russo /Mario Sabatini /
Ivo Saglietti / Daniela Sala / Roberto Salomone /
Simone Sapienza / Riccardo Sartori / Emanuele
Satolli / Luca Scabbia / Giorgio Scala / Stefano
Schirato / Federico Scoppa / Emanuele
Scorcelletti / Federico Serra / Michele Sibiloni /
Mariano Silletti / Christian Sinibaldi / Valentina
Sinis / Massimo Siragusa / Luca Sola / Mauro
Spanu / Massimo Spinolo / Andrea Staccioli /
Herbert Steele / Stefano Stefano Rellandini /
Mario Taddeo / Michele Tantussi / Christian
Tasso / Lorenzo Angelo Terraneo / Chiara Tesser /
Francesca Todde / Patrick Tombola / Dario
Tommaseo / Stefano Torrione / Christian Tragni /
Simone Tramonte / Alessandro Tricarico /
Gianfranco Tripodo / Filippo Trojano / Yarin
Trotta Del Vecchio / Alessandro Trovati / Lorenzo
Tugnoli / Serena Tulli / Mauro Ujetto / Mattia
Vacca / Clara Vannucci / Pasquale Vassallo /
Alessandro Vecchi / Antonello Veneri / Filippo
Venturi / Raffaele Verderese / Paolo Verzone /
Federico Vespignani / Matteo Vieille / Fabrizio
Villa / Laura Villani / Alessandro Vincenzi /
Daniele Volpe / Francesca Volpi / Filippo

Zambon / Stefania Zamparelli / Erberto Zani /
Barbara Zanon / Bruno Zanzottera / Elisabetta
Zavoli / Francesco Zizola / Lorenzo Zoppolato /
Marco Zorzanello / Gian Paola Zorzi / Vittorio
Zunino Celotto

Ivory Coast
Legnan Koula

Jamaica
Norman Grindley

Japan
Hiroshi Aoki / Takashi Aoyama / Yasuyoshi Chiba /
James Whitlow Delano / Toru Hanai / Yusuke
Harada / Kazuo Horiike / Teruaki Iida / Tomonori
Iwanami / Taro Karibe / Yosuke Kashiwakura /
Kyung-Hoon Kim / Rei Kishitsu / Yohei Koide /
Aki Kurata / Dai Kurokawa / Shingo Kuzutani /
Hiroko Masuike / Shigeki Miyajima / Yuki
Miyatake / Toru Morimoto / Takashi Nakagawa /
Takuma Nakamura / Shiro Nishihata / Satoshi
Oga / Kiyohiro Oku / Jiro Ose / Kiyoshi Ota /
Takashi Ozaki / Kyujiro Sakamaki / Hiroto
Sekiguchi / Atsushi Shibuya / Yoshi Shimizu /
Kazushige Shirahata / Rei Shiva / Akira Suemori /
Yasuhiro Sugimoto / Ryuzo Suzuki / Yusuke
Suzuki / Tadatomo Takagi / Kentaro Takahashi /
Satoshi Takahashi / Tetsuro Takehana /
Masayuki Terazawa / Sachie Torikai / Kenichi
Unaki / Daisuke Wada / Naohiro Yamada / Yuichi
Yamazaki

Jordan
Ammar Jamil Awad / Ahmad Gharabli /
Muhammed Muheisen

Kazakhstan
Grigoriy Bedenko / Ivan Bessedin

Kenya
Thomas Mukoya Abuoga / Kigen Cheboite /
Georgina Goodwin / Brian Inganga / Tony
Karumba / Joseph Kipsang / Simon Maina /
Kevin Midigo / Phoebe Okall / Thomas Omondi
Obiero / Brian Otieno

Kosovo
Armend Nimani

Kyrgyzstan
Danil Usmanov

Lebanon
Mustapha Elakhal / Natalie Naccache / Hasan
Shaaban / Marwan Tahtah / Rodrigue Zahr

Libya
Taha Jawashi / Taha Hussien Sayeh

Liechtenstein
Peter Klaunzer

Lithuania
Eimantas Genys / Tadas Kazakevicius /
Kazimieras Linkevičius / Renaldas Malychas /
Paulius Peleckis / Alfredas Pliadis / Andrius
Repšys

Macao
Yalin Shao

Macedonia
Tomislav Georgiev / Boris Grdanoski / Georgi
Licovski

Madagascar
Rija Emadisson / Rija Randrianasolo

Malaysia

Osman Adnan / Supian Ahmad / Muhamed Fathil Asri / Mohammad Azman Bin Abdul Ghani / Tan Chee Hon / Wei Seng Chen / Stefen Chow / Glenn Guan / Norman Hiu / Fazry Ismail / Firdaus Lati / Kah Meng Lek / Irwan Majid Majid / Mohamed Sairien Mohamed Nafis / Ahmad Yusni Mohammad Said / Mohd Faihan Mohd Ghani / Nick Ng Yeow Kee / Shahir Omar / Kah Vee Pan / Aizuddin Saad / Mohd Samsul Said / Lo Sook Mun / Chen Soon Ling / Ee Long Tan / Fok Loy Wong / Ahmad Yusni

Mali

Bakary Emmanuel Daou / Moussa Kalapo

Malta

Darrin Zammit Lupi

Mauritius

Kadrewvel Pillay Vythilingum

Mexico

Octavio Aburto / Theda Acha / Daniel Aguilar / Juan Pablo Ampudia / Santiago Arau Pontones / Guillermo Arias / Francisco Javier Belmont Bautista / Tamara Maria Blazquez Haik / Fernando Alfonso Brito Lizárraga / Fernanda Nikteha Cabrera / Narciso Contreras / Alejandro Cossio / Juan Carlos Cruz / Rodrigo Alberto Cruz Perez / José Rafael Cruz Vázquez / Rafael del Río Chávez / Emilio Espejel Sanchez Mejorada / Georgina Yelena Espinosa Pérez / Eduardo Feldman / Allan Fis Grossman / Gerardo Enrique Flores López / Eliud Gil Samaniego / Monica Gonzalez Islas / Claudia Guadarrama Guzmán / Hector Guerrero / José Emmanuel Guillén Lozano / Bernandino Hernandez / Nora Elsa Hinojo Escamilla / Rodrigo Jardon / Carlos Jasso / Miguel Juarez Lugo / Yael Martínez / David Martinez Pelcastre / Victor Medina / Eduardo Mejia / Pedro Ramon Mera Olguin / Alberto Alejandro Millares Méndez / José Luis Morales Luna / Karina Pampo / Anuar Patjane / Alejandro Prieto / Juan De Díos Ernesto Ramírez Bautista / Oswaldo Ramírez Sánchez / Pablo Luis Ramos García / Josue Rivas / Christian Rodriguez / Cristopher Rogel Blanquet Chavez / Ulises Ruiz Basurto / Omar Alejandro Ruvalcaba Casillas / Carlos Alberto Santiago Rocha / Armando Santibáñez Romellón / Diego Ricardo Sierra Moreno / Jordi Sifuentes / Enrique Sifuentes Ramos / Jorge Silva / Luis Octavio Silva Hoyos / Marcela Taboada Avilés / Andrea Tejeda / Joel Trejo / Sergio Antonio Velasco Garcia / Gerardo Vieyra / Jorge Villalpando Castro / Christian Vizl / Antonio Zazueta Olmos / Cortes Zuzunaga Luis

Moldova

Serghei Donets / Ramin Mazur / Anton Polyakov

Mongolia

Bayasule Bao / Rentsendorj Bazarsukh

Morocco

Abdellah Azizi / Seif Kousmate

Mozambique

Mario Macilau

Myanmar

Ye Aung Thu / Thet Htoo / Min Myo Nyan Win Ko Myo / Zay Yar Lin / Bo Bo Lynn / Nyein Chan Naing / Minzayar Oo

Namibia

Karel Prinsloo / Tielman N Van Lill

Nepal

Bijaya Biju / Uma Bista / Skanda Gautam / Prakash Mathema / Sharad Sharad / Narendra Shresta

The Netherlands

Mona Alikhah / Saskia Aukema / Jan Banning / Amit J. Bar / Shirley Barenholz / Cynthia Boll / Theo Bosboom / Henk Bothof / Jurriaan Brobbel / Maartje Brockbernd / Geert Broertjes / René Clement / Eelkje Colmjon / Rachel Corner / Roger Cremers / Merlin Daleman / Chris de Bode / Henk de Boer / Jan de Groen / Gerrit de Heus / Ralph de Pagter / Marco de Swart / Sander de Wilde / Aleid Denier van der Gon / Joep Derksen / Jasper Doest / Ellis Doeven / Jan Everhard / Bart Eysink Smeets / Floor Fortunati / Flip Franssen / Reinier Gerritsen / Guillaume Groen / Johan Hahn / Chantal Heijnen / Piet Hermans / Carina Hesper / Harry Heuts / Roberto Hüner / Jasper Juinen / Chris Keulen / Huub Keulers / Arie Elbert Kievit / Joris Knapen / Bart Koetsier / Carla Kogelman / Linsey Kuijpers / Adrian Kuipers / Bas Losekoot / Marinka Masséus / Ralf Mitsch / Frank Muller / Ilvy Njiokiktjien / Paco Nunez / Robert Oosterbroek / Van Der Lingen Oostland / Mardoe Painter / Ahmet Polat / Frans Poptie / Patrick Post / Pim Ras / Michael Rhebergen / Maikel Samuels / Alexander Schippers / Birgit Schuch / Merijn Soeters / Arjan Spannenburg / Jan-Joseph Stok / Ritzo Ten Cate / Cris Toala Olivares / Jeroen Toirken / Sander Troelstra / David van Dam / Kees van de Veen / Freek van den Bergh / Janus van den Eijnden / Selma van der Bijl-Umans / Catrinus van der Veen / Eveline van Elk / Patrick van Gemert / Joris van Gennip / Joel van Houdt / Ge-Jan van Leeuwen / Kadir van Lohuizen / Marielle van Uitert / Eddy van Wessel / Siese Jan Veenstra / Peter Verdurmen / Koen Verheijden / Anne-Marie Vermaat / Frank Viergever / Dirk-Jan Visser / Niels Wenstedt / Fleur Wiersma / Emily Wiessner / Robbert Wijtman / Lucas Wittebol / Sinaya Wolfert

New Zealand

Martyn Aim / Scott Barbour / Kent Blechynden / Martin de Ruyter / Glen Howey / Andy Jackson / Iain McGregor / Jiongxin Peng / Hannah Peters / Richard Robinson Grange / David Rowland / Mark Taylor / Staton Winter / Jing Zhao

Nigeria

Ademola Ajayi / Kunle Ajayi / Abayomi Ademola Akinlabi / Rasheed Akinyele / Yagazie Emezi / Odutayo Odusanya / Stanley Ogidi

Norway

Jarle Aasland / Odd Andersen / Morten Antonsen / Lise Åserud / Terje Bringedal / Bjorn Steinar Delebekk / Andrea Gjestvang / Eirik Grønningsæter / Johnny Haglund / Pål Christopher Hansen / Pål Hermansen / Katinka Marie Hustad / Arnfinn Johansen / Anne-Stine Johnsbråten / Anne Marit larsen / Daniel Sannum Lauten / Kyrre Lien / Jon Olav Nesvold / Adrian Nielsen / Aleksander Nordahl / Line Ørnes Søndergaard / Espen Rasmussen / Patrick da Silva Saether / Siv Johanne Seglem / Fredrik Varfjell / Hans Arne Vedlog / Grøtt Vegard Wivestad / Marie von Krogh / Otto von Münchow / Knut Egil Wang

Pakistan

Abdul Baqi / Zahid Hussain / Zoral Naik

Palestine

Mohammed Abed / Ibraheem Abu Mustafa / Ahmad Al-Bazz / Musa Alshaer / Alaa Badarneh / Laura Boshnak / Ahmed Deeb / Mahmoud El Hams / Ahmad Gharabli / Mahmud Hams / Wesam Hashlamon / Wisam Hashlamoun / Shadi Hatem / Ahmed Jadallah Salem / Mohammed Asad Muhaisen / Sameh Nidal Rahmi / Issam Rimawi / Mohammed Saber / Mohammed Salem / Suhaib Salem

Panama

Essdras M Suarez

Paraguay

Jorge Saenz

Peru

Eitan Abramovich Samesas / Omar Lucas Ara Castro / Gisella Benavides / Ernesto Benavide del Solar / Max Cabello Orcasitas / Sebastian Castañeda / Sharon Castellanos Tuesta / Osc Durand / Gladys E. Alvarado Jourde / Hector Emanuel / Carlos Garcia Granthon / Marco Gar Guillermo Gutierrez Carrascal / Alexis Huacch Magro / Silvia Izquierdo / Miriam Patricia Moreno Serpa / Erick Winder Nazario Gil / Musuk Nolte Maldonado / Leslie Searles / Christian Yonathan Ugarte Bravo / Javier Zap

The Philippines

Jesus Aznar / Xyza Bacani / Keith Kristoffer Bacongco / Mark Louis Balmores / Noel Celis Jonathan Cellona / Alexis Carlo Corpuz / Clare Fausto Cortes / Mark Cristino / Linus Escandor Carlo Gabuco / Oliver Garcia / Fernando Sepe Maria Virginia Cruz Sy / Amelito Tecson

Poland

Michał Adamowski / Michal Adamski / Piotr Augustyniak / Mateusz Baj / Andrzej Banas / Grzegorz Banaszak / Jacek Baranowski / Szymon Barylski / Krystian Bielatowicz / Mar Bielecki / Magdalena Błachuta / Filip Błażejowski / Marta Bogdanowicz-Kamirska Kamil Broszko / Grzegorz Celejewski / Łukasz Cynalewski / Wiktor Dabkowski / Dariusz Delmanowicz / François Devos / Michal Dyjuk Jacek Fota / Daniel Frymark / Jakub Gadek / Robert Gajda / Lukasz Gdak / Dominika Gesic Marcin Gimiński / Paweł Głogowski / Korneli Glowacka-Wolf / Arkadiusz Gola / Adam Gole Anna Gondek-Grodkiewicz / Jan Graczyński / Andrzej Grygiel / Wojciech Grzedzinski / Mare Grzesiak / Maciej Grzybowski / Adam Guz / Rafał Guz / Bartosz Hołoszkiewicz / Mariusz Janiszewski / Adam Jankowski / Monika Jaśkowska-Bablok / Adrian Jaszczak / Pawe Jędrusik / Tomasz Jodlowski / Bartlomiej Jurecki / Krzysztof Kalinowski / Jakub Kamins Grzegorz Klatka / Anna Klepaczko / Filip Klimaszewski / Jan Klos / Tytus Kondracki / Tadeusz Koniarz / Pawel Kosicki / Joanna Kosowska / Maciej Kosycarz / Kacper Kowal Andrzej Kozioł / Michal Krawiec / Karina Krystosiak / Arkadiusz Kubisiak / Dariusz Kurowski / Stanislaw Kusiak / Jacek Kusz / Jacek Labedzki / Adrian Lach / Pawel Laczny Marek Lapis / Arkadiusz Lawrywianiec / Tom Lazar / Damian Lemański / Gabor Lorinczy / Maciej Luczniewski / Zuzanna Lupa / Maciaj Maciąg / Krystian Maj / Aleksander Majdans Grażyna Makara / Krzysztof Mania / Tymon Markowski / Katarzyna Markusz / Boguslaw Maslak / Wojciech Matusik / Pawel Matyka / Andrzej Mikulski / Maciej Jan Moskwa / Joan Mrowka / Mikolaj Nowacki / Konstancja Now Konopka / Mateusz Ochocki / Patryk Ogorza Tomasz Padlo / Kacper Pempel / Mirosław Pieślak / Radoslaw Pietruszka / Paweł Piotrowski / Robert Pipala / Jakub Porzycki

rzysztof Racoń / Magdalena Rakita /
ksymilian Rigamonti / Jakub Robowski / Ewa
newicz / Adam Rostkowski / Bartosz Rozalski /
n Rusek / Michał Ryniak / Wojciech Ryzinski /
wek Rzewuski / Bartek Sadowski / Frej
bastian / Tomasz Sępień / Rafał Siderski /
chał Sita / Mateusz Skwarczek / Bartosz
óżyński / Dawid Stube / Waldemar Stube /
mona Supino / Michal Szalast / Andrzej
kocki / Kamil Szumotalski / Tomasz Szustek /
ek Szydłowski / Piotr Tracz / Anna Maria
wińska / Joanna Urbaniec / Michał Wende /
egorz Wójcik / Rafal Wojczal / Daniel
moczyl / Marcin Zaborowski / Marek
krzewski / Krzysztof Zatycki / Beata Zawrzel /
wid Zielinski / Michał Zieliński

rtugal
dré Alves / Rodrigo Antunes Cabrita / Vitor
nuel Barros / Carlos Barroso / Pedro
navente / Sandra Bernardo / Ana Brígida / Rui
, José Carlos Carvalho / Bruno Colaço /
rio Cruz / Leonel de Castro / Patricia De Melo
reira / Rui Duarte Silva / Nuno Fernandes /
ge Firmino / Pedro Fiuza / Bruno Fonseca /
e Fragozo / Lara Jacinto / João Carlos Santos /
no José Gonçalves / Eduardo Leal / Jose
es Amaral / Artur Machado / Helio Madeiras /
Maia / Ruben Filipe Mália / Egidio Eduardo
ıta Santos / Gonçalo Manuel Martins /
eta Moura / Pedro Noel da Luz / Paulo Nunes
Santos / Rui Oliveira / Antonio José Pedrosa
a Costa / Luis Pereira Barbosa / Rui Pires /
ardo Ramos / Miguel Ribeiro / Daniel
rigues / Reinaldo Rodrigues / Gonçalo Rosa
Silva / Francisco Salgueiro / José Carlos
gueiro / Pedro Saraiva / Bruno Simões
tanheira / Gonçalo Nuno Simões Rodrigues
rtins / Marcos Sobral / Vladislav Sokhin /
quim Pedro Teixeira Caseiro Dâmaso /
uel Wise

rto Rico
é Enrique Jimenez Tirado / Dennis Jones /
os Alejandro Rivera Giusti / Erika P.
ríguez

nania
reea Alexandru / Horia Razavan Calaceanu /
ut Calinescu / Andreea Campeanu /
heliu Cazacu / Vasile-Vlad Chirea / Vadim
rda / Amnon Gutman / Cosmin Iftode /
gos Lumpan / Silviu Matei / Ioana Moldovan /
in Pascaluta / Mircea Restea / Mugur
tariu

sia
ey Abanin / Aleksandr Agafonov / Egor Aleev /
gavko Alexey Sergey / Alexander Anufriev /
rey Arkhipov / Vladimir Astapkovich / Dmitr
rov / Maxim Babenko / Xueqi Bai / Eugenia
unova / Dmitri Beliakov / Victor Berezkin /
try Berkut / Yulia Bezuglova / Sergey
ylev / Alexei Boitsov / Julia Borovikova /
tina Brazhnikova / Svetlana Bulatova / Denis
n / Aleksandr Buzin / Konstantin Chalabov /
triy Chelyapin / Andrey Chepakin / Elena
nyshova / Roman Demyanenko / Boris
natovsky / Tatyana Egorova / Sasha Elfman /
eny Epanchintsev / Dmitry Ermakov / Sergey
okhin / Anastasia Evsinekina / Alexander
renko / Evgeny Feldman / Dmitry Feoktistov /
ey Filippov / Vladimir Finogenov / Iulia
shina / Albert Garnelis / Daria Garnik / Emil
ullin / Mary Gelman / Artem Geodakyan /
il Gilvanov / Andrey Golovanov / Pavel
vkin / Grigory Golyshev / Kirill Gorelov / Tata
an / Mikhail Grebenshchikov / Maxim

Grigoryev / Yuri Gripas / Igor Gruzdev / Sergei
Gubanov / Sergei Guneyev / Viktor Guseinov /
Sergei Ilnitsky / Ilyas Ilyasov / Daria Isaeva /
Evgenii Ivanov / Misha Japaridze / Mikado
Kadachnikov / Yuri Kadobnov / Oleg Kargapolov /
Nikolai Khizhniak / Yury Khodzitskiy / Elena
Khovanskaya / Sergei Kivrin / Ivan Kobilyakov /
Alexey Kompaniychenko / Sergey
Kompaniychenko / Oleg Konstantinov / Eduard
Korniyenko / Maxim Korotchenko / Dmitry
Kostyukov / Ludmila Kovaleva / Denis
Kozhevnikov / Yuri Kozyrev / Alexandr Kryazhev /
Kirill Kudryavtsev / Kirill Kukhmar / Alexey
Kunilov / Vladimir Lamzin / Oleg Lastochkin /
Artur Lebedev / Dmitry Aleksandrovich Lebedev /
Artem Lunev / Natalia Lvova / Svetlana
Makoveeva / Marina Makovetskaya / George
Malets / Vadim Massalimov / Vladimir Melnik /
Valery Melnikov / Raisa Mikhaylova / Anna
Miroshnichenko / Viatcheslav Mitrokhin / Carla
Moral / Irina Motina / Boris Mukhamedzyanov /
Anton Mukhametchin / Ovik Mushegyan /
Sergey Nazarov / Juri Nesterenko / Vitaly Nevar /
Andrey Nikerichev / Valeri Nistratov / Sergey
Novikov / Anton Novoderezhkin / Georgi Orlov /
Valentinas Pecininas / Vladimir Pesnya /
Alexander Petrosyan / Misha Petrov / Eugene
Petrushanskiy / Ivan Petrushin / Ilya Pitalev /
Maria Plotnikova / Svetlana Pojarskaya /
Alexandr Polyakov / Vladimir Pomortsev / Oleg
Ponomarev / Ksenia Posadskova / Fedor
Prokofjev / Andrey Pronin / Sergey Pyatakov /
Ekaterina Repina / Andrey Rudakov / Anastasia
Rudenko / Fyodor Savintsev / Alexander
Scherbak / Natalia Seliverstova / Andrey
Semenov / Evgeniy Serov / Valeriy Sharifulin /
Sergey Shchekotov / Anna Shulyatyeva / Denis
Sinyakov / Yuliya Skorobogatova / Olga
Smirnova / Yuri Smityuk / Donat Sorokin /
Alexander Stepanenko / Natalia Stupnikova /
Kristina Syrchikova / Grigory Sysoev / Alexander
Taran / Svetlana Tarasova / Yaroslava Tarasova /
Fyodor Telkov / Lena Tsibizova / Anton Unitsyn /
Alexander Usanov / Alexander Utkin / Tatiana
Valko / Alexander Vedernikov / Vladimir
Velengurin / Anton Velikzhanin / Tatiana
Vinogradova / Smirnov Vladimir / Pavel Volkov /
Vladimir Vyatkin / Irina Yulieva / Oksana
Yushko / Natalya Yuzeeva / Alexey Zamorkin /
Konstantin Zavrazhin / Alexander
Zemlianichenko / Anatoly Zhdanov / Elena
Zhunova / Maxim Zmeyev

Saint Kitts & Nevis
Wayne Lawrence

Saudi Arabia
Iman Aldabbagh / Tasneem Alsultan

Senegal
Ousmane Ndiaye Dago

Serbia
Oliver Bunic / Igor Čoko / Marko Djurica /
Svetlana Dojcinovic / Marko Drobnjakovic /
Andrej Isakovic / Marija Jankovic / Aleksandar
Kamasi / Milutin Markovic / Predrag
Milosavljevic / Mitar MItrovic / Nemanja Pancic /
Igor Pavicevic / Aleksandar Plavevski / Marko
Risovic / Srdjan Sulejmanovic / Goran
Tomasevic / Dragana Udovicic / Vladimir
Zivojinovic

Singapore
Suhaimi Abdullah / Amrita Chandradas / Young
How Hwee / Zann Huizhen Huang / Yong Teck
Lim / Ranjan Ramchandni / Chih Wey Then /
David Wirawan

Slovakia
Martin Bandzak / Rene Fabini / Dorota Holubová /
Jan Husar / Peter Korcek / Juraj Mravec / Jana
Rajcova / Igor Stančík / Gabriela Teplicka

Slovenia
Almira Ćatović / Maja Hitij / Ciril Jazbec / Matjaz
Krivic / Dejan Mijović / Andrej Petelinšek /
Andrej Tarfila / Samo Vidic / Tadej Znidarcic

Somalia
Mohamed Abdwiwahab / Feisal Omar / Mustafa
Saeed

South Africa
Neil Aldridge / Pieter Bauermeister / Marius
Bosch / Rodger Bosch / Madelene Cronjé /
Adrian De Kock / Felix Dlangamandla / Paul Gary
Botes / Brenton Geach / Ihsaan Haffejee /
Christiaan Kotze / Kim Ludbrook / Moeletsi
Mabe / Aurélie Marrier D'Unienville / Joy Meyer /
James Oatway / Mujahid Safodien / Susan Scott /
Alon Skuy / Gareth Smit / Brent Stirton / Cornell
Tukiri / John Wessels / Mark Wessels

South Korea
Jinsub Cho / SeongJoon Cho / Woohae Cho / Yoo
Jin Choi / Sung-Young Chun / Jean Chung / Jae
C. Hong / Jinhwon Hong / Heon-Kyun Jeon /
Hanjo Jung / Sanghwan Jung / Hong-Ji Kim /
SeongGwang Kim / Byeongsik Lim / Haseon
Park / Jun Michael Park / Jungkeun Park /
Joonhee Shin

Spain
Borja Abargues / Alfredo Aguilar Rubio / Pedro
Luis Ajuriaguerra Saiz / Vicente Albero Irles /
Martí Albesa Castañer / Sergi Alcazar Badia- /
David Aliaga Martínez / Biel Aliño / Eloy Alonso /
Román Alonso / Delmi Alvarez / Samuel Aranda /
Celestino Arce Lavi / Javier Arcenillas / Pablo
Argente Ferrer / Juan Arias Soler / Bernat
Armangue / Gonzalo Arroyo Moreno / Antolin
Avezuela Aristu / José Aymá Gonzalez / Javier
Aznar / Alberto Barba Pardal / Raul Barbero
Carmena / Pau Barrena Capilla / Sergio
Barrenechea de la Fuente / Alvaro Barrientos /
Edu Bayer / Raúl Belinchón Hueso / Iván Benítez
Forniés / Unai Beroiz / Andoni Berriochoa
Gabiria / Pablo Blazquez Dominguez / Enric
Boixadós / Jordi Boixareu / Anna Bosch / Jordi
Busque / Jordi Busquets Nuell / Albert Busquets
Plaja / Lluis Busse / Germán Caballero / Tomas
Calle / Enrique Calvo / Olmo Calvo Rodríguez /
Sergi Camara Loscos / Alejandro Cámara
Martínez / Salvador Campillo Alba / Bernat
Camps Parera / Miguel Candela / Juan Carlos
Cárdenas Plá / Felipe Carnotto Díaz / Daniel
Castro Garcia / Xavier Cervera Vallve / Gregori
Civera / Pablo Cobos Terán / Jordi Cohen
Colldeforns / Pau Coll Sanchez / Jose Colon
Toscano / Maria Contreras Coll / Ramon Costa
López / Carlos de Andrés / Joan de la Malla /
Ofelia de Pablo del Valle / Javier de Pablo del
Valle / Samuel de Román / Oscar del Pozo /
Emilio José Delgado Fraile / Cesar Dezfuli /
Nacho Doce / Oscar Dominguez / Adrián
Domínguez / Miguel Egido Martínez / Sergio
Enríquez-Nistal / Josep Mª Escoda Borràs /
Sergi Escribano / Ramon Espinosa / Patricia
Esteve González / Alberto Estévez / Jesús F.
Salvadores / Joaquín Farrero MartÍnez / Erasmo
Fenoy / Javier Fernandez / Jose Miguel
Fernandez De Velasco / Ekaitz Filarmendi
Urrutia / Angel Fitor / Carlos Folgoso Sueiro /
Claudia Frontino / Alvaro Fuente / Garikoitz
Garaialde / Santiago Garces / Jaime Garcia /
Jota Garcia / Àngel García / Jesús García /

Roberto García Díaz / Albert Garcia Gallego / José Jaime Garcia Garcia / Isidro García Puntí / Pablo Garcia Sacristan / Ricardo Garcia Vilanova / Aitor Garmendia / Juli Garzon Comas / Eugeni Gay Marín / Carlos Gil / José Pascual Gil Rubio / Sonia Giménez Bellaescusa / Susana Girón / Gema Gómez Forgas / Joaquin Gomez Sastre / David González / Mdolors Gonzalez - Luumkab / Daniel González Acuña / Jorge Gonzalez Moreno / Pedro Pablo González Rodriguez-Armestre / Amador Guallar / Jorge Guerrero Ordonez / Francisco Javier Guiñales Gutiérrez / Isamel Guye / Antonio Heredia Sánchez / Nacho Hernandez / Jose Ángel Hernandez Gomez / Diego Ibarra Sánchez / Agustín Iglesias Otero / Jorge Miguel Jaime Baez / Jesus Jimenez / Rodrigo Jimenez Torrellas / Miguel Angel Jorquera / Maria Jou Sol / Xabier Mikel Laburu van Woudenberg / Pablo Lasaosa / Daniel Leal Olivas / Sebastian Liste Vicario / Antonio López Diaz / Jorge López Muñoz / Jose Manuel Lopez Perez / José A. López Soto / Nuria López Torres / Brais Lorenzo / Javier Luengo / Cesar Julio Manso Arroyo / Clara Margais / Jose Enrique Marin Zarza / Francisco Márquez Sánchez / Roberto Martínez Astorgano / Diego Martinez Carulla / Andrés Martinez Casares / Javier Martinez Llona / Núria Martinez Seguer / Alejandro Martinez Velez / Héctor Mediavilla / Patrick Meinhardt / Jose Luis Mendez Fernandez / Álvaro Minguito Palomares / Pablo Miranzo Macià / Fernando Moleres / Pep Morata Morales / Marta Moreiras / Emilio Morenatti / Raúl Moreno / Jesus Moron / David Mudarra / Angel Luis Navarrete Cuervo / Gloria Nieto Alvarez / Cristina Núñez Baquedano / Daniel Ochoa de Olza / Henar Ortega Hortigüela / Carles Palacio I Berta / Santi Palacios / Alberto Paredes Pena / Eva Pascual Reyes / Iker Pastor Guerra / Cipriano Pastrano Delgado / Francisco José Pelay Cortés / Marta Perez Lopez / Jesús Pérez Marabel / Francisco Javier Pérez Moure / Encarnación Pindado González / Daniel Planas Labad / Juan Plasencia García / Mariano Pozo Ruiz / Rafael Marchante Rafael Marchante / David Ramos / Joaquin Ramos / Joan Manuel Ramos Fernandez / Elias Regueira Garcia / Jaime Reina Alcocer / Pablo Requejo García / Francisco Richart / Miguel Riopa / Daniel Ríos / Angel Rivero Perez / Daniel Rodríguez Cabrera / Fermín Rodríguez Fajardo / Jose Luis Rodriguez Sanchez / Alberto Rojas / Jaime Rojo / Jordi Ruiz Cirera / María Del Mar Sáez Martínez / Rubén Salgado Escudero / Daniel Salvà / Moises Saman / Griselda San Martin Alonso / Natalia Sancha García / Borja Sanchez / Javier Sanchez-Monge Escardo / Guillem Sartorio / Jordi Secall I Pons / Faustino Soriano Marco / Carlos Spottorno / Teresa Suárez Zapater / Anna Surinyach / Luis Tato / Llibert Teixidó Ballester / Javier Teniente Lago / Gabriel Tizon Vazquez / Maria Torres-Solanot / Felipe Trueba / Jose Uris Domingos / Guillem Valle / Joan Valls / Rubén Vázquez / Susana Vera / Jordi Vidal Cotrina / Roser Vilallonga Tena / Gabriel Villamil / Jaime Villanueva / Pere Virgili / Alvaro Ybarra Zavala / Miguel Zavala / García Zurita

Sri Lanka
Indunil Usgoda Arachchi / Pradeep Dambarage / Vimukthi Indrajith Embuldeniya / Ruwan Meegammana / Musthaq Thasleem

Sudan
Mohamed Abdallah / Salih Basheer Abdelgabar

Suriname
Ranu Abhelakh / Roy Ritfeld

Sweden
Joel Alvarez / Urban Andersson / Andreas Bardell / Niclas Berglund / Loulou D'Aki / Troy Enekvist / Åke Ericson / Malin Fezehai / Anders Forngren / Linda Forsell / Jessica Kristina Gow / Niclas Hammarström / Paul Hansen / Anders Hansson / Lotta Härdelin / Casper Hedberg / Robert Henriksson / Christoffer Hjalmarsson / Peter Holgersson / Pontus Hook / Olof Jarlbro / Stefan Jerrevång / Simon Johansson / Moa Karlberg / Jesper Klemedsson / Pavel Koubek / Lina Larsson / Roger Larsson / Magnus Laupa / Fredrik Lerneryd / Jonas Lindkvist / Lars Lindqvist / Nora Lorek / Staffan Löwstedt / Daniel Malmberg / Joel Marklund / Lisa Mattisson / Jack Mikruit / Daniel Milton / Jonathan Nackstrand / Anette Nantell / Michael Nasberg / Daniel Nilsson / Nils Petter Nilsson / Cletus Nelson Nwadike / Emilia Petersson Ellafi / Carl Sandin / Sebastian Sardi / Stig Torbjorn Selander / Åsa Mikaela Sjöström / Sanna Sjosward / Tom Svensson / Ola Torkelsson / Roger Turesson / Elisabeth Ubbe / Magnus Wennman / Jimmy Wixtröm / Peter Wixtröm

Switzerland
Niels Ackermann / Zalmaï Ahad / Reto Albertalli / Sébastien Anex / Daniel Auf der Mauer / Valérie Baeriswyl / Denis Balibouse / Franco Banfi / Christian Bobst / Nicole Boekhaus / Jean-Christophe Bott / Stéphanie Buret / Christophe Chammartin / Michele Crameri / Sibylle Feucht / Massimiliano Hirzel / Piotr Jaxa / Blaise Kormann / Patrick Bruno Kraemer / Alex Lambrechts / Christian Lutz / Pascal Mora / Dominic Nahr / Rolf Neeser / Massimo Pacciorini-Job / Nicolas Righetti / Patrick Rohr / Thomas Sbampato / Meinrad Markus Schade / Chris Schmid / Roland Schmid / Claudio Sieber / Dominic Steinmann / Simon Tanner / Olivier Vogelsang / Michael von Graffenried / Andreas Walker / Thomas Weisskopf / Stefan Wermuth / Matthieu Zellweger

Syria
Msallam Abd Albaset / Ammar Abd Rabbo / Zakaria Abdelkafi / Sameer Al-Doumy / Nazeer Al-khatib / Khalil Ibrahim Alachawi / Carole Alfarah / Amer Almohibany / Thanaa Arnaout / Mohammed Badra / Abd Doumany / Abdulmonam Eassa / Sami Kara Ali / Bassam Khabieh

Taiwan
Tien Shiung Chang / Boheng Chen / Cho Pang Chen / Nana Chen / Chia-Chang Hsieh / Chuang Kun Ju / Yu-en Lin / Tzu Cheng Liu / Yu Hsuan Sheu / Yingting Shih / Chienyi Tseng / Ed Wu / Chih-Wei Yu / Chun-Te Yuan

Thailand
Piti Anchaleesahakorn / Sirachai Arunrugstichai / Panupong Changchai / Tanat Chayaphattharitthee / Bundit Chotsuwan / Jittrapon Kaicome / Athit Perawongmetha / Atiwat Silpamethanont / Natis Sirivatanacharoen / Rungroj Yongrit

Tunisia
Ons Abid / Amine Landoulsi

Turkey
F. Serra Akcan / Ali Can Altunbaş / Özkan Bilgin / Sinan Cakmak / Ünal Çam / Sabiha Çimen / Onur Çoban / Şebnem Coşkun / Nazim Dastan / Cagdas Erdogan / Salih Zeki Fazlıoğlu / Abdurrahman Gök / Tahsin Engin Gökten / Mehmet Ilbaysozu / Emrah Kartal / Barbaros

Kayan / Sevilay Kelek / Yunus Keleş / Ertugrul Kilic / Ozge Elif Kizil / Murat Kula / Levent Kul Mustafa Olgun / Riza Özel / Emin Özmen / Ali Ihsan Öztürk / Murat Saka / Murat Şengül / Uygar Onder Simsek / Ercin Top / Tahir Ün / Aytaç Ünal / Arif Hudaverdi Yaman / Güven Yılmaz / Fırat Çağlayan Yurdakul

Uganda
Max Bwire / Martin Kharumwa / Esther Mbabaz Maria Wamala

Ukraine
Arthur Bondar / Andriy Cherchenko / Pavel Dorogoy / Alexander Ermochenko / Gleb Garanich / Oleksandr Kromplias / Dmytro Kut Oleg Makovskyi / Pavlo Maydikov / Oleg Nikitenko / Mykhaylo Palinchak / Oksana Parafeniuk / Stepan Rudik / Oleksandr Rupet Zoia Shulga / Ganna Smal / Anatolii Stepanov Anatoliy Stepanov / Volodymyr Tverdokhlib / Anastasia Vlasova / Svitlana Yanovska

United Kingdom
Carl Adams / Alice Aedy / Roger Allen / Charlc Anderson / Olivia Arthur / Matthew Aslett / Guilhem Baker / Vince Bevan / Harry Borden Shaun Botterill / Tom Bourdon / Andrew Boye Joshua Bright / Henry Browne / Clive Brunski Fernando Carniel Machado / Brian Cassey / Peter Caton / Matt Cetti-Roberts / David Chancellor / Dan Charity / D J Clark / Garry Clarkson / Constantine Corbas / Andy Couldridge / Damon Alexander Coulter / Carl Court / Edward Crawford / Tim Cuff / Ben Curt Simon Dack / Nick Danziger / Prodeepta Das Jon Davey / Simon Dawson / Carl de Souza / Adam Dean / Peter Dench / Kieran Dodds / Alecsandra Raluca Dragoi / Luke Dray / Jilliar Edelstein / Marc Ellison / Chris Fairweather / Taimur Faruki / Rick Findler / Julian Finney / Adrian Fisk / Stuart Forster / Ian Forsyth / Andrew Fosker / Stuart Freedman / Robert Gallagher / Kieran Galvin / Sophie Gerrard / D Giannopoulos / Joe Giddens / Michael Goldre Anna Gordon / David Graham / Lorenzo Grifantini / Laurence Griffiths / Andy Hall / N Hall / Robin Hammond / Owen Joseph Harvey Philip Hatcher-Moore / Richard Heathcote / Mark Henley / Clare Hewitt / Michael Hewitt Jack Hill / Adam Hinton / Katherine Holt / Da Homewood / Andrew Hone / Mike Hutchings Jonathan Hyams / Dan Istitene / Ian Jacobs / Thabo Jaiyesimi / Bram Janssen / Thomas Jenkins / Stefan Jeremiah / Ed Jones / Tobin Jones / Michael Kemp / Hugh Kinsella Cunningham / Glyn Kirk / Dan Kitwood / Chin Lee / Louis Leeson-Smith / Geraint Lewis / Ia MacNicol / Robert Martin / Dylan Martinez / Clive Mason / Rachel Mccowat Taylor / Hann. McKay / Toby Melville / Burhan Mohammed / Jeff Moore / Gregory Moss / Nicola Muirheac Daniel Mullan / Arun Nangla / Leon Neal / Ma Neville / Lucy Nicholson / Philip Noble / Bria Cliff Olguin / Alfred Oluwatoyin Oshodi / Jude Palmer / Colin Pantall / Stuart Paton / Marcu Perkins / Robert Perry / Kate Peters / George Philipas / Christopher Pillitz / Christopher Pledger / Giles Price / Kathleen Prior / Howa Pugh / Paul Raftery / Andy Rain / Carl Recine Martin Richardson / Nigel Roddis / Stefan Rousseau / David Sandison / Oliver Scarff / Gabriele Sciotto / Bradley Secker / Jeremy Selwyn / Justin Setterfield / Richard Seymou Simon Sharp / David Shaw / John Sibley / Le Stephen Smith / Toby Smith / Kate Stanwort Rob Stothard / Matt Stuart / Shi Tang / Sam Tarling / Anastasia Taylor-Lind / Ian Teh /

mond Terakopian / Andrew Testa / Claire
omas / Sarah Tilotta / Tommy Trenchard /
neon Trenchev / Mary Turner / Aubrey Wade /
p Warwick / Sophie Wedgwood / Andrew
ekes / Alex Whitehead / Mathieu Willcocks /
nes Williamson / Andrew Sun Tun Wong /
nes Wright / Chris Young / David Young / Tariq
di / Alice Zoo

ited States
sey M Addario / Bess Adler / Jennifer Adler /
x Aguilera-Hellweg / Diana Zeyneb Alhindawi /
ol Allen-Storey / Kainaz Amaria / Frank
on / Jason Andrew / John Angelillo / Drew
gerer / Bryan Anselm / Karen Anthony /
ardo Arduengo / Corey Arnold / Aleksandra
tyunova / Jonathan Bachman / Zachary Bako /
lah Amatullah Barrayn / Don Bartletti /
xander Basaraba / William Allen Baxter /
l Beaty / Robert Beck / David Becker / Al
lo / Daniel Beltrá / Amy Beth Bennett / Bruce
nnett / Noah Berger / Joshua Bergeron / Alan
ner / Brian Bielmann / William Keith
mingham / Kirsten Bitzer / Michael Blake /
ah Blesener / Victor Blue / John Boal / Anna
iazis / Scott Brennan / Richard Brian / Paula
nstein / Milbert Brown / Andrea Jean Bruce /
ra Buckman / Joe Buglewicz / Gerard
khart / Andrew Burton / Matthew Busch /
se Butler / Renée Byer / Andrew Caballero-
nolds / Mary F. Calvert / Robert Lee Carr /
eph Cavaretta / Barry Chin / Jessica Chou /
hael Chow / Jessica Christian / André Chung /
thew Cicanese / Giles Clarke / Jay L.
ndenin / Nadia Shira Cohen / Carolyn Cole /
e Comer / Thomas Cordova / Gary Coronado /
nuel Corum / Andrew Craft / Scott Dalton /
ren DeCicca / Harriet Dedman / Louis
uca / Bryan Denton / Julie Dermansky / Sima
/ Jessica Dimmock / Olivier Douliery / Craig
ning / Daniel Dreifuss / Alice Driver /
stide Economopoulos / Josh Edelson /
othy Edwards / Debbie Egan-Chin / Matt
/ Khlood Eid / Sean Elliot / Loren Elliott /
ald Erdrich / Peter Essick / Josh Estey /
rge Etheredge / Timothy Fadek / Steven M.
/ Patrick T. Fallon / Heidi Fang / Megan
ner / Gina Ferazzi / Jon Ferrey / Marcus
tl / Deanne Fitzmaurice / Annie Flanagan /
nine Flaton-Buckley / Lauren Fleishman /
Flynn / Hannah Foslien / Charles Fox / Tom
/ Ric Francis / Brian L. Frank / Dustin Franz /
abeth Fraser / Misha Friedman / Trevor Frost /
sandr Fumarov / Sean Gallup / Preston
naway / Eugene Garcia / Marco Garcia /
k Garten / Ryan Garza / Salwan Georges /
aldine Hope Ghelli / Melissa Golden / David
man / Glenna Gordon / Gise Greenway /
Gulick / Erol Gurian / Michelle Gustafson /
s Gutknecht / David Guttenfelder / Carol
y / Maan Habib / Jane Hahn / Bob Hallinen /
Haner / Paul Hanna / Dariyoosh Hariri /
rew Harnik / Andrew Harrer / Mark Edward
ris / Matthew Hatcher / Karl Haupt / Jeff
nes / Laura Heald / Todd Heisler / Max
man / Edward Hersom / Allison Hess / Sam
dt / Matthew Hinton / Evelyn Hockstein /
adan Hoffman / Sarah Hoffman / Jeremy
an / Mark Holtzman / Erin Hooley / Sarah
kins / Christina House / Vasha Hunt / Peg
ter / Jennifer Huxta / John Ishii / Ellen Jacob /
y Jacobsohn / Kerrick James / Yalonda
es / Jay Janner / Monique Jaques / Megan
ger / Joseph Johnston / Alvin Jornada /
on Joyce / Joel Angel Juarez / Greg Kahn /
n Kasmauski / Mark Kauzlarich /
stopher Keane / Reseph Keiderling /
hanie Keith / Ryan M. Kelly / James Kenney /

Jeffrey Kerby / Calla Kessler / Laurence
Kesterson / Natalie Keyssar / John Kim / John
Kimmich / Kohjiro Kinno / T.J. Kirkpatrick / Paul
Kitagaki Jr. / David Klutho / Mackenzie Knowles-
Coursin / Luc Kordas / Isadora Kosofsky / Lisa
Krantz / Suzanne Kreiter / Kelsey Kremer /
Christopher LaMarca / Rodney Lamkey, Jr. / John
Lamparski / Mette Lampcov / Ashley Landis /
Gerardo Lara / Adrees Latif / Gillian Laub / Jae
Lee / Matthew John Lee / Erik S. Lesser / Marc
Lester / Amir Levy / Kevin Liles / Dina Litovsky /
Jim Lo Scalzo / Jeremy Lock / Delcia Lopez /
Katharine Lotze / Spencer Lowell Mishlen /
Robin Loznak / Kirsten Luce / Gabrielle Lurie /
M.Patricia Lynch / Melissa Lyttle / Chris
Machian / Jose Luis Magana / Michael Magers /
Michael Scott Mashaskey / David Maialetti / Todd
Maisel Andre Malerba / Melina Mara / Diana
Markosian / Pete Marovich / Joel Martinez /
Pablo Martínez Monsiváis / Sahsa Maslov / AJ
Mast / Soraya Matos / Dania Maxwell / Matthew
McClain / Kristi McCluer / John McDonough /
Michael F. McElroy / Madalyn McGarvey / Bruce
McNamee / Eric Mencher / Peter J. Menzel /
Justin Mark Merriman / Rory Merry / Sebastian
Meyer / Johnny Milano / Victoria Milkovich /
Sarah A. Miller / Andrew Mills / Lianne Milton /
Donald Miralle / Logan Mock-Bunting / Genaro
Molina / Philip Montgomery / John Moore /
Andrea Morales / John Moran / Kimberly Nicole
Moran-Woo / David Moriya / Christopher Morris /
David Paul Morris / Laura Morton / Bonnie Jo
Mount / Zora Murff / Jordan Murph / Edward
Murray / Nish Nalbandian / Jacob Naughton /
Sol Neelman / Greg Nelson / Kathryn Nelson /
Andreas Neumann / Gregg Newton / Jonathan
Newton / Michael Nigro / Benjamin Norman /
Thomas Nybo / Caitlin O'Hara / Michael Patrick
O'Neill / Adriane Sage Ohanesian / Scott Olson /
Francine Orr / Amy Osborne / Mike Osborne /
Nitin K Oza / Darcy Padilla / Michele Palazzo /
Brian Palmer / Ilana Panich-Linsman / Jason
Patinkin / Amy Pearson / John Francis Peters /
Mark Peterson / Scott Peterson / Jessica Phelps /
David J. Phillip / Stephen Phipps / Holly Pickett /
Terry Pierson / Matthew Pillsbury / Spencer
Robert Platt / William B. Plowman / Robert
Pluma / Suzanne Plunkett / Smiley Pool /
Mamta Popat / Alex Potter / David Lee Proeber /
Alice Proujansky / Chelsea Purgahn / Staton
Rabin / Joseph Raedle / Erick Rasco / James
Rassol / Jonno Rattman / Julia Rendleman /
Andrew Renneisen / Adam Reynolds / Sarah
Rice / Emilie Richardson / Charlie Riedel /
Jessica Rinaldi / Kevin Rivoli / Zachary Roberts /
Michael Robinson Chavez / Ricardo Rocamora /
James Rodriguez / Paul Rodriguez / Gabriel
Romero / Andrea Rosebush-DiCenzo / Jenny
Ross / Christine Ruddy / Jeffrey Russell / RJ
Sangosti / Aaron Joel Santos / Marcus Santos /
Troilan Santos / Dustin Satloff / Erich Schlegel /
Susan Schulman / Patrick Semansky / Jon
Shapley / Luke Sharrett / Ezra Shaw / Shay Shay
Horse / Qilai Shen / Ricci Shryock / Sam
Simmonds / Denny Simmons / Mike Simons /
Stephanie Sinclair / Luis Sinco / Wally Skalij /
Laurie Skrivan / Brendan Smialowski / Ali Smith /
Byron Smith / Drew Anthony Smith / Patrick
Smith / Steven G. Smith / Brian Snyder / Jared
Soares / Nichole Sobecki / Kenneth Somodevilla /
Brianna Soukup / Triston Spinski / Maranie Rae
Staab / John Stanmeyer / Susan Stava / George
Steinmetz / Chase Stevens / Mike Stocker /
Susan Stocker / Robert Stolarik / Scott
Strazzante / Justin Sullivan / Lawrence
Sumulong / Chitose Suzuki / Lea Suzuki / Lexey
Swall / Hilary Swift / Terray Sylvester / Marcin
Szczepanski / Kayana Szymczak / John Taggart /

Taimy Alvarez Taimy Alvarez / Mario Tama /
Andri Tambunan / Wei Tan / Ross Taylor / Patrick
Tehan / Shmuel Thaler / Eric Thayer / Albert
Tielemans / Lonnie Timmons III / Tara Todras-
Whitehill / Amy Toensing / Jonathan Torgovnik /
Winslow Townson / Erin Grace Trieb / Robert
Tringali / Linda Troeller / John Trotter / Richard
Tsong-Taatarii / Nicole Tung / Thomas Turney /
Jane Tyska / Dana Ullman / Gregory Urquiaga /
Nuri Vallbona / Joseph Van Eeckhout / Carolyn
Van Houten / Anand Varma / Brad Vest / Ami
Vitale / Amanda Voisard / Sarah Voisin / Stephen
Voss / Fred Vuich / Mark Wallheiser / Guy
Wathen / Jim Watson / Susan Watts / Emree
Malone Weaver / Taylor Weidman / Sandra Chen
Weinstein / Jim West / Jay Westcott / Andrew
White / Jared Wickerham / Jeff Widener /
Christian Wilbur / Danny Wilcox Frazier / Rick T.
Wilking / Jana Williams / Robert Wilson / Damon
Winter / Steve Winter / Dan Winters / Roger
Woodruff Arnold / Rachel Woolf / Alex
Wroblewski / Arash Yaghmaian / Devin Yalkin /
Marcus Yam / Caroline Yang / Cenzig Yar / Kiliii
Yuyan / Daniella Zalcman / Mark J. Zaleski /
Jingtao Zhao / Moe Zoyari

Uruguay
Ana Ferreira / Santiago Barreiro / Julio Etchart /
Guillermo Giansanti / Enrique Kierszenbaum

Uzbekistan
Anzor Bukharsky

Venezuela
Leonardo Alvarez / Orlando Baquero Suarez /
Juan Barreto / Carlos Becerra / Juan Pablo
Bellandi / Marco Antonio Bello / Luis Cabrera /
Jose Caruci / Oscar B. Castillo / Alejandro
Cegarra / Luis Cobelo / Ariana Cubillos / Jaime
De Sousa / Fabiola Ferrero / Carlos Garcia
Rawlins / Roberto Jesús Gil Padrino / Juan
Carlos Hernandez Soria / Fernando Llano /
Miguel Lopez / Adriana Loureiro Fernández /
Vladimir Marcano / Gregorio Marrero / Giovanna
Mascetti / Humberto Matheus / Rodolfo Antonio
Mejías Molina / Jacinto Oliveros / Federico Parra /
Alejandro J Paredes Perez / Manaure Quintero /
Wilfredo Riera / Reynaldo Riobueno / Carlos
Sanchez / Ronaldo Schemidt / Belinda Soncini /
Jaime Villalta / Saúl Zerpa

Vietnam
Lam Khanh Bui / Chinh Huu Luong / Thanh Hai
Nguyen / Khanh Nguyen Thanh / Quang Phan /
Anh Tuan Vu / Thao Vu Xuan

Yemen
Khaled Abdullah / Yahka Arhab / Thana Faroq /
Mansour Mohen

Zimbabwe
Lucy Broderick / Charmaine Chitate / Angela
Jimu / Davina Jogi / Jekesai Njikizana / Zinyange
Auntony Ruzvidzo

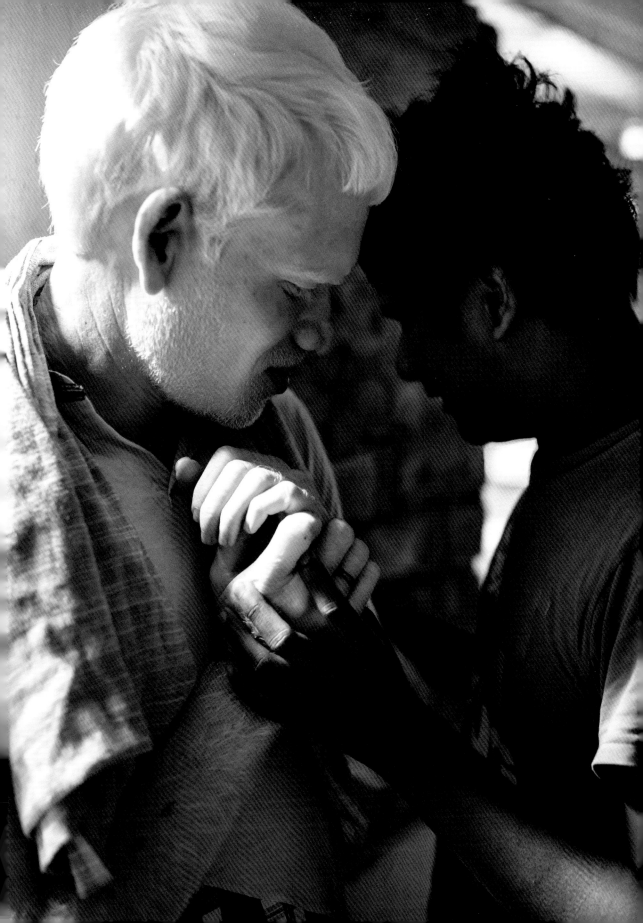

Canon Ambassador Brent Stirton on blindness: There are more than 40 million blind people in the world today. Most of them don't have to be – people simply need access to decent eye care from an early age. Sadly, millions live without it and are forced to experience an ever-darkening world. It doesn't have to be that way.

I was in India working on a story about a cure for blindness when I heard about an amazing school for blind students. It's one of the few facilities of its kind in India, a place where many blind people are condemned to a lifetime of begging – a short and hard existence. This school represents a rare investment in care for the blind and is linked to a hospital that performs free surgery for the poorest of the poor to help them regain their sight.

On my first day there, I noticed a tight knit group of boys with albinism, a congenital disorder characterised by a partial or complete absence of pigment in the eyes, hair and skin. They have about 5 percent of their sight – essentially, they're legally blind, but can make out shapes. Their condition not only makes them susceptible to skin cancer, but also causes them to slowly lose their sight. I did a formal portrait with these boys on that trip, and I've returned to the school over the years to photograph these remarkable individuals as they've grown older. One day, I hope to capture them in productive roles in Indian society, utilising the skills they've gained from their schooling. That would be very satisfying.

For a photographer, sight is everything. If I can't see, I can't take pictures, and if I couldn't take pictures, I don't know what I'd do. In a way, blind people symbolise my greatest fear. But when, as they often do, they rise above the afflictions they've suffered in life and prove what worthwhile members of society they can be, they embody the triumph of the human spirit. This school has given students, often from the poorest of circumstances, a genuine sense of self-worth. It's given them solidarity, purpose, and completely changed their lives.

Photographing them has certainly done the same thing for me.

Find out more on canon-europe.com/pro

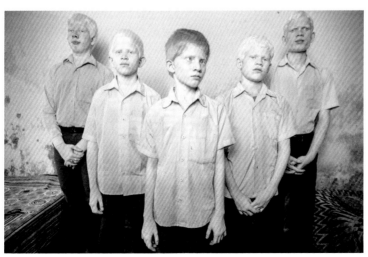

© Brent Stirton, Canon Ambassador

Live for the story_

WORLD PRESS PHOTO

Copyright © 2018
Stichting World Press Photo, Amsterdam,
the Netherlands, www.worldpressphoto.org
Schilt Publishing, Amsterdam,
the Netherlands, www.schiltpublishing.com

All photography copyrights are held by
the photographers.

Schilt Publishing
Peter Martensstraat 121
1087 NA Amsterdam, the Netherlands
Tel.: +31 (0) 6 51 98 47 47
www.schiltpublishing.com

Distributed in North America by
Ingram Publisher Services
One Ingram Blvd.
LaVergne, TN 37086, United States of America
Tel.: +1 866 400 5351, ips@ingramcontent.com

Managing Editor
David Campbell
Editor
Rodney Bolt
Production Coordinators
Chee Yee Tang, Yasmin Keel
Picture Coordinator
Thera Vermeij
Research Coordinator
Yi Wen Hsia
Research
Christian Schwieter, Jerzey Brinkhof,
Kayle Crosson, Samira Damato

Art Director
Teun van der Heijden
Design
Heijdens Karwei, Amsterdam,
the Netherlands, www.heijdenskarwei.com

Print & Logistics Management
KOMESO GmbH, Stuttgart, Germany
www.komeso.de
Lithography, printing and binding
F&W Druck- und Mediencenter GmbH,
Kienberg, Germany, www.fw-medien.de
Paper
Maximat Prime, 300 / 150 g
Produced by UPM, distributed by IGEPAgroup

Production Supervisors
Maarten Schilt, Yasmin Keel

ISBN 978 90 5330 901 8

On the front cover:
Ronaldo Schemidt, Venezuela,
Agence France-Presse,
'Venezuela Crisis',
World Press Photo of the Year 2017

On the back cover:
Anna Boyiazis, USA,
'Finding Freedom in the Water'

World Press Photo Foundation
World Press Photo, founded in 1955, is an independent, non-profit organization based in Amsterdam, the Netherlands.

#WPPh2018

Patron
HRH Prince Constantijn of the Netherlands

Managing Director
Lars Boering

**World Press Photo receives support from the Dutch Postcode
Lottery and is sponsored worldwide by Canon.**

Supporters
Delta Lloyd • ING • Mettaal • VCK Logistics

World Press Photo holds the official accreditation for good
practices from the Central Bureau on Fundraising (CBF).

MIX
Paper from
responsible sources
FSC® C018828
www.fsc.org